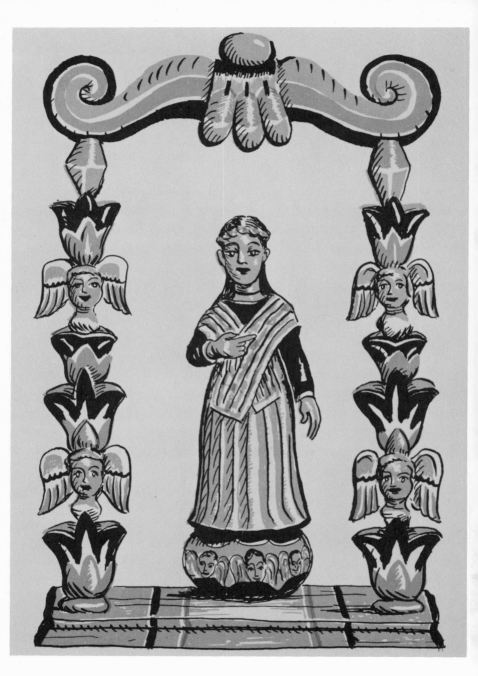

ROLAND F. DICKEY

NEW MEXICO VILLAGE ARTS

Drawings by Lloyd Lózes Goff

University of New Mexico Press
Albuquerque

© by Roland F. Dickey 1949, 1970. All rights reserved. Manufactured in the United States of America by the University of New Mexico Printing Plant, Albuquerque. Library of Congress Catalog Card No. 71-107101. Calligraphy by Robert Stanford Wallace.

FOR PEG

PREFACE

THIS BOOK DOES NOT RE-count famous names and urbane schools of art. It tells of ordinary men and women who worked with their hands to create a satisfying way of life in the Spanish villages of New Mexico.

A sympathetic study of objects and actions common to the daily lives of a people fosters understanding of their spirit and culture. We learn thus their likeness to ourselves and to all the inhabitants of the earth who eat, build shelters, and deck their bodies. At the same time, the marks which distinguish them as a group rise in sharp relief. We are led to inquire what human and environmental factors underlie these differences, and what events impel a people to evolve a trastero *rather than some other form of cabinet, or to gain religious comfort from a* santo *rather than an ikon or a katcina.*

The commonest everyday item—a chair, a knife, a coat—invites us to speculate on the long ingenuity of man. The wooden box must have known a long evolution of experiment and logic seeking maximum storage space and portability in a unit which by its inherent geometric structure had strength. And if, as some think, the chest began as a hollow log, or, as others believe, it was once a wicker cage covered with hide—

who then, was clever enough to reproduce this form in slabs of wood, and what man made the transition from thong-bound sticks to mortise and tenon or tongue and groove? Mankind's uncelebrated heroes first compounded glue, had insight to the myriad forms of the hinge, perfected the auger, painstakingly wrought levers into a lock.

What was in the mind of the Persian who carved a wreath of flowers about the neck of a stone bull? Was he simply a realist, copying an animal decked for ceremonial procession? And, if this is true, why should an ancient warlike people desire to garland their beasts with so beautiful and delicate a thing as a flower? And why, in the soft pine of a chest, should a New Mexico villager carve again this same flower which rides like a daisy chain through the hands of countless artists, from Persepolis to Santa Fe?

Indeed, the decorative arts seem begun and cultivated like a potted plant, in sheer nostalgia for spring. They compensate for wintertimes of the spirit. Sometimes they are a release from muscular boredom, like doodling at the telephone, and sometimes an expression of ego. Again, the mere expenditure of inutile effort is sufficient to make a thing seem precious, even beautiful. The awareness of death and time bring a strong wish to be remembered, to place upon an object the mark: I, John Doe, wrought this for the sons of my sons, that my name be not forgotten.

In New Mexico, as in all parts of the world, men sifted the past and surveyed the present, solving the problems which pressed them, and conceiving new inventions. Eating habits

shape utensils and religious beliefs supply symbols, but environments dictate materials and individual men imprint these with their genius.

PREFACE TO THE 1970 EDITION

 IN THE years since 1949, when this book first appeared, the traditional arts and crafts of the Southwest have experienced still another cycle of lapse and rescue. The indigenous arts continue to be endangered, yet they are tough and persistent, and old motifs emerge in new media. A number of ancient occupations, including weaving, metalwork, and Indian pottery, have survived in New Mexico, long past their expected span, to satisfy local preferences and the demands of tourists. During the nineteen-thirties and forties, the vanishing art traditions were recorded and encouraged by the W. P. A. and other agencies. In the sixties and seventies, public and private funds are assisting craftsmen with design, techniques, and marketing, so that the old looms are creaking once more, colcha needles flash, wood chisels are at work. Meanwhile modern and historic examples are being collected by museums, studied by scholars, and admired by the public. The proud story of regional heritage is being told again in brochures and exhibitions.

I find in New Mexico Village Arts, *preserved like insects in amber, a world I knew and loved. At the end of the book I*

wrote, "... there is no returning. The tide of history engulfs us all." One can return, of course, in books, in photographs, and best of all by touching the things made and used by human hands. It is in the arts that the spirit of man is captured and set free.

To those who helped initiate this work and bring it to fruition, among them Russell Vernon Hunter, Paul and Virginia Sears, Helen Gentry, David Greenhood, Lloyd Lózes Goff, and Robert S. Wallace, I am grateful. For believing in the book, Frank McNitt, Dee Linford, Edward and Judy Lueders, Hugh Smith, Arch and Vera Napier, Mary E. Adams, Blair and Carol Boyd, and Lawrence Clark Powell merit special thanks.

Roland F. Dickey

TABLE OF CONTENTS

LIST OF DRAWINGS

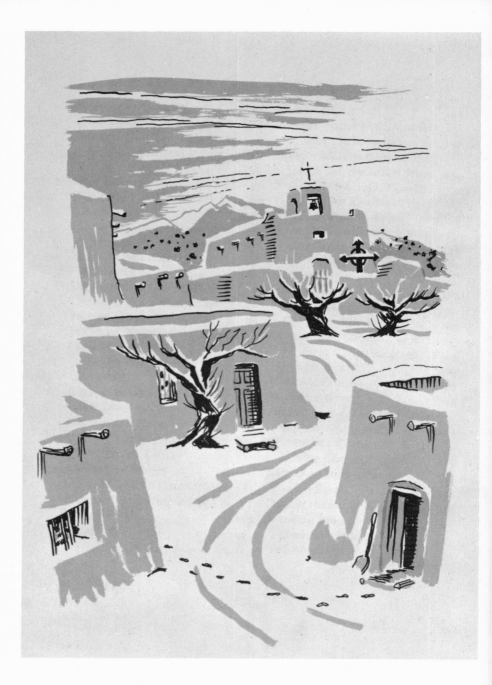

I. The VILLAGE

CHAPTER ONE A DRY & THIRSTY LAND

NEW MEXICO IS A ROBUST land, ribbed with tall ranges and cut by slow-moving streams. The clouds are caught and drained by the peaks, and water descending sharply has torn the landscape in harsh profiles. Between the mountains and the rivers are wide, dry plains. For centuries the rivers have nursed agricultural civilizations in the great valleys.

Less than fifty years after the sailing of Columbus, Spanish soldiers were riding up these valleys, bearing European ideas, metal, language, and religion. By 1598, nine years before Jamestown, they had established New Mexico's first settlement, at the junction of the Chama and the Rio Grande. From the resident Indians the invaders seized their requirements in food, shelter, clothing, and labor, and thus assimilated many of the everyday patterns of ancient Pueblo living. Their efforts wavered between the moral obligation to establish Christianity among the Indians and the temptation to exploit these

3

people. Pressed beyond endurance, in 1680 the Pueblos rose
in rebellion and forced the little band of Spaniards to flee to
El Paso. In the twelve years that elapsed before Spain's
authority was reasserted in her most northern province, the
Indians endeavored to untie the Gordian knot which had fet-
tered them for a century. They demolished missions and held
ceremonies to counteract baptism. From 1692 onward there
was sufficient tranquility in the Southwest to foster a settled
existence, although the Spanish villages experienced the real
and impending terror of raids from fierce nomadic tribes—
Apaches, Navajos, Utes, Comanches—encircling New Mexico.

Early in the nineteenth century the Independence of Mex-
ico divorced New Mexico from its nebulous loyalties to Spain,
and in 1846 the flag of the United States was raised over the
Plaza in Santa Fe. More significant in the daily life of the resi-
dents than political change was the flow of alien goods from
Mexico over the Chihuahua Road, and from the United
States over the Santa Fe Trail. This commerce increased enor-
mously with the entrance of the railway in 1878, and brought
in its wake a tide of English-speaking settlers which by 1910
approximately equalled the native population. In 1912, New
Mexico became the forty-seventh state of the Union.

We are little concerned with the transient military and civil
officials of New Mexico, whose home ties and loyalties were
elsewhere, and who made every effort to carry their previous
mode of living with them, returning to it as soon as they were
able. Likewise, the *hacendados,* the landowners who reaped
their living from the sweat of peon and Indian and aped the
manners of the Viceroy's court, made small contribution in-
deed to the creation of an indigenous New Mexican culture.
To their credit, however, is the patronage of artists and the

importation of examples of art which served as stimuli to local ingenuity.

Our hero, then, is the ordinary man, who met the land squarely, wrested from it his food and clothing, built his house from its soil and trees, and, after the first generation, looked upon New Mexico as his only home. His language is Spanish, his religion, Roman Catholic. His culture pattern, garnered from all the shores of the Mediterranean, fermented in the Iberian sun, is that of sixteenth-century Spain modified by brief encounter with Mexico, and sharpened into a regional entity by comparative isolation in the valleys of New Mexico.

Because he lived on the perimeter of European history, its thunder reaching him only as a confused echo, the New Mexican tended to fossilize certain Medieval ways of thinking and acting. In the course of centuries he learned to work in characteristic ways, and thus created a tradition of arts and crafts recognizable as his own.

Like Pueblo Indian and Iberian, the New Mexican was a farmer who lived in a village. Surrounded by aboriginal neighbors, he sought safety in community existence, and assuaged his loneliness in the companionship of family and friends. The Pueblos had taken comfort in the mountain barriers which stood between their towns and the hunting grounds of the warlike tribes who hemmed them in. The Spaniards moved into localities already farmed and irrigated by Pueblo Indians and founded Hispanic villages in the valleys of the Rio Grande and its tributaries. In the middle of the seventeenth century only about one thousand Spaniards inhabited the province, the Indians outnumbering them twenty-five to one. Spanish security, precarious as it was, lay

in the possession of firearms and the peaceful inclination of
the Pueblo peoples. During the eighteenth century, however,
the Spaniards steadily gained the upper hand, and by 1794
their population approached twenty-three thousand, while
the Pueblo peoples had diminished to half that number.

The current of history began to catch up with New Mexico
in the nineteenth century, and provincial ways felt the in-
creasing impact of the Industrial Revolution. Frontier as-
pects faded. After 1846, the territory filled rapidly with fam-
ilies from beyond the Mississippi who introduced the tempo
of the aggressive American republic. The newcomers made
the trip between Independence, Missouri, and Santa Fe by six-
mule stagecoach in twenty to twenty-five days. Passengers
were charged $150 winter rates, and $25 less in the summer,
"provisions, arms, and ammunition furnished by the propri-
etors." Villagers abandoned their handicrafts in favor of the
manufactured goods which general merchandise stores ex-
changed for wool, hides, wheat, corn, and mortgages.

In Hispanic times, the villager fed himself mainly by agri-
cultural and pastoral pursuits, occasionally augmenting his
diet with wild game and fruits. His staple foods were Indian
corn, beans, chile, and the milk and flesh of goats. He was no
great hunter, for firearms were the instruments of soldiers
and *rancheros,* and he had to rely on traps, the spear, and the
bow and arrow. The presence of abundant game and fish near
even the largest communities in 1846 proved that this food
source had not been exploited overly. Many areas had excel-
lent grass, and supported large herds of sheep which were
more significant for mutton than for wool. A lesser number
of goats was maintained for milk and cheese, chevon and
leather. The few cattle were primarily work oxen.

Drying was almost the only method of preserving foods known to the Indians and the Spanish colonists, although salting was practiced to a limited extent. Chile, apricots, peaches, melons, currants, and raisins were dried in the sun. The Pueblos were more ambitious than the Spaniards in planting European fruit trees, and it is said that when the Indians tried to eradicate all traces of white occupation after the Rebellion of 1680, there were hot disputes over destroying the orchards. Buffalo, venison, and domestic meats were cut in small pieces and hung on lines to dry them into "jerky," so hard and tough that it had to be pulverized and boiled. Jerky was the mainstay of travelers.

New Mexicans are held in a village relationship by the need to share water. With an average precipitation of less than fifteen inches a year, rainfall in the valleys is so little that farming is almost totally dependent upon irrigation. The size of cultivated plots is determined by the distance which water can be ditched successfully from the river. A well-organized system of coöperation is paramount in the maintenance of irrigation canals, *acequias* they are called, and the just distribution of water. Precedent for irrigation methods exists with the Pueblo Indians, who have farmed thus for centuries, and in Spain, where the Water Tribunal sits regularly in the plaza of Valencia to decide farmers' disputes.

Men of the village dug an *acequia madre,* or mother ditch, which tapped the river at a higher level some distance upstream, and returned unused water below the last field. Each plot of ground had its own cross-ditch with a gate opening on the main canal, and the cultivated land was divided into small level areas surrounded by earthen banks so they could be flooded to a depth of several inches. The watering process was slow; a single man could irrigate about five acres a day. In normal seasons water was unlimited, but in times of drouth it was rationed on the basis of acreage, and fines were imposed for exceeding the quota.

The plots cultivated by individual farmers were small, seldom more than ten acres. In 1855, the largest farm managed by a single wealthy owner consisted of 1,721 acres in Bernalillo County. Division of land was by the feudal system of long, narrow strips, which ran from the river to the *acequia madre.* In the break-up of haciendas during the last century, and the consequent sub-dividing of lands, much valuable ground was wasted at the fence lines, as present-day aerial maps reveal. Very few fences were constructed in pre-American times, and these were adobe walls or palisades of brush intended to protect small gardens. During the growing season, the villagers used the herder system to keep animals from the crops.

Farmers made most of their own implements—hoes, spades, plows, and carts—of wood, for all wrought iron was imported and too expensive for an ordinary laborer. Likewise, the utensils for processing and serving foods were fashioned at home, except pottery, for which the villagers traded with Pueblo Indians.

The villager had to be self-reliant, for he was the most neglected individual in New Mexican society. The Spanish

crown opened its purse for the spiritual welfare of the Indians, and sponsored caravans of supplies which came to New Mexico with the tools and materials the Franciscan mission fathers needed to build churches and hospitals. Paintings, musical instruments, rich robes, and gold and silver altar service helped to convince the Indians of the power and magnificence of Christianity. Civil officials were men of rank and family who drew upon their personal fortunes and exploited both Spanish and Indian labor to buy elegant entertainment, fine horses, imported clothing, and expensive tableware. Superior as it was to anything in the province, the show of the grandee was often tawdry; too many of New Mexico's administrators were failures and trouble makers at home, diplomatically exiled to the north for political expedience. But the villager, a Christian by birth and a laborer by inheritance, had no one in authority who was worried much about either his spiritual or his physical status. He was the victim of an economic system in which the scales were balanced against him and made him the prisoner of perpetual debt.

Before 1846, the business of New Mexico was transacted principally by barter, the value of produce and labor being based on theoretical sums of money. Kearney's soldiers reported that the natives refused gold coins, preferring silver, and the enlisted men had great success with the large buttons on their jackets as a medium of exchange. Landowners reckoned the service of peons at as low as two dollars a month, and this was credited in goods at the master's store. The practice amounted to slavery, since the peon was overcharged for his needs, yet by law he had to continue working until his debt was finished. While he could not be bought and sold like a slave, the peon had to provide his own keep, and an unscru-

pulous master took no responsibility for his servant's old age. Not all villagers fell into the peon category. Some were soldier-citizens, paid in land for their services to the government. Others were tradesmen—weavers, shoemakers, and black-

smiths—whose living was not dependent on land. As the years progressed, an increasing number of New Mexicans were descendants of the ruling families, and escaped peonage by virtue of being "poor relations."

Lacking sufficient goods for trade, the laboring New Mexican was obliged to obtain his needs from his environment. This he did with eminent success. He not only devised his tools—and some of these, such as the loom, were most ingenious in the absence of metal—he found time to imitate some of the luxury goods which officer and priest imported from Mexico. Native workmen coöperated to build their own parish churches. Village artists learned to carve the figures of the saints in cottonwood. They learned to grind tempera colors from minerals and to paint religious pictures and altar dec-

orations. Women dyed homespun wool with indigo, brazil-wood, and wild plants, and embroidered handsome altar cloths. With handmade musical instruments and improvised costumes, the people performed miracle plays and dramatized the pageantry of the church. Religion remained their strongest link with the distant homeland, and their greatest oppor-

tunity to express themselves in music, theater, and the manual arts. Except for chests, furniture rarely was imported, and local carpenters constructed pine pieces for churches and wealthy homes. With the passing of time, all these native works came to be more than imitations. A spirit of original design entered New Mexican art, and by 1800 the tradition was fixed firmly in regional techniques and characteristic motifs.

Despite the obstacles of distance, difficult terrain, and marauding Indians which stood between New Mexico and the world of fashion, occasional visitors from Mexico and Louisiana refreshed the province with goods and information. The visits were infrequent enough to give time for the frontier settlements to digest and distort the rare items of news, and to copy and change the meager equipment which reached them. The seventeenth-century mission caravans arrived three years apart. Commerce between New Mexico and the Louisiana French occurred before 1723, because in that year an order from Spain declared such dealings illegal. Several times afterwards the possessions of French traders were confiscated. The legal barriers were circumvented by holding Indian fairs at Taos and Pecos for the purpose of trading with the Comanches, who had access to Louisiana merchandise, and carried French guns. An annual fair was established in Chihuahua late in the eighteenth century to stimulate Mexican trade with the residents of New Mexico. In exchange for salt, hides, village and Pueblo textiles, the Chihuahua merchants offered arms and ammunition, hardware, spices, medicines, fine cloths and Chinese shawls, paintings, and other religious goods. The government charged a sales tax, and the balance of trade was always in favor of Mexico, leaving the

provincial traders, like the peons, perpetually in debt. The yearly turnover of goods at the fair was once calculated at thirty thousand dollars.

After 1821, Mexico no longer was obligated to buy from Spain, and she turned to the markets of the United States. Under these conditions, the Santa Fe Trail flourished, and Yankee teamsters profited by the arduous trip from Missouri to New Mexico. The Trail traders were taxed at Santa Fe, five hundred dollars or more the wagonload, but frequently found it worth while to drive an extra six hundred miles to the market at Chihuahua City. Such luxuries as coffee, cotton prints, shawls, pictures, furniture, and hardware found eager customers in the Southwest. Despite the tax, American merchants could gain four to eight hundred per cent on the two or three thousand dollars worth of goods in each wagon.

Native craftsmen displayed proficiency and creative talent in the items which could be made from local materials. When copying the articles most frequently imported, metalwork and chests for example, it was natural for artisans to repeat Continental fashions. The inability of poorer folk to afford alien luxuries impelled them to try making these for themselves.

Not only isolation from the centers of civilization, but distances within New Mexico slowed the diffusion of art styles and to this day continue as a factor in the preservation of folk arts and customs. People of the mountain villages seldom found an excuse for the exhausting horseback ride to Santa Fe or Albuquerque. This accounted for the localization of certain art styles, such as the dramatic painting of the Truchas-Santa Cruz area, the architectural deviations of Sandia and Manzano villages, and the preponderance of large, facile

sculpture types in the neighborhood of Valencia and Tomé.

The roads of the province were not surfaced in Hispanic times, and in this respect it was fortunate the climate was so dry. Zebulon Pike noted a bridge of eight spans across the Rio Grande at San Felipe Pueblo, but fording was the universal practice, and travelers had to take their chances with whirlpools and quicksand. Horses were the only means of rapid travel, and every man took pride in his horsemanship and his accuracy with the lasso. *Rancheros* invested small fortunes in elaborate tooled leather saddles and bridles, shining with silver ornaments. Severe curb bits were preferred by the Spaniards, and as one American officer remarked, "with their large, cruel bits, they harrass their horses into a motion which enables them to gallop very long without losing sight of the starting place." Apaches and the poorer Spaniards shod their horses and mules with rawhide shoes instead of metal. The ownership of horses, and all other animals, was determined by a brand burnt in the hip. As may be seen in native paint-

ings, these brands were large curlicues resembling rubrics. Under Spanish law, the *fierro* was the brand of the original owner. When the animal was sold, a second brand, called the *venta* or buyer's brand, obliterated the first. Illegal branding

seems to have been no less common then than it came to be
in the heyday of American cattle ranching.

Like the cowboy, the muleteer had a professional place in
the Southwest. As in most Spanish countries, the *mula de
carga,* or packmule, was pressed into service for much of the
freighting between New Mexican communities. Mules, the
offspring of a horse and a jackass, were preferred for their
stamina and ability to forage. They fetched thirty dollars in
the market, three times the price of a horse. The muleteer
handled a string of ten of his cunning and obstinate charges
with great skill and a justly famous profane vocabulary. An
old jenny with a bell led the string, each animal wearing a
square pad of stuffed leather or a blanket of native *jerga* cloth
to ease the load of some three hundred pounds. Many strings
of mules made up a mule train, and one animal was always
assigned to carry the stone *metate* needed to grind corn for
tortillas. A few wealthy families owned carriages, "cumbrous
uncouth vehicles," pulled by four or six mules, and accom-
panied by the pomp and ceremony of outriders and postilions,
which were essential for protection from bandits and hostile
Indians.

The mule figures in the local version of a well-known
Christian legend applied to a celebrated statue of the Christ
Child at Zuñi Pueblo. After the Child was born at Hawikuh,
one of the "Seven Cities of Cibola" abandoned before 1680,
the sheep, the pigs, and the dogs licked its face. The mule re-
fused; therefore, unlike the other animals, the mule never is
blessed with babies.

"When New Mexico has become a state, the faithful burro
should be engraved on the coat of arms, as an emblem of all
the cardinal virtues." W. W. H. Davis may have written these

words to dignify the term "burros," derisively applied to those determined Americans who pursued the Mexican War. But certainly the modest little creature whom St. Francis called "my brother the ass," adopting its rope as the badge of Christian servitude, played an important though anonymous role in the development of the Spanish Southwest. The villager who could not afford a mule or a horse could at least keep a donkey to carry his wood and pack his grain. Taos whiskey and wild marsh grass, two items reputedly essential to the men and beasts of the United States Army, came to Santa Fe on the backs of burros. The whiskey arrived in kegs of hollowed-out cottonwood, and the hay in twelve-pound bundles, selling at two for a quarter "without the blanket" in which it was carried. Jackasses were equipped with neither saddle nor bridle; the rider wielded a club to guide his mount, urging coöperation by prodding him with the sharp point. New Mexicans followed the proper custom of mounting a burro from behind and riding "astride the rump abaft the hips."

For goods too bulky to place on the backs of mules and burros, the colonists employed crude wooden carts, constructed much like those long used in the south of Europe, but without benefit of iron. Stout, long-horned oxen pulled these vehicles at an incredibly slow pace across the arid plains and over steep mountain passes. The "bull-whackers" of the Santa Fe Trail introduced the light Conestoga wagon, but because sizable hardwood does not grow in New Mexico, and smithies were ill-equipped to make metal parts, the more efficient conveyance was not copied here. Discarded Yankee wagon tires became an important source of iron to the natives. Many traders sold some of their wagons at high prices, knowing they could replace them in the States. They substituted

sturdy New Mexican mules for overworked horses, and they
brought home with them the Spanish burros which sired the
famous Missouri mule. When factory-made wagons arrived
by rail in the 1880's, the villagers purchased them eagerly and
such wagons are still an important feature of rural economy.
Indians took to four-wheeled transport as readily as they had
to the Spanish horse, and the little Studebaker wagon with its
canvas cover is a familiar sight on the Navajo reservation to-
day.

THE low economic status of most New Mexicans and their
casual contacts with the advancing world did not make formal
education urgent. Reading and writing were the accomplish-
ments of priests, officials, and clerks; others had only the "sim-
plest rudiments." Comparatively few books, even religious,
were brought into the province, and no facilities for printing
existed until shortly before American occupation. It is safe
to say that when the Mexican government, early in the nine-
teenth century, ordered the confiscation of all United States
newspapers and all copies of Rousseau's *Social Contract* in

New Mexico, they found little evidence of such democratic propaganda. During the seventeenth century, Franciscans organized schools which taught reading, writing, music, and crafts to Indian boys, and probably they extended this training to Spanish children. With the growing uncertainty of church income, educational facilities deteriorated from about 1790 until the middle of the last century, when Archbishop Lamy brought Sisters of Loretto and Christian Brothers to establish parochial schools.

Lamy complained of the poor preparation of the local priesthood, perhaps basing his judgment on experiences like that related by J. W. Abert in 1846. It is impossible to guess how much of this incident is tongue-in-cheek:

"While Lieutenant Peck and I were conversing with the priest, he asked us our names and professions. We told him; and, as soon as he understood that we belonged to the corps of topographical engineers, he said: 'Ah! I suppose, then, you know something of astronomy and mathematics?' We replied, 'A little'; whereupon he got a piece of paper and pencil, and drew several figures, saying, 'este es el cuadro?' yes, that is a square; 'este un cerco?' yes, sir; 'y este es un triangulo?' yes, that is a triangle. Then throwing up the pencil, and rubbing his hands in great glee, 'Ah! voy [viendo] son astronomos y mathematicos.' Thus, we were pronounced by the padre of Albuquerque to be astronomers and mathematicians. Soon after this discussion of the exact sciences, a very handsome lady, who graced the establishment, entered the room, and he presented us to her; saying: 'Estos caballeros son astronomos y mathematicos.' "

A later note from the same diary is more reassuring:

"I have been much surprised by the many men and chil-

dren of the lower class that I have met with who both read and write; in fact, all that we questioned seemed to be educated, thus far, but they have no books; I only recollect to have seen a Roman Catholic catechism at Padillas. Many of the sons of the ricos are well educated; we saw several who had been at Union College, St. Louis. They speak French and English, and understand their own language grammatically."

Davis estimated in 1855 that at least twenty-five thousand of the sixty thousand residents of New Mexico were illiterate, a situation paralleling that of modern Spain, where nearly half the populace cannot read and public secretaries are found in every village. A vote in the 1850's on the question of tax-supported schools for New Mexico found only thirty-seven out of some five thousand ballots in favor. Already, Protestant mission schools had been opened, and it is probable that the natives feared encroachment on parochial training. Within a few years public schools were widespread, but official proclamations still are printed in two languages, although education is now in English.

As evidenced by the mechanical arts, the state of science in New Mexico was not much in advance of the "mathematics and astronomy" which impressed the Albuquerque priest. American soldiers and travelers were among the first to give us scientific reports of plant and animal life, geologic formations, mineral wealth, and accurate climatic data. Despite the abundance of surface coal, Americans were the first to exploit it extensively, if one overlooks the use of coal by the Hopi for firing pottery in pre-Hispanic times. The methods of mining and reducing metal were extremely primitive and most of the gold, silver, and copper ores were sent to Mexico for refining.

As early as 1629 Fray Alonso de Benavides, far more learned than most men of his day, observed the ore deposits in New Mexico and even tried to stimulate interest by showing specimens to the local gentry. When they laughed at him, the monk commented: "As they have a good crop of tobacco to smoke, they are very content, and wish no riches. It seems as if they had taken the vow of poverty—which is much for Spaniards, who, out of greed for silver and gold, would enter Hell itself to get them." Gamblers at heart, the Spaniards never admitted that the wheel of fortune was loaded against them in the search for treasure. When they captured Moorish mosques at home in Spain, they dug up the floors seeking jewels and gold. In Mexico they sought the Aztec hoard. The exploration of New Mexico was motivated by mythical stories of seven cities of gold. The abandoned missions of Gran Quivira and Quarai were ransacked by fortune hunters, and even to-day one hears of Spanish and Indian treasure hidden in New Mexico long ago.

Medical knowledge was no more available than natural science. After the Franciscan hospitals at Santa Fe and San Felipe closed, European medicines continued to be shipped into the province. These, in all their questionable efficacy, were only for the privileged. The poor continued the fatalistic philosophy about death and disease which was their Medieval heritage, alleviating suffering with empiric remedies and consoling themselves with witchcraft. The Indians had a useful understanding of the properties of native plants and the villagers learned the more common formulas. In their desperation they confused superstition with religion and built up an extensive folklore in miraculous cures. Belief in sorcery was

even more intense than in Massachusetts, and both Indians and Spaniards were embroiled in notorious trials involving these matters. Old women of the villages still practice a healing trade, half medicinal, half psychological.

T H U S far we have examined some of the factors affecting the life, and therefore the arts, of the New Mexico villager. Primitive economics, inadequate medicine, brief education, poor roads and slow transportation, he shared with rural folk everywhere in the world. His distance from the active centers of civilization denied him many innovations and kept certain aspects of his culture at the static level of three hundred years ago. Yet he had several assets. His family and community life and his religion gave the native a warm sense of security and individual importance. The climate of New Mexico, though dry, is not rigorous and allowed him a long growing season and the opportunity to be out-of-doors throughout the year. Except for iron tools, his environment supplied him all the materials essential to a satisfactory existence, and if the little metal he needed had not been easier to obtain by trade, he could have refined this also. Even if he did not exploit his environment to its fullest potential, he worked it enough to pro-

vide comforts and pleasures without an unreasonable expenditure of energy.

Social pleasures were many. The New Mexican enjoyed the gregarious experience of returning to his village after a day's labor in the irrigated fields. He squatted on his heels against a sun-soaked adobe wall and chatted endlessly with his neighbors in a sing-song rural Spanish. A little home-made wine prompted him to compose new verses to a popular ballad tune, accompanied by the bawdy laughter of his companions.

Saints' days divided the calendar into festive seasons when the villagers carried the rose-decked figure of the patron saint, perhaps the farmer's friend, St. Isidore, in solemn procession through the fields.

After Mass, women scurried home to unburden the mud oven of its steaming corn and chile. The men ate first, while the women cackled in the kitchen over the ailments of their cousins. As in Continental fashion, it was the custom to serve the food in courses, one dish at a time. In the afternoon, children played singing games like "Picking Piñons for Coyote," reciting endless rhymes:

Pepenando piñoncito
Para el pobre coyotito.

Meanwhile men knelt in circles in the shade of a cottonwood, betting on the spurs of a favorite cock, or caught in the intensity of monte gambling. In the evening everyone flocked to the large hall of the *patron,* and amused himself in spirited Aragonese dances to the sharp melodic whine of handmade fiddle and harp, timed by the tap of a little drum. Long after the elders were in bed, the night air echoed with the voices of young men harmonizing in musical thirds, prolonging the end of each phrase in high, wild falsetto.

Little bonfires heralded the beginning of religious holidays, a custom of long standing, for in 1626 Benavides speaks of them in Santa Fe: "On that night, quite a stormy one, they lighted their luminaries and celebrated as much as they could."

"Long shall I remember the fete of Tomé, a scene at once so novel and so striking," wrote Lieutenant Emory in 1846.

"During the day I had been puzzled by seeing at regular intervals on the wall surrounding the capilla, and on the turrets of the capilla itself, (which be it remembered is of mud,) piles of dry wood. The mystery was now cleared up. At a given signal all were lighted, and simultaneously a flight of rockets took place from every door and window of the chapel, fireworks of all kinds, from the blazing rocket to children's whirligigs, were now displayed in succession. The pyrotechny was the handicraft of the priests. I must say the whole affair did honor to the church, and displayed considerable chemical knowledge. Most of the spectators were on mules, each with his woman in front, and it was considered a great feat to explode a rocket under a mule's belly without previous intimation to the rider."

For the celebration of Christmas and Easter, long miracle plays were performed—*The Shepherds,* and *The Flight into Egypt*—with plaintive choruses and actors dressed like pictures in the church. A strong flavor of pre-Christian rites, both Old World and New, clung to these performances. The delicate shuffling ritual of the Shepherds in *Los Pastores* suggested the antique minuet danced by choir boys on the steps of the high altar of Seville Cathedral, and the staves carried by New Mexican *Pastores* were decorated in unmistakable recollection of feather wands made by Indians of tropical

America. Especially on Christmas Eve, the plays are revived today in New Mexican communities when the people visit their neighbors singing and re-enacting the story of *La Posada,* the search of Mary and Joseph for an inn where they could rest. At house after house the Holy Family meets "no vacancy," until at last they reach the Bethlehem of the village hall, where actors await them to begin a performance of *Los Pastores.* Nowadays, the Hermit of the group wears a Santa Claus mask, a tinsel star on a string leads the Shepherds to a creche beneath a Christmas tree, and Mary serves Coca-Cola to the resting herdsmen, even Bartolo, the lazy one, awakening for his share.

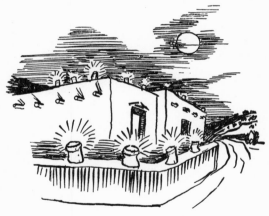

Instead of the juniper vigil fires of former days, the natives make *farolitos,* little lanterns of burning candles set in sand inside paper bags, which they place in rows to outline the flat rooftops with tawny, flickering lights. The custom has appealed to Anglo-American residents, and they too announce Christmas Eve with candles in grocer's bags, calling them *luminarias.*

Since, in many respects, New Mexico was a Medieval world until it became a part of the United States, the villagers were poorly prepared for the changes of the Industrial Age which began to intrude upon their quiet valleys about 1846. To Americans, New Mexico seemed but another incident in the conquest of the West, an incident, however, which required special handling. In occupying Indian lands, it had been the custom to push these so-called savages from their hunting grounds, and as soon as possible to establish settlements very much like parent towns of the Atlantic Seaboard, which in turn resembled those of northern Europe. In New Mexico the American vanguard met, not warlike tribes, but men of European descent. Since hardly a skirmish occurred in taking New Mexico, and both the Spanish residents and the Pueblos were peaceable and coöperative, there was no excuse to overwhelm the region with Yankee strength. The Spanish villagers were given automatic citizenship in the United States. The Indians, whom Americans always have held in scalp-conscious regard, were placed under the supervision of "the Great White Father in Washington." Thereafter, the conquest of New Mexico by the United States was largely a matter of economics and education.

For thirty years after 1846, Americans were a long and expensive distance from their base of supply, and they found it necessary to compromise with such native materials as adobe, to which they added milled lumber from local forests. The approach of the transcontinental railroad opened Eastern markets, fostering sheep and cattle raising and the mining of coal and metals. These furnished employment for the natives, both Spanish and Indian, generally as laborers. Displaced from their former agricultural security, these peoples often

faced new economic problems of seasonal employment and inadequate wages. The railroad brought countless itchy-footed newcomers, eager to better their lot in a new locality which they at first did not recognize as essentially unlike that conquered by their fathers and grandfathers. Ambitious entrepreneurs turned huge herds on what they took to be endless range grass, plowed up thin topsoils, denuded supposedly inexhaustible forests, and ran to the end of big-pay mineral veins. Where this has happened, there has been an exodus of the population, leaving in its wake tumbledown houses, fields of thistles, and rusting machinery.

DURING the first half century, American colonization followed to a large degree the pattern already set in Illinois and Missouri. "Progress" was the keynote, and progress consisted of active merchandising, rapid building, and the organization of political government on accepted lines. Men with an instinct for farming must have been the first to realize that the Territory presented quite different problems from anything previously encountered. To exist by the land, they had to learn the laborious processes of irrigation, and be content with small acreage. Not until much later did they evolve the

techniques of "dry farming," bringing the consequences of the "Dust Bowl" upon their own heads. At first there were three acceptable ways to try for sudden wealth: gold and silver mining, trade, and real estate. In mining and merchandising the Spaniards had anticipated them; there was room, however, for modern methods. With periodic set-backs, the real estate boom has continued in New Mexico for a hundred years, and has taken on new impetus with the development of machine industry during World War II. After centuries on an agrarian base, the cultural and economic balance of the New Mexico village is still teetering from the shift to American cash economy.

Progressive citizens were eager to merit election to statehood by endowing the Territory with the physical appearance of states which had preceded New Mexico into the Union. They were right in assuming that Congress would decide on this basis. Many of them, both Spanish and English, were deeply ashamed of those villagers who refused to listen to the tin horn of progress and abandon their cool adobe houses, their colorful religious life, and their accustomed diet. The Main Street atmosphere with false second stories was achieved, but it was disturbing to have this conventional setting invaded by soft Andalusian speech and blanketed Indians.

"He never speaks to me until election" is a favorite native saying. Politics are meat and drink to Spaniards, and New Mexican orators, who had a taste of republican government under Mexico, took to the democratic system as their birthright. Politics in action is not necessarily admirable, but many times it served to prevent encroachment on the rights of Spanish-speaking citizens, and the latter were fortunate in the leadership of such brilliant men as Amado Chaves and O. A.

Larrazolo. Both Spaniards and Indians found champions among persons whose primary interest was not economic success. Educators, writers, artists, and anthropologists discovered much to admire in the pre-American civilizations of New Mexico, and hastened to spread this news.

About the turn of the present century there began a steady contagion of regional pride, not only in the Southwest, but throughout the country. Some of the roots of this sentiment lay in popular journalism: America was coming of age, and for many years a large reading public had enjoyed the New World's young but exciting heritage in the works of Cooper and Irving. William H. Prescott had provided a background for the Hispanic theme in his *Conquest of Mexico,* and Lew Wallace romanticized this conquest in *The Fair God.* Later, Wallace was to live in New Mexico as its Territorial Governor, and to finish writing the last quarter of *Ben-Hur,* including the celebrated Crucifixion scene, in the Palace of the Governors. Mrs. Wallace busied herself with impressions of *The Land of the Pueblos.*

Perhaps the Southwest's most successful publicist was Charles F. Lummis. An intimate acquaintance with the country, and the ability to express his enthusiasm in dramatic phrases, enabled Lummis to focus the spotlight of public interest on romantic aspects of history and scene. Adolph F. Bandelier pioneered scientific interest in the Indians of New Mexico. Mary Austin applied her woman's intuition to the spiritual life of the Pueblos, and also was one of the first to preach the values of New Mexican handicrafts. Stay-at-homes visualized the wonders of the West through active sketches by Frederic Remington and the remarkable photographs of Ben Wittick and W. H. Jackson. A nucleus of artists and liter-

ati came to live in the brilliant, sunlit air of Taos and Santa
Fe, founding the art colonies which are now world-famous.

Discovering that noted persons were fascinated with their
environment and cultural heritage, New Mexicans, who once
had watched so eagerly for news of the outside world, turned

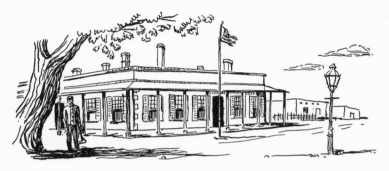

their eyes inward upon themselves and their ancient ways of
life. Societies were founded for the purpose of recording and
preserving the historical, ethnographic, and artistic elements
of Spanish and Indian life. Collectors and museums in many
countries began acquiring katcina dolls and *santos,* costumes,
metalwork, and textiles. Meanwhile, research workers pored
over the Spanish archives in Santa Fe, Mexico City, Madrid,
and the great libraries, pursuing the story of New Mexico and
her illustrious citizens. The journals of Zebulon Pike, Josiah
Gregg, George Kendall, and a host of other travelers took on
renewed significance and were brought freshly into print.

Some of the best descriptions of New Mexico life as it
existed before American ways wrought great changes were
found in mid-nineteenth century diaries of soldiers and offi-
cials. Among the United States Topographical Engineers
were men extraordinarily well equipped by language and gen-

eral knowledge, but most of all by sympathetic curiosity and
a sense of humor, to describe the intimate details of the coun-
try through which they passed. Usually they were repelled
by the mud houses and the low economic status of the natives,
and some of them were horrified by religious arts and customs,
which they duly recorded for our edification.

Many visitors praised the courteous manners of the vil-
lagers. "The kindness of these people was remarkable," wrote
one American officer. "We were struck with their politeness;
they always uncovered their heads when offering a light for
our 'cigarito'; and, when they made any movement, prefixed
it with 'con su licencéa, Señor.' " And almost as often these
travelers were shocked by what they referred to as the "loose
morals" of New Mexicans; that is, women who smoked (even
in bed!), painted their faces with red *alegria* juice, and wore
dresses cut low at the neck and high at the elbows and ankles.
Healthy young men like Kendall, once accustomed to the
fashion, decided that the "natural" figures of New Mexican
señoritas were an improvement over the misshaped lacings of
ladies at home. They remarked on the bravado of *vaqueros*
who could make a cornhusk cigarette and light it with flint
and steel while riding at full tilt, and they marvelled at the
general preoccupation with gambling, bull-baiting, and cock-
fights. With the perspective universal in the military, these
men commented on the quality of food, drink, and feminine
beauty, in that order, but few of them paid much regard to the
minor arts, except to point out the Spartan quality of accom-
modations by enumerating items of furniture in the houses
where they stopped. Detailed knowledge of ordinary things is
gleaned mainly from official papers, and from those objects
which have been preserved in actual use or by collectors.

For more than a hundred years now, the Spanish villages of New Mexico have been part and parcel of the United States, accepting American culture, and contributing to it in turn. It seems worthwhile to examine the lives of the natives and the works of their hands as they existed before this major cultural change, and further to note their development under the impact of history. New Mexico village arts have completed the cycle of a mature style. They have come from imitative beginnings to a robust individuality, followed by a decadence and a forgetting, and at last a revival in homes of today.

Imagination is the essential tool of art, and in meeting the challenges of their environment, the New Mexicans had more recourse to this tool than to any other.

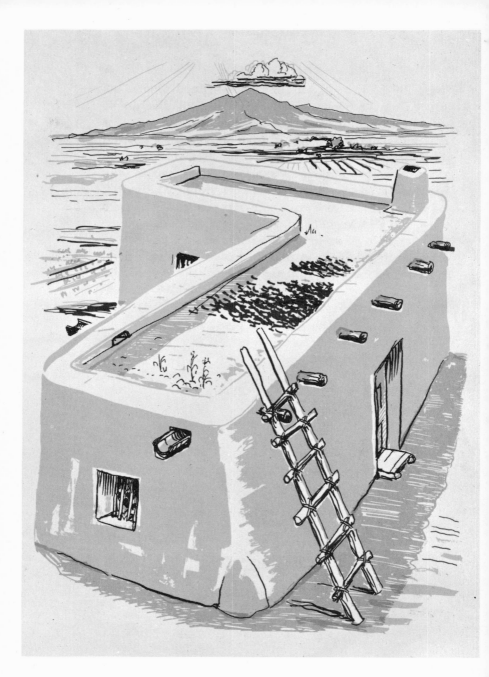

II. The HOUSE

CHAPTER TWO
EARTH IS LIFTED

MAKING MUD-PIES WAS SERI-
ous business to our ancestors. Tamping
wet earth into wooden forms and letting
the sun dry it, makes a building material
known to peoples of all the continents.
Clay, sand, straw, and water are available to every man, and
this mixture dries to the hardness of rock. Durable and easy
to use, dried mud resists fire, deadens sound, and insulates
against cold and heat. Hannibal's North African legions seem
to have brought the techniques of earth construction across
the Mediterranean, and from Caesar's soldiers the French
and the English learned to make houses of rammed earth.
This process, known as *pisé de terre*, was familiar to English
colonists, and houses built of rammed earth before the date
of American Independence still stand in Eastern states.

Like his Spanish forebears and his Pueblo neighbors, the
New Mexican uses mud to build his house. *Adobe*, he calls it,
a term of Moorish origin to which our word "daub" is related.
From a distance, the native village is a cluster of great clay

33

cubes melting into the landscape. The houses repeat the colors of the soil and the gentle contours of the mesas.

"It was remarked how delightfully cool the houses were," wrote Captain A. R. Johnston, who accompanied Stephen Kearny in 1846. He noted in his diary the typical house construction in New Mexico:

"The process of building houses, make brick, dry them in the sun, build with mud mortar, lay over the roofs beams which come from the distant hills, then boards or poles, then earth and spouts, whitewash with gypsum, smear the walls outside with mud, also the floors; the houses being hung with looking-glasses and images, floors carpeted, no pain in walking about—mode of building peculiarly adapted to the country and climate."

The adobe-maker digs a shallow pit in clay soil. He pulverizes the earth and adds water. By treading with bare feet, or driving animals around the pit, he mixes the mud to a stiff paste. Thin layers of grass, straw, or manure are spread over the mud at intervals and tramped in. The straw adds no strength to adobe, but keeps it from cracking while drying. The addition of sand to soil that is too clayey serves the same purpose.

A wooden form, like a shallow box without top or bottom, is used to mold adobe bricks. The form is dipped in water, placed on level ground, and filled with mud. The adobe mixture is pressed firmly into the mold and leveled off with a flat stick. When the form is lifted by its handles, the new adobe brick is left standing free. A day or so in the sun dries the brick enough for it to be placed on edge. After several days the bricks are firm and hard, and they are stacked edgewise, three or four high, to await use in housebuilding.

Adobe bricks are of a size and weight that can be handled readily by one man. An average brick measures sixteen inches long, ten inches wide, and four inches thick, and weighs forty or fifty pounds. Two men can mix and mold more than a hundred adobe bricks a day, or roughly one hundred square feet of wall.

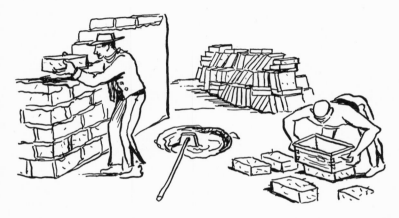

Villagers choose a well-drained site, and lay a foundation of uncut stones, mortared with mud, about eighteen inches above the soil. The rock foundation discourages the capillary action of ground-water, and guards against flood. On this is built the adobe wall, the bricks laid in level rows and cemented with thick mud mortar. Corners are bonded by interlacing the bricks, and the joints are alternated in each brick course. The wall is allowed to dry for a week before lintels and roof-timbers are applied. Older houses commonly have walls two feet or more in thickness, and the resulting deep windows and doorsills give a feeling of pleasant security to the architecture.

New Mexican builders use pine-log beams, called *vigas,* to

support the roof. Logs for *vigas* average six to ten inches in diameter, and fourteen to twenty feet long. Workmen strip the timbers clean of bark and with the aid of ropes lift them into place on top of the wall. *Vigas* are laid the short way of the house, at intervals of two or three feet. In some communities, *viga*-ends project beyond the wall on each side, forming a characteristic exterior feature.

The roof is flat. In former times, small logs were split with wedges and laid flat-side down across the beams to form a ceiling. Sometimes pine sticks or peeled aspen poles were used in the same way. Today, ceilings are made of rough lumber. Upon this is laid a tight layer of brush—chamiso bush or yucca leaves. This layer is plastered with a thick coat of adobe, followed by quantities of loose earth to a thickness of eight inches or more.

To diminish erosion of an adobe wall, the native raises it in a *pretil,* or low parapet around the roof. Flat stones laid on top of the wall help to turn the rain. Pueblo Indians once used the roof parapet as a defensive wall. By placing the larger ends of all *vigas* on the same side, and keeping the lower edges level, the ingenious workman achieves a slight pitch to his roof with tapering pine logs.

An adobe wall receives its distinctive character and its greatest protection from a heavy coat of mud plaster over the surface of the bricks. This plaster often comes from a community pit, proved by experience to be hard and durable. It marks each New Mexico village with an identifying color— rich red, ochre, dazzling white. Wheat straw, mixed with the mud to keep it from cracking, lends a golden sheen. The plaster is applied by hand, and gives to the entire structure soft, undulating lines.

This mud plaster prevents wind and water from eroding the joints between the adobe bricks, and is renewed annually. In many Pueblo communities, regular ceremonies are associ-

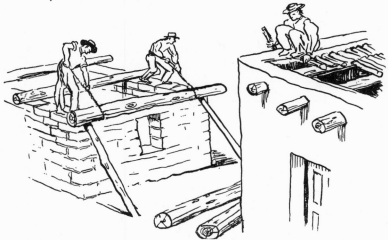

ated with house repair. In Spanish villages it is customary to fix the roof and replaster the walls before the fiesta of the patron saint. After holes and cracks are filled with adobe, the entire exterior is finished with a thin clay wash to give it fresh, even color. Plastering is done by women, while heavier repairs are made by men.

Iron, that index of European progress, was precious to the early Spanish colonist. Every adz, saw, and auger, every hinge and nail, reached New Mexico by tedious caravan. To the cost of an item in Mexico or Spain was added transport and trader's risk. The colonist was a poor man; often a knife and an axe were his only metal tools.

Machine-cut lumber was an American innovation to New Mexico. Formerly houses had small doors of adzed pine or cottonwood planks. Hardware was so scarce that doors turned

on wooden pins in sockets instead of metal hinges. Doors were made without nails, using wooden dowels and goathide glue.

The interior was dark, for windows were few and tiny. In the early years of the colony, animal skins were hung over the openings in bad weather. Later, scraped raw-hides stretched across the window admitted feeble light. Gypsum, said Davis, "is found in foliated blocks of numerous layers, which, being separated, are used for window-glass by the country people." Bits of this crystallized gypsum, or selenite, were set in the grooves of a wooden grill to make a crude window. Glass was so prized it was framed, painted, and hung on the wall.

When the *conquistadores* first visited New Mexico, in the sixteenth century, they found Indians living in great communal apartments which the Spaniards called *pueblos,* or towns. These great houses consisted of cubical rooms, built one against another, sharing common roofs and walls. Two- and three-story groups were common, and even five and six stories, the upper rooms set back in stairstep fashion. The lower-story roofs provided floors and balconies for those above. Several hundred souls might occupy such a house.

Adobe was the primary building material of the Pueblos, and the roof of poles and mud rested on pine *vigas* laid across the walls. Since these walls were very thick, and the short spaces between them spanned by heavy timbers, the structure had enough strength to support many tiers of rooms. No doors or windows broke outer walls of the Pueblo lower story, and the Indian reached his apartment by scaling a ladder. Tree trunks, with stubs of branches left for toeholds, served as ladders, which were withdrawn when the community was in danger of attack. First-story rooms were customarily used for the storage of grain, and could be entered by descending a ladder

through a hole in the roof. Doors, often scarcely a yard high, connected the inner rooms. J. W. Abert reported of Sandia Pueblo, in 1846, that the houses "are only one story high, but have no entrance except in the roof, where it is sheltered by a curious conical structure, built of adobes. These have an opening on the south side, and one ascends to the azotea, or roof, by means of ladders." It is possible that Abert mistook mud ovens, which were formerly built on the roof, for such a structure. However, the kiva at Isleta Pueblo has a somewhat similar shelter over the roof-entrance.

Many of the Indian towns were walled, or like Acoma, dependent upon the natural fortification of cliffs. They were built around two or more dance plazas, and normally the only buildings separate from the communal dwellings were kivas. In these ceremonial chambers—round or square, and submerged two-thirds beneath the ground—the men met for fraternal council and to dress for religious dances.

Several methods of building were in use by Southwestern Indians at the time of the Spanish invasion. The most advanced type consisted of roughly trimmed and fitted stones, usually cemented with mud mortar. At Acoma and the Hopi Pueblos, irregular stones are set in heavy adobe mortar. Castañeda, in 1540, observed another technique. Grass and brush were set on fire, and while the ashes still smoldered, water and earth were stirred in. This mixture was made into balls, which hardened in the sun, and were used instead of stones, with mud for mortar.

In *cajon*, or "box" construction, large blocks, rather than bricks, were made of adobe. The mud, rather dry, was molded directly on the wall between boxlike frames, in much the same technique as European rammed earth. The ancient

Pueblo foundations of the Governors' Palace in Santa Fe are of this type. The method was practiced as late as 1846, for Johnston observed that "Fences are made of clay, by putting the mould on the wall and filling it, and leaving the large brick thus formed to dry there."

The *jacal*, or log-and-mud house, is a distinct type of New Mexican construction, resembling the usual adobe in outward appearance. Ordinarily it is found in the higher mountain villages, such as Manzano and Tierra Amarilla, where timber is plentiful. However, Abert reported it in the Rio Grande Valley as "mud and palisades." Pine posts, six or eight inches thick, are set side by side in the ground as a house wall. The palisade thus formed is then plastered with thick coats of adobe mud. In areas of heavy rain and snow, a gable roof, covered with split logs, was used with this type long before metal roofs were introduced by Americans. Vertical-log houses similar to *jacal* were built by early settlers of the Thirteen Colonies before Scandinavians introduced the conventional "log cabin" of horizontal timbers notched at the corners.

The original style of Pueblo architecture exists only in ruins. The living Pueblo peoples, using the tools of their European neighbors, have adopted many foreign building practices. A few characteristic forms remain—the communal many-tiered dwelling, and the round kiva with its ladder. The pre-Spanish architecture was characterized by the "chewed" ends of timbers cut with stone axes, entrance through the roof, and the absence of conventional doors and windows. Among Indian contributions is the ceiling of peeled poles set side by side between the *vigas*, often in a herringbone pattern. The sticks were sometimes alternately painted in earth colors.

Davis says "it is only a choice room that is ornamented in this manner." The style reminds one of the Moorish multi-colored wood ceiling. In recent years, the Pueblos have adopted standard doors and windows of American vintage and find locks necessary to keep out prying tourists.

The first Spanish colonists in New Mexico made intimate acquaintance with Pueblo architecture by living in it. Don Juan de Oñate, when he established San Gabriel as the first settlement in 1598, drove out the occupants of a whole pueblo to house his followers. Since the Indians were so inhospitable as to protest, Spanish soldiers began burning them at the stake. Indians were forced not only to labor as builders, but to furnish much of the food and clothing needed by the colonists.

When the Spaniard began to build for himself in New Mexico, he abandoned the Pueblo multi-roomed structure, which was designed to shelter a large division of the Indian community. Consistent with the organization of Spanish society, the colonist preferred a small one-storied home, intended to house the patriarchal extended family. The house in Spain had developed the character of a fortress during eight centuries of Moorish wars. Barren outer walls and strong gates, with domestic doors and windows opening on an inner court, were an equally practical arrangement in the New World. Aside from providing a stronghold against Indian attack, the enclosed patio was a pleasant retreat in winter and summer weather.

Those communities which experienced little molestation from Apaches and Navajos, gradually gave up the fortified patio in favor of houses planned on straight lines or an L-shape. When the population of an hacienda approached the status of a village, its families separated into small-house units,

each responsible for a patch of ground. Repeatedly the central government found it necessary to warn these settlements against making themselves vulnerable by scattering their houses up and down the watercourses.

Beginning with a single room, the house grew like a game of dominoes. As each son brought home his bride, he added a room to one end of the paternal dwelling. Every room had its own outside door, and the system solved the in-law problem by giving privacy to the married couples of the family. American mores have broken up the Spanish patriarchal system, for today's young man prefers to establish his own household.

In the details of ordinary houses, there was little visible change from Pueblo to Spanish-Pueblo architecture. The European, more secure than the Indian by possession of firearms, enlarged the openings, and provided wooden doors and window-shutters which swung on crude pivots or leather hinges. Houses in Andalusia, even today, have wooden screens instead of glazed windows. The New Mexican colonist guarded his window openings with peeled saplings anchored in the adobe wall. During the nineteenth century, this grill assumed the decorative aspect of slats fretsawed in fancy shapes imitating ironwork. Some sections of New Mexico had the custom of extending the *vigas* several feet beyond the wall and covering these with poles and brush to provide a shade. Public buildings and large houses utilized such European forms as porches resting on free-standing posts topped with wide wooden capitals in typical Spanish design. Carved and painted wood was likewise restricted to churches and wealthy homes.

Coming from areas where houses of wood and brick are in fashion, many travellers to New Mexico are critical of adobe

construction. One of the early tourists, George F. Ruxton, an Englishman who saw the Rio Grande in 1846, expressed great

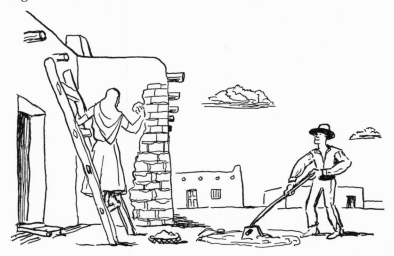

contempt for the native village, which he likened to "a dilapidated brick kiln or prairie dog town; indeed from these animals the New Mexicans seem to have derived their style of architecture."

United States Army engineers were more charitable; they noted the value of adobe and used it in the construction of several forts. At Santa Fe, on August 18, 1846, "as the sun was setting, the United States flag was hoisted over the palace, and a salute of thirteen guns fired from the artillery planted on the eminence overlooking the town." The next morning this eminence, "being the only point which commands the entire town, and which is itself commanded by no other," was selected as the site of Fort Marcy. "On the 23d, the work was commenced with a small force," wrote Engineer Emory. "On the 27th, 100 laborers were set to work on it, detailed from the

army; and, on the 31st, 20 Mexican masons were added."

Thus began, in the new territory of New Mexico, a third style of architecture, to be called "Territorial." It combined the building techniques of three cultures—Pueblo, Spanish, and American. The soldiers at Marcy and other forts, directing "Mexican masons," added the architectural notions of the Eastern Seaboard and Victorian England. Mass production soon entered the picture. The sawmill and the brick-kiln changed the face of the New Mexican house.

"The state of the mechanic arts among the New Mexicans is very low, and apparently without improvement since the earliest times," declared W. H. Davis in 1855. "There are a few carpenters, blacksmiths, and jewelers among the natives, but if ever so well skilled, it would be impossible for them to accomplish much with the rough tools they use." Davis was amazed at the primitive handling of wood. "Nearly all the lumber used for cabinet-making and building is sawed by hand, and carried to market on burros, two or three sticks at a time, and sold by the piece. The heavier scantling is dressed with an axe, and sold in the same manner."

By 1855, three sawmills were in operation. When the railroad chugged down the Rio Grande Valley twenty-five years later, skilled Yankee masons and carpenters supervised the building of "shack-towns" that mushroomed at division points. The great pine forests of New Mexico, almost untouched before 1880, were attacked by armies of axemen to house the boom of American settlers.

Old photographs of Army forts show the salient features of the Territorial style. Plumb-line and level were applied to adobe walls, which were given a coat of lime plaster to ward off erosion. Six courses of kiln-fired bricks formed a cornice

around the roof. Instead of *vigas,* machine-sawed beams supported a flat roof of boards, covered with roofing felt and sealed with tar. Window openings were planned to accommodate millwork frames, and eighteen to twenty-four small panes of glass were fitted in standard sash. Ordinary windows and doors received a narrow casing of flat boards, with a triangular or curved header across the top.

Post headquarters buildings and "Officer's Row" were distinguished by large windows with louvered shutters. A wooden architrave of classical derivation surmounted each front door and window. Americans introduced another note almost unknown to casual New Mexico architecture—the symmetrical placing of openings, each with the top on the same level. Customarily, a formal front door was flanked on either side by pairs of windows, all in the same design. This door might be shaded by a flat-roofed porch with square columns of milled lumber—often four boards nailed to form a tube with capital and base of planed moldings. Such a porch received a roof cornice of wood or bricks. For exterior woodwork, the Army used "issue" oil paint—green for shutters, white for window and door frames. Square chimneys above the main roofline betrayed conventional brick fireplaces on the inside. Drain spouts, made by tacking three boards together, carried off rainwater at the rear of the building.

Merchants and government officials, who came to make their homes in the Rio Grande Valley, learned from the Army engineers, but were not bound to the rigid pattern of the military. For domestic houses the Territorial style evolved into a less formal and much more charming blend of New Mexico and New England. Where Army barracks had been masculine and stodgy, Territorial houses in Santa Fe and

Albuquerque took on a lightness and grace altogether new to
the province. Windows of ample proportion let sunshine
into the house. Local blacksmiths wrought hardware to fasten
big wooden shutters. Slim white pillars lined the porch which
shaded the imported Boston rocker. Masons vied with each
other in inventing patterns for the rows of red bricks that
capped garden walls and edged long straight rooflines. Old
residents who knew that cement plaster tended to crack and
separate from adobe surface, came to prefer the old-fashioned
mud plaster for their walls. White oil paint covered the exte-
rior wood, and in combination with red brick coping and
natural adobe walls, the Territorial house had a restful color
scheme.

The native New Mexican, now called a "Spanish-Ameri-
can," was a little overwhelmed by this sudden progress in his
quiet valleys. He did his best to assimilate whatever phases of
the new culture he could comfortably afford. The full Terri-
torial style never came into great vogue in the rural villages,
because it called for much unnecessary "fancy work" in the
form of milled lumber and fired bricks. The use of bricks was
largely confined to the few towns with commercial brickyards.
The village carpenter showed his appreciation of better tools
by creating fresh and beautiful designs in wood. When glass
became plentiful and cheap, he adapted his window frames to
accommodate it. Quantities of "barn sash" were sold by the
general merchandise stores, but glass panes were almost as
small as those of wagon-train days, for they had to come nearly
two thousand miles in little boxcars over bumpy railroad
track. Simple triangular boards topped windows and doors of
the new railroad stations. The New Mexican liked this style
and copied it in every village and town.

Beautiful doors were a feature of the Territorial style, and native carpenters showed the greatest ingenuity by contriving new and interesting patterns. Doors were commonly wide and low, without glass, and ornamented with beveled panels in various arrangements. Sometimes doors were divided in the

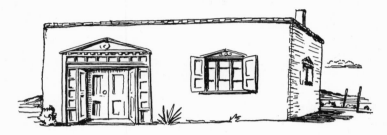

center to provide small double doors. It was customary in some localities to place window panes in a narrow strip above the door and on the sides, the glass set in deep frames of complex moldings. The pediments above doors and windows were graceful combinations of interrupted moldings and fretwork cutouts. Enjoying fine tools for the first time since his ancestors left Spain, the villager displayed skill almost to excess in doors and steeples and altarpieces for the church.

Many forms of the Territorial style are found in New Mexico. William Lumpkins notes a particularly fine variation at Old Mesilla, where pink volcanic tufa was carved in a wave-like profile as cornice for the roof. Harmonizing with this were stone *canales,* with square or rosette carvings at the spout end. Gable and hip roofs became common under American influence, covered with shingles or zinc-coated iron. The galvanized iron, or "tin," roof was widely adopted by native villagers, since it eliminated constant repairs to the earthen roof, and if properly constructed, the overhanging eaves protected

adobe walls. At Tijeras and neighboring villages, it became the convention to set a square window cornerways in the attic gable. The frame paralleled the angle of the roof and provided a diamond-shaped ornament.

During the sixty-six years it took New Mexico to achieve statehood, the architectural aspects of the larger towns changed greatly. Sharp brick corners and useless wooden balustrades replaced the gentle profiles of adobe. The first Baptist Church in Santa Fe had a dome which collapsed before the edifice was finished. Only the French background of Archbishop Lamy saved the Cathedral from looking like a Connecticut church, and even this structure was planned for tall twin spires, but compromised with a tin roof. The Territorial Legislature copied the lines of a thousand mid-Victorian buildings, and the state capitol displayed an aluminum likeness of the mother dome in Washington.

Blessed with a lean pocketbook and an instinct for restraint, only the Spanish New Mexican managed to make regional houses and amusing church steeples.

About the turn of the present century, New Mexico discovered among her resources an intangible element, which could not be mined or farmed, but was nonetheless capable of exploitation. The natural beauties and the picturesque cultures of the state proved to be of increasing interest to travelers and those seeking health or sanctuary. It was found that these people bought food, lodging, and souvenirs, and even houses and land. Individuals and militant groups advocated a revival of what they conceived to be original New Mexican architecture. The Santa Fe Railroad and the city of Santa Fe launched campaigns for the "Pueblo" style of building. There emerged all sorts of well-intended efforts including imitations of Cali-

fornia mission and Texas ranch-home. Indian decoration was mixed indiscriminately with motifs from other cultures. Roof-tile, which has no pre-American precedent in New Mexico, was introduced as a wall-coping. Adobe walls were plastered in bright-hued, rough stucco. In recent years houses made of hollow tile and cinder brick have been modified with concrete in stiff imitation of the soft lines of an adobe house.

The wild exuberance of this regional building spree has begun to subside, and the new style, which might be called New Mexico Revival, begins to assume definite characteristics. Several architects, among them William Lumpkins, Truman Matthews, and John Gaw Meem, have attacked the problem with success, taking cognizance of local materials and motifs in relation to modern living.

Labor-saving methods of making adobe have been introduced in recent years. Mud can be stirred in pug mills, like doughmixers, turned by horses or machines. Smaller adobe bricks have come into use, and with them multiple molds which form two or four bricks at a time. The steel plow made possible *terrones*—natural adobe bricks of clay topsoil, thrown up in thick strips by the moldboard of the plow. Plant roots hold *terrones* together. The process is the same as that of the "sod shanty" famous in the homesteading days of the Great Plains. In recent years a weather-resistant adobe has been produced by mixing asphalt compounds with earth.

The rural New Mexicans find it an economy to continue to build in the fashion evolved by their ancestors. Many of them have little cash, and except for windows and doors, they can obtain the materials for a house from the earth and the forest. The city-dweller lacks the time and inclination to make the continual repairs which are necessary to the early type of

adobe house. For him the Territorial style or some version of the Spanish-Pueblo house with an asphalt roof and walls plastered with concrete is a simpler solution.

In an outpost society, each man is faced with varied tasks. To live, he must be herder and hunter, farmer and artisan. By necessity, the New Mexican of a century ago was his own architect, mason, and carpenter. He was a busy man. He chose things near at hand and used them with a minimum of energy. Because they were effective and cheap, he took earth, timber, and stone. He fitted them together in a simple and satisfying manner to shelter himself from wind and sun. His practical and his aesthetic solutions are important today in a characteristically New Mexican architecture.

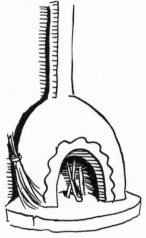

CHAPTER THREE

PARLOR PIECES

WE ENTERED "THE LARGest home in the place," wrote Kendall of the 1841 Texan Santa Fe Expedition. "It had but two rooms, the earthen floor and scanty furniture of which gave them a prison-like and desolate appearance. Not a chair or table, knife or fork, did the occupants possess, and we were given to understand that we were in the house of the 'first family' of Anton Chico."

Early New Mexican interiors were plain indeed, for the common people had little that could be called furniture. The very materials which create variety were at a premium: wood,

glass, paint, and colored fabrics. The walls were white or
earth color, and the ceiling was dark with smoke from the
corner fireplace. The principal furnishing of a poor man's
house was his bed of sheepskins or buffalo hide. At bedtime he
took off his sarape and spread it over himself as a blanket. In
daylight the bed was rolled tightly and shoved against the
wall as a seat.

Dust-catching furniture and delicate fabrics had no place
in the earthen house of working people. The house had to be
simple and functional, and its materials were selected be-
cause they were near at hand and easy to use. Furnishings bore
the stamp of the neighborhood and the owner's craftsman-
ship. Walls and floors of hand-plastered adobe gave gentle
roundness and irregularity to the corners and the door and
window openings. The villager could strengthen the tamped
earth floor by soaking it with animal blood, which produced a
tough, springy surface, for blood is one of the strongest
natural cohesives. The floor was covered with untanned bull-
hides and checkered carpets of hand-woven wool. All the
woodwork, the doors, the ceiling, the furniture—was of un-
painted pine, bearing the patina of age and daily use. What
the house lacked in variety, it gained in simple harmony.

For whitewash, the housewife disintegrated gypsum rocks
by baking them for three days. The resulting powder was
mixed with wheat flour and water to make a thick paste. This
had to be used quickly before "it goes to sleep," as the native
says; that is, solidified in the pot. The woman applied this
gesso plaster, or *yeso,* to her adobe walls with a sheepskin pad,
to make a thin, hard coat of dazzling white. *Yeso* walls were
typical of Moorish interiors.

Balls of *tierra amarilla,* or *tierra de ora,* were a trade item

at Nambé Pueblo. This tawny, golden clay, bright with flakes of mica, was mixed with water and painted on the lower quarter of the wall as a wainscot. In Santa Fe Trail days, calico was pasted around the walls in a gay border which served to keep whitewash from rubbing on the clothing. The custom seems to stem from Spain, where, during the sixteenth and seventeenth centuries, plaster walls were relieved by a dado of painted canvas or colored, stamped leather. Moors had set the fashion of cementing vivid tiles in the lower half of a wall. Rural New Mexicans now use oilcloth in a similar manner to keep grease from spotting the adobe kitchen walls.

The fireplace is the moment of departure between the architecture and the furnishings of a house. It is at once a focal point of function and an opportunity for creative expression. One sees the corner fireplace in thirteenth century sculpture on Reims Cathedral, and in an early fourteenth century painting of the Masaccio school. It is an economy for builder and user, for the stone or brick corner of a room serves as two walls of the chimney, and increases the footage of fireback. Adobe walls are ideal for such a structure, and the corner fireplace developed original forms in New Mexico. The adobe maker built a bell-like shape in the corner of the room, modelling it gently upward until it melted into a chimney. Single adobe bricks could be laid one above another across the corner to make a triangular chimney, or pairs of bricks built into a square one. The chimney was carried a short distance above the roofline, and strengthened by mortaring to the mud parapet of the roof. It was necessary to use care at this point to avoid exposing the wooden ceiling to heat.

The fireplace opening is horseshoe-shaped, and piñon sticks are placed on end, tepee-fashion, to heat the back wall with

a minimum of fuel. Andirons are unnecessary. The natives are so fond of the corner fireplace that they sometimes build a short artificial wall to create a corner, the wall serving to shield the fireplace from drafts.

Under the pottery-skilled hands of Pueblo women, adobe reached consummate grace and delicacy in the corner fireplace. This Indian fireplace consists of an adobe chimney terminating at the base in a tiny shelf with slender wings reaching to the floor, exposing a maximum of the firebox. The most exquisite modelling and proportion is achieved, and the design is accented by a band of colored clay. Pueblo pottery jars are used as chimney pots on top of adobe chimneys. At Zuñi, these jars, each with its bottom broken out, are nested five and six high, making a tall, decorative chimney high above the roofline. Castañeda, in 1540, observed a box-like fireplace in a Pueblo kiva: "In the interior there is a fireplace like the binnacle of a boat where they burn a handful of brush with which they keep up the heat." The present Indian fireplace is an ingenious adaptation of a sixteenth-century European style.

Soft pine was the wood most used for New Mexican furniture, for the maker had a choice between that and cottonwood, which is brittle, tough to cut, and irregular in shape. Pine responds readily to the knife, the adz, and the axe—the tools of every villager. Saws and chisels were borrowed round-robin. Only a professional would have so costly an aid as a plane or an auger, and in 1790 there were but thirteen carpenters in the whole of New Mexico.

The long, coarse grain of pine splits and splinters, and is low in tensile strength. Pine swells and shrinks more than many woods, and warps readily under the extremes of drouth and dampness in the Southwest. Because of these factors, nails

and screws are unsatisfactory for pine furniture, and were expensive in early days. Hardwood is so rare in New Mexico that Kearny's soldiers were happy to find a broken Yankee wagon wheel from which they could fashion tent pegs.

It is a testament of human endeavor that the Spanish colonist surmounted these difficulties and created sturdy, handsome, well-proportioned furniture.

The frailties of pine dictated construction. Great delicacy was not possible, and the craftsman confined his ornament to shallow carving and bold cutout patterns. The pieces tended to be heavy, but never gross. The furniture maker used square posts, and many of his design elements were based upon straight lines. His saws were coarse and cumbersome, and the wood-lathe was virtually unknown.

The cabinetmaker used full mortise and tenon joints, preferring square to round, as he made holes with a chisel rather than an auger. He reinforced the joint with a wooden pin thrust through mortise and tenon at right angles. Tabletops and other flat pieces he attached to the base with pegs, the boards being laid side by side, bevel-edged, but rarely tongue-and-grooved. Since the exposed ends and edges of pine splinter, the carpenter rounded them by sanding with pumice. It was not usual to project the end of a tenon beyond the mortise hole.

For glue the craftsman scraped the inner surfaces of sheep and goat hides. Sinews of animals, or hooves and horns were used similarly. These he soaked in water for twenty-four hours, and then boiled to thick consistency. The same formula was used in gesso by painters.

The low bench-like seat against the wall was the most characteristic piece of New Mexican furniture, and perhaps

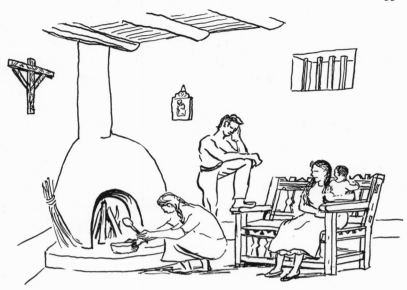

the only furniture in Indian homes of pre-Spanish times. In company with the pillow or hassock, it was a favorite of the Moors and Spaniards. This seat was achieved in various ways. Most commonly, bedding and mattresses were folded and pushed against the wall to increase floor space in the small rooms. A bench of adobe masonry or split logs was often a permanent part of the interior wall. As movable furniture, long benches were made from planks, a form still common in rural New Mexico. The bench is an easy means to provide seats for the members of a large family, and is equally convenient indoors and out. For comfort, the seat was covered with hides and native or Indian blankets.

The bench, dignified with a back, and enhanced with cutwork or carving, became a settee and one of the most attractive and comfortable items of local furniture. Seating two to

six persons, the settee might be fitted with arms at each end, and sometimes in between to divide it into separate seats. The seat consisted of a single hand-adzed plank, sixteen or eighteen inches wide. Legs were four, six, or eight in number. The rear members extended upward at a slight angle to support the back, which was made of two narrow, scalloped or serrated boards running the length of the piece, in many instances holding shaped slats or simulated spindles. A wide, notched apron finished the front edge of the bench, and sometimes a matching stretcher added further strength. Shallow carving enriched the surface with geometric flowers or parallel grooves and gave emphasis to structural lines. By opposing cutout curves, points, or stairsteps in the splats and stretchers, pleasantly enclosed open spaces were created.

Tall Yankee travellers complained of bumping their heads on low doors in New Mexico. Few of the Spaniards seem to have topped five feet, six inches, and many Pueblo Indians were even shorter. The furniture was on the same scale of smallness and lowness. Ordinary chairs were of a size we would refer to as a "bedroom" chair today, and followed the style of the spindleback chair of the sixteenth century. The seat and legs had the proportions of a square box, with the back slightly higher than the distance from seat to floor. The back inclined somewhat and a rectangular panel at the top framed spindles or shaped slats. Around the seat of the chair was a narrow wooden skirt with plain or serrated edges. Stretchers of flat or spindle type were mortised into the legs near the floor. Frequently no carving was evident, or only chisel grooves and routings. A variety of such small chairs may be seen in the dining room at La Fonda in Santa Fe.

Great chairs were copied from those in the village church,

which were made at the suggestion of the priest for seats beside the altar. In design and construction, these chairs resembled the simpler chairs of early Gothic period. A skeleton frame with a minimum of paneling saved the piece from heaviness. Pine posts about three inches square outlined the box-like structure on severely formal lines. The back was stiff, often perpendicular, and topped with a flat crosspiece sawed in rising stairstep pattern. Great chairs had straight arms, mortised onto the upper ends of the front legs. The arms might be curved laterally, and horizontal grooves in the uprights imitated spindle turnings, ball feet, and knobs on the back posts.

Despite an abundance of animal skins, and the presence of leather in Spanish furniture tradition, comparatively little rawhide was used in New Mexican pieces. The European style called for metal tacks and bosses, but rawhide laces substituted here. Pine furniture was in need of the bracing which wooden seats and backs provided. Most of the leather chairs one sees in the Southwest today are recent copies derived from Spanish and Italian models.

The very nature of pine thwarted the perpetration of the baroque and rococo which came into such grotesque flower in Spain and Mexico. From time to time, hardwood furniture reached New Mexico from the centers of Latin culture, and served as a model for isolated pieces. Near the end of the seventeenth century a few armless, highbacked chairs were carved in imitation of Continental vogue. These were so uncomfortable as to restrict their use to the formality of the church or display in wealthy homes.

Custom did not demand separate rooms for eating and sleeping, and therefore did not ask specially designed furni-

ture for these functions. Every room was for living, and the bed was spread on the floor. It was also the custom to build up a platform of adobe padded with buffalo hides for a bed. Davis saw such a structure in Taos in 1855. Two benches pushed together, or the top of a large chest, might serve the same purpose. Bedsteads seem to have been few indeed before 1840. The style of older examples indicates that they were copied from beds brought by Santa Fe Trail, and we find approximations of Colonial Spool and American Federal. For the new bedstead a word was coined, *camalta,* or "high bed." The construction of these beds is somewhat foreign to the native style, and the fact that most of them are no larger than couches points to the portable daybed as a probable ancestor. A wooden frame was laced with ropes as a base for the mattress, which consisted of a cloth bag filled with raw wool. The wool was held firmly in place by a concealed network of strings which could be untied when the housewife wished to wash the cover and padding. To the frame were fastened rudimentary head and footboards, perhaps no more than the legs lengthened into shaped posts.

The table never was appreciated greatly by people who did not read and write habitually, and who followed the Oriental and Amerindian custom of sitting on the floor at meals. "When sitting, our chins just reached the table," wrote Emory of breakfast at Los Padillas. Not only was the typical

table non-functional in height, it was provided with a wooden apron which made placing one's knees beneath it impossible. New Mexican tables were almost invariably small, and resembled Victorian "occasional" pieces. As furnishings of haciendas, they were remarkably ornate, and, like the bed, seem to have been copied from Yankee models. The planks of the top were pegged into a deep, rectangular frame, which was mortised to the legs. The latter were tapered, or relieved with grooves and chip-carving. Shaped stretchers braced the legs a foot or so above the floor, the mortises alternated so two tenons could extend through each leg, concealed joints being impractical. The space between the stretchers and the frame or apron was filled with vertical spindles or slats in classic shapes.

As in the Middle Ages, chests doubled as tables during the first two centuries of the northern Spanish colonies. For this reason the cabinetmaker failed to conceive the table as something at which one could *sit*. It is obvious that ornament and show were the first consideration—New Mexican tables were not capably designed for writing or dining. At social gatherings, the table was a buffet, being heaped with food and pots of liquor. Levelness was not a virtue of the table, nor any other piece of New Mexican furniture, for the mud floor was uneven, and disparity was compensated by digging a hole in the floor, or putting a chip under the offending member. The Spanish clerk worked at a *vargueño,* a sort of chest filled with drawers, from which the lid was let down as a writing surface. A recent version of this, the United States Army field desk, came to be known and hated by every soldier in the service troops. Ignoring function, local tables were fine examples of ingenious design and workmanship.

The paucity of movable furniture which marked lower class homes was not so true of official Santa Fe and the scattered haciendas. Rich men could assign peon labor to the construction and decoration of furniture. Emory describes a house at Bernalillo in his diary for September 4, 1846:

"We were led into an oblong room, furnished like that of every Mexican in comfortable circumstances. A banquette runs around the room, leaving only a space for the couch. It is covered with cushions, carpets, and pillows; upon which the visitor sits or reclines. The dirt floor is usually covered a third or a half with common looking carpet. On the uncovered part is the table, freighted with grapes, sponge-cake, and the wine of the country. The walls are hung with miserable pictures of the saints, crosses innumerable, and Yankee mirrors without number. These last are suspended entirely out of reach; and if one wishes to shave or adjust his toilet, he must do so without the aid of a mirror, be there ever so many in the chamber."

The seats were "covered with beautiful Navajoe blankets, worth from 50 to 100 dollars."

"All the hidalgos pride themselves on allowing nothing but silver to approach their tables, even the plates are of silver," observes Emory. "But with all this air of wealth, true comfort is wanting; and very few of our blessed land would consent to live like the wealthiest Rico in New Mexico."

Another American officer, Lieutenant Bourke, carried the point still further in 1880. Comparing the nocturnal life with that of New Jersey watering places, he concludes: "The antiquity of blue-blooded, high-toned, 'gente fina,' New Mexican families can always be discovered from the comparative plenty or scarcity of bedbugs and coroquis in their residences;

in some of the 'Sangre azul' houses, a traveller can lose a pint of blood in a night."

In furniture, the early craftsmen failed to take advantage of the attractive color and grain to be found in red juniper and yellow pine. Most pieces were left unpainted, but a few were covered with white gesso. With long wear, the pigment left a pleasant patina, serving to sharpen the grain and bring out carving in bold relief. Touches of tempera pigment were added most rarely, except on the painted chest, which was heavily endowed with color. Homemade spirit varnish was far too costly, so mutton tallow was tried as a wood preservative, resulting in a darker color but little real protection.

Within the limits of construction requirements, there was a great variation among individual objects of furniture. No two pieces were alike. The furniture lacked mathematical precision because workmen lacked accurate measuring tools, and this contributed further to differences between items. Apparently each order was tailored to the carpenter's or the buyer's taste, unhampered by such conventions as the height of a chair seat or the dimensions of a table. Decoration was equally a personal matter, and it seems never to have been the custom to make "matching sets."

Despite this factor of variation, New Mexican furniture is

recognizable because of the wood and the details of construction. A certain sense of proportion achieved by eye rather than mathematics, and the repetition of familiar motifs, help to identify it. The cabinet maker trailed in the wake of European fashions, but he interpreted them in his own way. Circumscribed by tools, materials, and training, the craftsman made furniture that was honest, sturdy, and beautiful.

It was inevitable that the interior of village houses should be influenced by Yankee ideas and the things for sale at the mercantile store. Of the pieces arriving by Santa Fe Trail, Davis noted in 1855 that "ordinary pine furniture costs more than mahogany in the Atlantic States." After 1880, the railroad brought glass, factory furniture, oil paint, and wallpaper. Unable to afford the latter, Spanish villagers took a clue from the new "shack towns" and covered their weatherstained *vigas* and board ceilings with fresh, clean newspapers.

In competition with the rising tide of imported American furniture, the local craftsmen ceased to make the more complex beds, settees, and chairs. The villagers began to use milled lumber and wire nails for the things they needed most —shelves, benches, boxes, and work tables. Carving was abandoned in favor of oil paint in the colors of the new flag flying over the plaza at Santa Fe. Blue became a requisite for doors and windows; it was the Virgin's color, and would keep out witches.

The greatest charm of the early New Mexican interior was the presence of well-proportioned plain spaces, frugally ornamented at focal points. Colors were few, and low in key, being derived from the earth and native dye-plants. Furniture was that of immediate need, and it, too, had plain surfaces and cautious decoration. The success of this system was based

upon necessity, not philosophy. The New Mexican surrounded himself with all the elegance he could muster. It is to the good fortune of art, and not the native, that he was forced to apply himself to the resources of his environment.

Many successful present-day interiors have been created with early New Mexican furniture. It combines well with the severest pieces from colonial New England and the more restrained examples of Pennsylvania German. There is an unfortunate tendency on the part of newcomers to mix native New Mexican with peasant and Old Mexico themes, introducing a galaxy of bizarre colors.

Native patterns have had a lively revival in new furniture for pseudo-Hispanic homes and public buildings in the Southwest. It has been necessary to adapt the designs to today's standards of comfort and utility, and this can be done with taste. The pieces tend toward formality, and are well suited to hotels and institutions which capitalize on the picturesque qualities of the region. The result is not unpleasing, nor is it a complete betrayal of the principles by which the early craftsmen worked. Motifs are shown to advantage at the University of New Mexico Library and Student Union Building.

New Mexican furniture, carefully handicrafted in the best tradition of older pieces, is both handsome and durable. Modern pieces can be frank and sensible adaptations of honest and unpretentious periods, and are a refreshing departure from the repetitive machinemade models which face us at every turn. However, the amount of handwork involved in mortise-and-tenon, pegged construction, and carving, makes the furniture relatively expensive, despite the low cost of pine.

Furniture connoisseurs are prone to be concerned more

with exclusive designs for the fabulous penthouse than with kitchen chairs for the Bronx apartment. In New Mexico, as elsewhere in the world, the more notable pieces of furniture came from the homes of the well-to-do. Yet the doings at Grand Rapids are of more significance in a machine-dependent democracy than the show windows of Fifth Avenue.

CHAPTER FOUR

FANCY BOXES

THE FEWER ONE'S possessions, the more precious they become. It was hard work to irrigate, and tend and shell and grind by hand, the corn that stood between the Spanish colonist and winter starvation. The harvest had to be protected against dampness and rodents. The daily ration of cooked beans and chile must be set out of reach of dogs and children. It was hard work to spin and dye and weave the wool for clothing. If the man were lucky enough to possess an extra sarape or a beaver sombrero, or if the woman had a silken Chinese shawl, a wedding heirloom passed down the family line, these must be hoarded against fiesta days.

Storage was one of the problems in New Mexico houses. If a dozen people must sleep on the floor, then the room must be kept clear, and storage confined to the wall areas.

The statue of the saint who watched over the welfare of the

family was given special protection. Sometimes the statue hung by a leather thong from a peg high in the wall. Often an arch-shaped niche was cut in the adobe to house a tiny altar with its flowers and candles. When the Romans carved stone niches for their household gods, they but copied Greek and Egyptian ideas. The Pueblo Indian hollowed a similar niche in his adobe wall to hold the bowl of sacred meal.

The New Mexican applied the name *nicho* not only to the hollow in the wall, but to many different cases he built to house religious objects. The Virgin might be sheltered in a painted wooden stall like a miniature sentry box, appropriately decorated with carving, paint, or straw mosaic. Sometimes there was only a suggestion of a *nicho* over her head, a fragile gateway carved with angels and the Holy Dove. An ornate wooden *nicho,* like a Victorian "whatnot" with carving enhanced with white gesso and tempera color, was designed to hang in a corner of the room. Like little lanterns were the punched-tin *nichos* which guarded the household saints from dust and roof drip. These tin boxes with glass sides rested against a wall, and rounded or hexagonal ones were made for corners. The same form may be seen today in rural villages of Spain and Provence, with a little herbarium of dried flowers and beadwork foliage surrounding the holy image. A large New Mexico family might have a high shelf with cutwork edges to hold its procession of saints, and a skilled carpenter could make a wall cabinet with a grillwork front from which statues peered like persons in a cage.

The storage space dedicated to everyday necessities was less ornate than the *nicho,* except in the homes of the rich. The New Mexican made space in the thick adobe walls by hollowing out openings. He inserted heavy plank shelves in the mud

edges of a rectangular hole in the wall. At the top of a tier of these built-in shelves he set a lintel of logs to support the weight of wall above. Blocked doors and windows are often made into storage units in old houses. When such shelves were hid behind doors swung on wooden pivots, the colonist unintentionally revived the earliest European ancestor of the cabinet. The carpenter conventionally divided each cabinet door into two panels, the lower somewhat longer than the upper. Because these cabinets were used for food, the top panels usually had open wooden grills to permit the circulation of air.

For a dish cupboard, the villager built a tall box with shelves and doors, which he called a *trastero*. The term may have come from *trastos de cocina,* the kitchen utensils which a *trastero* was designed to hold. Probably the native craftsman copied this piece of furniture from the armoire in the sacristy of the church. For centuries the armoire has proved useful for the storage of missals, vestments, and wine and oil for the altar. The armoire is thought to have been invented during the Middle Ages by stacking one chest upon another, and opening the fronts rather than the tops.

The *trastero* deserves to retain its local name, for it has persisted as a practical piece, and reached highly individual design in New Mexico. Though often the largest movable piece of furniture, the *trastero* was in keeping with the general smallness and lowness of native furnishings. The paucity of kitchen equipment determined its size. A *trastero* was rarely six feet tall, with the width about two-thirds of the height. It stood on short legs, and contained three or four shelves, a foot to sixteen inches in depth.

The *trastero* was the cabinet maker's opportunity to show

his skill and ingenuity. He divided each tall, narrow door into two panels, the lower one oblong, the upper one square. Like most Spanish craftsmen, he preferred to concentrate the ornament, so he left the bottom panels plain, and spent his skill on the upper section. The matching top panels were pierced in an attractive manner with maltese crosses, imitation spool turnings, a serrated wooden grill, or parallel rows of serpentine laths. A carved cornice, or crown, drew attention to the top of the *trastero*. Usually this followed the European convention of a low triangle, the apex broken by inverted curves. It might resemble a wide Moorish arch, or be composed of three half-moons carved like gigantic flowers.

The carpenter built a *trastero* by enclosing wooden panels in a stout frame. After he had adzed planks to proper thinness and sawed them to panel shape, the workman carved them to suit his fancy and beveled the edges with a "tongue" to fit into the frame. Small square timbers were cut with mortise and tenon joints, and grooved on the inner edges as a frame to receive the panels. Using a hollow chisel, the woodcarver accented the frame with parallel channels or egg-and-dart indentation. The carpenter coated grooves and joints with animal glue and set the panels in place in the frame. He pegged plain boards in position to cover the top, bottom, and back of the *trastero*.

The four main posts of the frame were extended as legs lifting the body of the *trastero* about six inches above the floor. The shelves were fastened with wooden pins to the back and sides of the *trastero*, or, more rarely, set in notches in the frame. To keep dishes from sliding off the inevitably warped pine boards, each shelf was given a lip of scalloped lath. The carved cornice or peak for the top was cut from a

single board and pegged to the front edge on the same plane with the doors. Occasionally the craftsman set a horizontal panel between the cornice and the top of the doors. This received a central lozenge, and was, in unusual instances, painted.

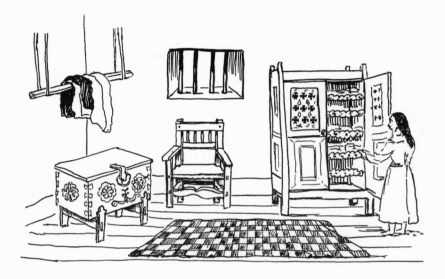

The grills and panels of each *trastero* door were tongue-and-grooved into a light frame of flat wooden strips. The doors could be hinged on wooden pivots like house doors, but since most *trasteros* were made for the well-to-do, it was customary to use metal hardware. The local blacksmith made a simple hinge of two iron staples, like cotter keys put eye-to-eye. One staple was driven into the door and its linking staple fastened in the frame. The latch was a leather thong, or the ironworker created a graceful hook-and-eye, the flat hook of one door revolving on a nail to fall into a metal eye on the

opposite door. Small cabinet locks and chest locks, probably imported from Mexico, were used also.

Light carving often distinguished otherwise plain panels of cupboards. The "linen-fold," one of the earliest ornaments of Gothic cabinets, appears on a number of New Mexican *trasteros* in the Fred Harvey collection. It imitates a piece of cloth, draped from the center in loose accordion pleats. Severely stylized flowers and leaves, often a pair of wreaths joined to form a fancy "H," were frequent choices of the woodcarver. Motifs were used strictly as design, the carver making no attempt to imitate plant textures. Certain rhythmic repetitions of straight lines, curves, and triangles were characteristic of New Mexico woodcarving in both furniture and architecture.

During the transition period after 1846, *trasteros* continued to have the same general appearance, but construction and decoration were much simplified by milled lumber. The native workmen abandoned difficult paneling in favor of single pieces of board for the sides and doors. As in other furniture, carving was no longer done, and ornament degenerated to edgings of heavy wooden lace for the shelves and cornice, patterned after the barge boards of Victorian houses.

Straw mosaic, a tedious but rewarding art, was an ideal enrichment for the panels of the *trastero*.

To prepare a base for straw mosaic, the New Mexico craftsman scraped a shallow indentation in the wood to be decorated. He smeared this with pine pitch obtained by baking green boughs over live coals. The artist split straws of wheat or oats and pressed them flat. Next he cut the straws in various lengths and inlaid them in the pitch to create an intricate mosaic. The dark brown tar made a complimentary matrix

for the shiny yellow straw. Two techniques were followed: The more difficult method was to cover the base solidly, developing a parquetry pattern by laying the straws in different directions. Equally handsome were the linear designs made by bright bits of straw contrasted against the pitch like stars in a dark sky.

Straw designs glued to wood and cardboard seem to have been introduced to Mexico from the Orient early in the nineteenth century. The work attracted Mexican Indians, who adapted it to an elaborate pictorial form, not unlike the fine mosaics which they had made with the colored feathers of tropical birds in pre-Hispanic times. The New Mexicans translated the art into local materials, and preferred geometric to realistic designs. Occasionally one finds crosses and stylized flowers depicted in native straw mosaic.

In addition to *trastero* and chest embellishment, straw mosaic was added to many wooden objects in the New Mexican home—boxes, candlesticks, crosses, and picture frames. A reredos frame in the Sanctuary at Chimayo is inlaid with straw. Although straw is thin and fragile, the process is remarkably permanent because the resin tends to preserve both the straw and its wood base. A considerable number of antique straw inlays are to be found in museums and private collections. The fashion waned about 1850, but was revived under the impetus of the Federal Art Project. One of the best modern examples of straw mosaic is on the *trastero* at Roswell Museum, reproduced by W.P.A. artisans from an early piece.

The patient art of fitting tiny pieces together was popular with New Mexican artisans only in straw inlay and filigree jewelry. The objects were small and the product soon fin-

ished. It is significant that both these arts came into greatest popularity during the nineteenth century. Even patchwork quilts were little known, and the free-patterned wool embroidery did not call for slavish attention. Spanish crafts had a strong mosaic heritage from the Moors, who excelled in intricate inlays of enamel, ivory, wood, and jewels. In New Mexico, the absence of varicolored woods and other precious materials may account for the lack of these arts. However, the active nature of the colonist and his dislike of exacting detail seem to have been determining factors. The "patience" arts are signs of leisure—nay, boredom—and the villagers not only were busy, but the mild winters permitted men and women to be out-of-doors daily and to lead a satisfying social life.

Adornments of turquoise and shell mosaic were made by the Pueblo Indians long before Spanish times, but the invaders failed to copy the process. The existence of such a complex art among the Pueblo peoples may have been due to the specialized nature of their society, which was so closely knit that only certain individuals mastered such techniques as making arrow points, decorating ceremonial gear, weaving or molding pottery. A similar division of labor existed in the Spaniard's homeland, but in the distant colonies it was each man for himself.

"Five big chests with locks and keys, at 3 pesos each," noted Fray Benavides in his list of supplies going to Santa Fe in 1625. He enumerated also forty-five boxes and "six loads of hay for packing."

The continual importation of goods in chests, from Coronado's armor boxes to the latest thing in G.I. footlockers, has kept the New Mexican aware of styles in this most portable

item of furniture. Though the local carpenter had his own notions about designing and decorating, he had less impulse for originality in the chest than in any other item of furniture. So many chests came in from the outside, and so many were made in imitation of these, that there is much disagreement between experts as to what does and does not constitute a genuine home-grown New Mexican chest. Someday these chests, along with the relics of the True Cross, will be X-rayed, and tree-ring borings taken, to settle these questions once and for all.

Much romance has been spun around chests, from doubloon-filled strong-boxes to great marriage *cassoni* painted by Andrea del Sarto or carved by Donatello. Always the chest evokes the adventures of travel, the spice of far-off places. Even the Pullman trunk in the attic can set our memories dancing.

The chest is one of the earliest and most widespread of furniture forms. Often several craftsmen were employed to complete a single chest, for a knowledge of differing trades was needed: carpentry, woodcarving, painting, and metalwork. The chest was the most characteristic piece of furniture during the Middle Ages, when humanity, as now, was restless and terror-stricken. At various times the chest has served as bed, seat, wardrobe, and jewel casket. It is the ancestor of the sideboard, the dresser, the sofa, and the chest of drawers. The transient quality of frontier life made chests essential in New Mexico.

Closets, as we know them today, were totally absent from the older New Mexican houses. The clothing in current use was slung over a pole suspended from the *vigas* by yucca ropes. The poor kept their winter blankets and heirlooms in plain

wood boxes. The wealthy, who dealt in such things as dower-
ies and deeds, stored their possessions in decorated chests.

Plain chests were by no means rare in Europe and the
Eastern Seaboard, but very few of these are deemed valuable
enough to reach the hands of collectors. Compared with the
ornate pieces exhibited by museums, New Mexican chests
were plain indeed. As in all local furniture, the wood was
pine, the construction elementary. But the Spanish colonists
were not immune to making the exterior of a box hint at the
richness of its content. They emulated in subdued form
many European fashions—shallow carving, wrought hard-
ware, staining and painting, gesso relief, and coverings of
leather and bright fabrics.

The ordinary villager, while he had few fine things to hide,
did need places to store food until the next harvest. Strings
of chile and dried meat, and bundles of herbs, he hung from
the *vigas* of the house. Festoons of Indian corn, the husks
braided together, dangled from the ceiling. Large chests, how-
ever, were needed for wheat and oats, which had to be
threshed soon after harvest, and large chests were needed for
the grain. When a quantity of wheat was milled, the flour was
put in large clay jars and tight baskets. Weavers and image-
makers needed chests to protect and transport their products,
and travelers and traders found stout boxes useful.

The construction of a New Mexico chest was that of an
old-fashioned wood box. The sides were made of four planks
interlocked at the corners with dovetail notches. A heavy
board was fastened to the bottom with tapering wooden pegs
driven deep into the edges of the chest. The lid was a flat slab,
reinforced at each end with narrow flanges of wood molding.
Normally the lid was not countersunk, and had no lip across

the front. When intended for grain and other common products, there might be neither lock nor hinges, but most small chests had iron hardware. The seams were cemented with native homemade glue, and in some cases the dovetail joints were strengthened or repaired with wooden pegs. The inside was sanded smooth, and sometimes was separated into two or more compartments. In very large chests the lid might divide in half laterally.

Characteristically, the ends of a chest were square, and the rectangular front or the lid of an average chest would equal two such squares. The top and back of the chest were left plain, while the ends and front were decorated. The inside of the lid might be painted. An especially handsome chest sat upon a stand, called a *tama,* a carved wooden framework not unlike a pair of andirons.

Chest locks followed the Spanish style: an iron plate behind which the mechanism was set into the wood. A narrow hasp a foot or more in length was bolted across the top of the chest, with the hinge at the chest edge. At the end of the hasp was a metal loop to snap into the lock. Most of the mechanisms seem to have been produced by locksmiths of Mexico and Spain, but there is evidence that plates and hasps, as well as hinges and ornamental iron straps, were made by local blacksmiths. Each lock was made individually, hence there were no standard keys. Locks were ponderous to compensate for the softness of the metal, and on a small chest had huge proportions.

The flat lockplates are a delight for variety in shape and cleverness of design. They were made in round, square, and oblong forms, with curved, scalloped, or notched edges. The shape of the keyhole might be repeated as a cutout border,

and heraldric designs incised as a simple pattern. The lock-plate was placed at the top center of the chest front. This put the hasp rather off center, because the keyhole was in the middle, and the hasp-hole to the left of this. Keys were large, and often quite plain, as compared with the intricacy of Moorish models. Chest decorators picked up motifs from the lock-plate, and, in the absence of a lock, might paint or carve an imitation.

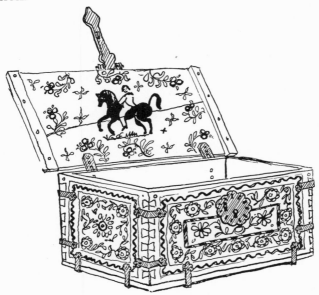

The hasp was hammered and filed into shapes fully as interesting as the lockplate itself. Staple hinges of the type described for *trasteros* were usual, and when strap hinges were used they might be concealed on the under side of the lid. The hardware was attached with hand-wrought nails, bradded or clinched inside the chest. Provincial officials used treasure and document chests composed of crude straps of iron over a

wooden frame, but these were not manufactured locally.

Spain was cherished by Imperial Rome because her mines abounded in the metals Rome needed for war. Spanish iron-workers were gifted, and warriors swore that the rivers of Spain possessed "peculiar properties for the tempering of blades." Long after the palsied Roman hand had dropped the Iberian Peninsula, the Moors welded a heritage of Asiatic patterns to Spanish steel. The skills of Damascus flourished in Toledo and Bilbilis, and for three centuries, until 1400, these two Spanish cities supplied the best swords in Europe. Proud of a tradition already waning in the age of firearms, Charles V, who owed an overseas empire to the sword of Cortez, gathered the finest collection of armor in the world.

An offspring of this Spanish union of Oriental and Occidental metal techniques was a special way of decorating chests. Wooden boxes were covered with Persian velvet—green was the favorite color. The metalsmith cut sheets of iron (or more precious stuff) into silhouettes of plants and beasts, and bradded these over the rich fabric. He bound the vulnerable corners and edges with scalloped metal straps.

Aware of this tradition, the New Mexican who could not afford sheet metal, carved the wooden panels of his chest in flat silhouettes that recalled Spain's iron age. Sometimes he stained or painted the interstices to make the designs stand forth, but the roughened texture of the carved-out parts was contrast enough.

Playful and kittenish are the Spanish lions that gambol across the fronts of chests carved in New Mexico. Heraldry is no longer the parlor-game of Europe, and the dignified symbols, once depicted in solemn realism on the shields of knights, are comic figures under the woodcarver's knife. The lion

rampant now has the *mañana* spirit, and prances lightly, shadow-boxing for an audience. The King of Beasts wears his mane like an apron and lets his tongue loll out waggishly. Oftener than not, he has become a sleek tigerish creature with a sinuous neck and no paintbrush tip on his tail. He still wears a three-pronged crown, derived perhaps from two ears and a forelock.

The chest was of all New Mexican furniture the most conventional, but symbols freighted with meaning in Europe became mere conventions three thousand miles from home. The craftsman desired to reproduce the elegance of imported pieces, but, as always, he expressed himself in colloquial terms, and produced something new and unmistakably native.

The scalloped wheel was a design frequently carved on chests. The artist made this chrysanthemum-like flower large enough to fill the square panel at each end of a chest, and repeated the pattern on a pair of panels on the front. The Spanish ancestor of the design was a rosette, stylized beyond recognition under Moorish geometry. The New Mexican drew it freehand by dividing a circle into quarters, and then subdividing each quarter into three segments, thus making a twelve-petaled design. A round dot forms the center, and slim spokes radiate from this dot to a scalloped outer edge. It was usual to hollow out the space between each spoke so that the wheel stood forth in bold relief. Occasionally, however, the design was carved intaglio, and ingenious craftsmen were not

bound to the standard number of spokes. The technique of drawing a circle with a string was by no means restricted to Euclid, and the village artist also knew that by using the radius of the circle he could make a handsome flower with six, pointed petals. This is one of the oldest decorations known to woodcarvers and stonecutters; it is found on the stone monuments of ancient Assyria, and on chest-shaped stone ossuaries of the early Christian era. New Mexicans, like the Spaniards before them, cut the design into the flat surface of corbels and incised it on chests and other furniture.

Triangular elements are common, and we find, for instance, the same motif of a square cut by triangles on a beam at Pecos Mission and on a chest from Alcalde. Some writers have seized on triangles and stairsteps as being of Indian origin, but the very same designs existed in Europe long before Columbus. The cross with equidistant arms appears in many forms, Celtic and Maltese crosses being the most frequent. There is little variety in border patterns, repetitions of semi-circles, crescents, and points being the most usual edgings for carved panels.

"If ye must make pictures," decreed Mohammed, "make them of trees and things without souls. Verily every painter is condemned to hell fire." The New Mexican artist frequently employed Moorish floral and arabesque ornament. He carved bouquets and trailing leaves on chests, preferring a broad line and plenty of space, leisurely filling a panel with decorous curves. Never meticulous, the villager took forms that were easy to do, and bent them to his needs. How plants grow was of little concern to him, since he was not teaching botany, but carving furniture. For the sake of balance, he was likely to mirror a bouquet, so that the fronds grew both up and down,

with flowers at top and bottom. Almost none of the elements are recognizable, though now and then we catch a glimpse of what was once a thistle or a rose. Native vegetation, such as the cactus, is notably absent. Classic forms—the pillar, the vase, and the chalice—are customary central figures. As with his carved lions, the artisan rarely attempted third dimension or texture, being content with simple outline.

The chests decorated with paint are so different from other New Mexican art that many persons feel these must have been imported, or created by itinerant artists from Mexico. The painted chests are exotic in their display of lush color and romantic themes. They are almost the sole examples of secular subject matter, and the drawing is sophisticated in comparison with most native religious painting, involving true perspective and light and shade to achieve realism.

Because of excellent design and amusing naïveté, these chests, whatever their origin, are the pride of collectors. Most painted chests were made to adorn wealthy homes, and to hold the dowers of hacienda brides. The decorated panels are a veritable catalogue of the pleasures of society. There is a continual procession of theatrical figures: gentlemen in high beavers bow to hoopskirted cotillion partners; bullfighters attack mock-fierce *toros;* young men strum guitars; prancing horses, their tails braided, their fat rumps inscribed with Spanish curlicue brands, are spurred by proud caballeros. The horses' legs are ridiculously small for the great bodies.

The chest pictures are interesting for their revelation of elegant Mexican dress and manners. The painters used more white than the sober religious artists, and recorded the white pleated shirts of men, lace blouses and petticoats for ballet-skirted girls, and white stockings for both sexes. Reds

and blues and shades of yellow were used generously on fringed shawls and sarapes, braid for gentlemen's breeches, and on bandoleers and epaulets for soldiers.

Painting techniques were as old as Egyptian sarcophagi. The raw wood was roughened and coated with successive layers of thin gesso, heavy in glue content. The gesso was almost water-thin, and, as each layer dried, it was sanded and the process repeated until a smooth hard surface was achieved. Powdered colors were mixed to a thick consistency in various mediums—goathide glue, varnish, and, more rarely, egg yolk or oil. In religious tablets, there was very little variance in the tone of a single color, which contributed to the somber effect. But in the painted chest, colors were mixed and charcoal black or gypsum white added for shaded effects.

As in European painting, the earth colors predominate—sienna, ochre, and other iron oxides, ranging in hue from yellow to deep brown. Amost invariably the backgrounds were solidly brushed in with dark, easily-obtained pigments—black or brown, their muddiness increasing with age. The painted panels are often well preserved at points not exposed to wear, which speaks for careful workmanship and well-prepared materials. In many cases the decoration was protected by a crude varnish made of amber-colored pine resin dissolved in grain alcohol, a medium also used as a vehicle for pigment.

The general appearance of New Mexican painted chests is much like those produced by the Pennsylvania Dutch. Although the drawing approaches caricature, it has a felicity that betrays the trained artist who gained his livelihood by such work. The brush strokes have rapidity and skill, and the composition is imaginative and free from much of the rigid

symmetry of religious pieces. Not tyrannized by religious formulas, the chest painter attempted human beings in the active attitudes of everyday life. Although his knowledge of anatomy had much to be desired, the results were lively and suggestive. Paintings done inside the lids of chests were often particularly fine, and, of course, better preserved. The composition was less cramped, and each element of design set to advantage against a dark background in the manner of Chinese lacquer.

Outlying communities favored the leather chest, often of buffalo hide, a style influenced by the parfleche bag of the Plains Indians. The rawhide was stretched tightly over a light, wooden framework and the corners and joints were bound with thongs. Leather fringe or lace inserts ornamented these chests. Some were slashed to reveal colored cloth inserts; others were painted with geometric designs. Rawhide chests were hinged and fastened with leather straps or thongs, which were tied or buttoned. Because of its light weight and toughness, the leather chest was the favorite of horsemen.

Although the flat-topped box was the accepted model, there were also chests with rounded or three-sided tops. This type has its ancestry in Medieval Europe, where shaped chests were found easier to rope on the backs of strong horses, called in France *chevaux bahutiers,* after the bahut or round-topped chest.

The accurate dating of New Mexican furniture is difficult, for cabinetmakers are not known by name, and the practice of inscribing pieces with the year was virtually unknown. Construction is a helpful clue, as well as the types of nails and metal hardware, when these are in evidence. The presence of milled lumber is almost certain indication of post-American

occupation (1846). The use of machined nails or screws and concealed joints instead of mortise and tenon occurred usually post-1880, when the railroad made Eastern furniture readily available in the Territory. The marks of precise tools, such as scroll saw, molding plane, and brace and bit, are more recent. Thin, planed lumber of standard dimensions is a sure sign of manufacture within the present generation. Aside from these factors, a knowledge of Continental furniture styles is useful, the New Mexican versions appearing ten to twenty years late. The costumes depicted on painted chests are of value, but in these there was a tendency to recall an earlier period of fancy dress, just as we find elegance and romance in American clothing of the Civil War era.

After American occupation, the chest and *trastero* were steadily replaced by tin trunks and bureau drawers. Heretofore, the drawer had been little used in native furniture, though it was known in the Spanish *vargueño,* or chest-secretary. Having, for the first time, a cash market for chile and corn, meat and wool, the New Mexican natives were quick to acquire such conveniences as oil lamps, cast iron stoves, and metal beds with comfortable springs. Furniture of all types came to be much more widely distributed among the working population than it had ever been under the feudal system of the hacienda. Storage space was increased to accommodate new possessions: tinned foods, pots and pans, tools, and ready-made clothing.

Because he had to share the resources of his land with the newcomers, the villager's standard of living in terms of health and contentment was not necessarily raised, but the New Mexican desired the comforts and accepted the complexities of the American civilization in which he now held citizenship.

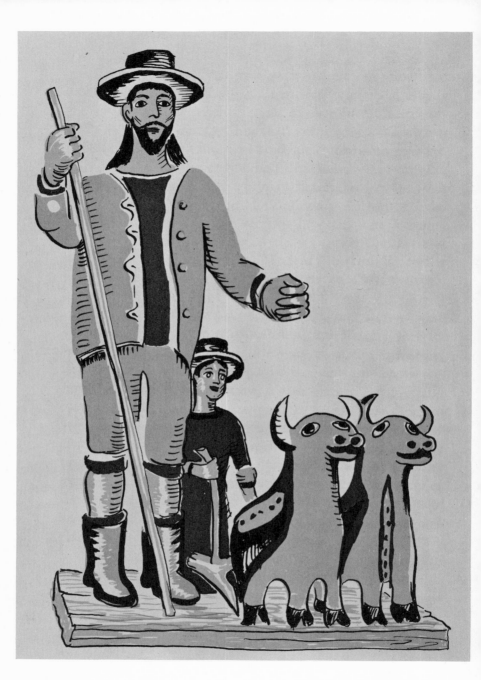

III. TOOLS and TECHNIQUES

DAILY BREAD

TO IGNORE COMMON activities is to deny ordinary men their place, however humble, in the scheme of society. We cannot overlook the inventiveness and logic by which people have supplied their needs. Urban man accepts from the hands of specialists those articles which the New Mexico villager had to make for himself; much of the creative effort of the frontier went into the manufacture of implements for daily use. Carving a plow or making an oven of adobe might not be called sculpture, yet the resulting pieces had esthetic value, and were always worked beyond the point of strict utility. The techniques of living in a community are basic to all its arts.

With only plows, shovels, and hoes at their disposal, and

these mostly of wood, the New Mexicans long ago worked out complex irrigation systems, many of which are still in use. The collective manpower of each community labored on the repairs of the main canals under the leadership of a "ditch boss" elected yearly. In the event of flood, the church bells called every man to the duty of mending the earthen banks. In some areas, dams were built to store water and to turn grist-mills. J. W. Abert saw such a dam at Manzano in 1846:

"On the side towards the mountains, there is a large dam, constructed of crib-work, 12 feet wide, and 8 feet high, and 100 feet long, formed of rough logs, and the interior is filled up with stones and earth. Just now the lake is nearly dried up, and the little mills that its waters used to turn have not sufficient power to grind the miller's corn. These mills, like everything else in New Mexico, are of very primitive style. There is a vertical axis, on the lower end of which is the water-wheel; the other end passes through the lower burr, and is firmly connected with the upper stone, which, as the axis turns, revolves upon the lower stone. Above all this, hangs a large hopper of ox-hide, kept open at the top by a square frame, and narrowed off towards the bottom, so as to present the form of an inverted cone. In the extremity of the bag is a small opening, and this is fastened to a little trough. One end of this trough being supported by its connexion with the hopper, the other end, or mouth, is sustained by a horizontal strip of wood, of which an extremity rests on an upright, and the other is upheld by an inclined stick that rests on the upper burr, so that the motion of the burr gives a jostling motion to the trough and hopper; thus the grain falls into the opening in the center of the upper burr, and passes out between the two burrs."

Only a few communities were equipped with these water-power mills; nineteenth century accounts mention them at Peralta and Peña Blanca; other mills are still in use near San Juan and Pecos. In addition to Indian maize, or corn, these mills were pressed into service for wheat flour, and to crush dried chile into powder. A limited amount of wheat was grown in the province, the native variety being a flint, with large fat grains which produced very white flour. Wheat was cut with hand sickles and threshed by driving animals over it on a piece of hard ground; it was then gathered up in leather bags. By pouring it on a blanket from a basket held aloft in the wind, the wheat was winnowed; another method was to shake it in a bullhide stretcher pierced with holes. Afterwards the grain was washed by dipping it in the river in shallow yucca baskets from Jemez.

Since mechanical grist-mills were not widespread, most housewives ground their grain by hand on a slab of stone called a *metate*. This stone was placed at an angle in a box which caught the flour, while the woman knelt at the upper end and rubbed the corn with a smaller stone, called a *mano* because it is held in the hand. Since the stone, as well as the grain, was ground down, minute quantities of sand entered the flour, and this accounts for the New Mexico saying that "Everyone swallows a *metate* and four *manos*." The Spaniards learned to use the *metate* from the corn-eating Indians of Mexico, the same methods followed by Pueblo peoples for centuries. The native corn has a very hard shell, which necessitates its being parched or boiled in limewater before grinding; a mashed hominy is the basis of breads and other cereal dishes. Native corns in red, yellow, blue-black, white, and mixed, differed in their use. Blue cornmeal is

preferred for *tortillas,* although cheaper meals are more common. *Tortillas,* the Mexican pancakes, are eaten so universally as bread that they constitute a characteristic native food.

It was the custom of New Mexican families to sit on the floor around the common pot of beans, dipping in with the *tortilla* as a spoon. "These two articles are invariably eaten together," says Davis, "and assist to put each other out of sight. A piece of corncake is torn up, doubled up in the shape of a scoop, and then filled with beans, when both are swallowed together, thus eating your spoon at each mouthful." *Tortillas* were prepared by patting balls of moist hominy dough into thin, round cakes and baking these on a metal griddle greased with mutton fat. The villagers planted two varieties of beans: the brown spotted *pinto* of the lower arid regions, and the round, brown *bolito* of the mountain areas. These were boiled with meat and flavored with garlic and chile.

Not every New Mexican family was limited to such simple fare, but even the *hacendado* who entertained Emory and his fellow American officers at Bernalillo drew largely on the staple foods of the country:

"The plates, forks, and spoons were of solid New Mexican silver, clumsily worked in the country. The middle of the table was strewed with the finest white bread, cut in pieces, and within the reach of every cover. At close intervals were glass decanters, of Pittsburgh manufacture, filled with wine made on the plantation. The dishes were served separately. The first was soup maigre; then followed roast chicken, stuffed with onion; then mutton, boiled with onions; then followed various other dishes, all dressed with the everlasting onion; and the whole terminated by chilé, the glory of New

Mexico, and then frigolé. Chilé the Mexicans consider the chef-d'oeuvre of the cuisine, and seem really to revel in it; but the first mouthful brought the tears trickling down my cheeks, very much to the amusement of the spectators with their leather-lined throats. It was red pepper, stuffed with minced meat."

The Spaniards discovered *chile colorado,* the red pepper, early in their New World conquests, and the spicy vegetable was soon transplanted to Spain, where it grows in Murcia. In New Mexico, green chile is baked as a condiment, and when ripe, the brilliant red pods are strung on yucca cord and hung on the outside *vigas* to dry in the sun for winter use. Chile becomes the spice and body of countless recipes, usually in combination with garlic and such native herbs as purslane and oregano, and it supplies the same vitamins as tomato and orange. Green chile is baked in the outdoor mud oven and mashed to a paste in a small stone muller resembling a mortar and pestle. In rural areas, food habits retain much of the intelligent balance of pre-American days—whole grain cereals, milk, chile, and beans—but the diet of urban natives has deteriorated in the direction of cheap, starchy manufactured foods—white bread, spaghetti, and fried potatoes.

The early New Mexican kitchen had few appointments, and, indeed, the room served also as living space and sleeping quarters. Cooking was done in the adobe corner fireplace, and in fair weather a fire was built outside, while all baking was reserved for the outdoor mud oven. Only a rich woman owned a copper kettle or an iron pot, and the ordinary housewife was content with a flat sheet of metal on which to fry her *tortillas.* The Spanish colonist moving into New Mexico came among peoples highly skilled in ceramics and basketry.

The Pueblo Indian furnished fat clay jars for water and cook-ing and storage. Baskets from Jemez and Hopi served to win-now and store grain.

For most of her daily utensils, the village housewife bar-tered with the Pueblo potters, of whom Davis wrote: "They devote the greater part of their time to the manufacture of earthenware, which they sell in quantities to the Mexicans. It exhibits some skill, and is often adorned with various de-vices painted upon it before it is burned. This ware is in universal use in the territory, and there is considerable demand for it in the market." After the Pueblo custom, the village women carried earthen jars of water on their heads, which caused them "to walk with great dignity." *Tinajas,* large jars holding as much as twenty gallons, provided storage for beans, flour, and cornmeal. Clay pots called *ollas* were used for boiling *frijoles* and meats. Because of the custom of eating from a common bowl, individual dishes were rare among the poor; even beverages, such as milk, sat in the center of the table in a large vessel, and all diners expected to drink from this. Sharp knives and wooden spoons were proper aids to eating, but the fork was only for the well-to-do; similarly the common folk of the Thirteen Colonies had scorned the fork as an affectation until well into the eighteenth century. In refined circles—the house of the padre or the *rico*—the table was graced by silver cups and a few cherished pieces of blue-and-white Spanish porcelain, which the potters of Mexico were learning to imitate. Pueblo Indian potters were induced to copy some of these shapes in their own porous wares, but they did not know the secret of hard glazes, applying only a slip of thin clay to cover the coarse grain.

The Spaniards seem to have had no appreciable influence

upon Pueblo pottery, because the same techniques, and many of the same designs and shapes, have continued from pre-Hispanic times until the present. In isolated instances, Spanish villagers made pottery of their own, but this they probably learned from Indian neighbors. The Pueblo woman molds a jar by twisting ropes of clay in circular coils, achieving a marvelously accurate form, which she decorates freehand and bakes in an open fire of dry manure. It is inconceivable that, during centuries of Spanish occupation, no one endeavored to convert Pueblo artists to the Old World potter's wheel and kiln. Because of ancient work taboos, Indian women resisted these mechanical aids, as well as the European loom, which surely would have destroyed unique elements of their craft.

Ceramics, therefore, are not significant in the art history of the Spaniards in New Mexico. When Yankee salesmen introduced crockery, dishes, and metal pans from the East, the villagers soon adopted them. In fact, Erna Fergusson tells the story of a local Spanish family who traded its heritage of hand-wrought silver plate for a set of Philadelphia chinaware emblazoned with roses. The Indians, deprived of their established trade in domestic earthenware for Spanish households, found a new and bigger market in souvenir items for American tourists, who demanded gaudy ashtrays, and little clay gods with pots between their knees to hold matches.

Although the Indians supplied vessels for cooking, the villagers made many of their own implements. They carved stirring sticks and spoons, bowls, trenchers, dough-trays, and cheese-presses from wood. They planted Indian gourds to make into scoops, bottles, and cups. The shape of these objects was often pleasant, for beauty and utility go hand-in-hand, but it was rare for them to be decorated by carving or

painting, in which respect local taste differed from the peas-
ant arts of Europe. In his spare time, the farmer made wooden
planting-sticks, hoes, shovels, and plows. His wife requested

such housekeeping aids as spindles, yarn racks, and foot-
shaped frames for knitted stockings. Cottonwood was pre-
ferred for kitchen tools, since it was durable, white, and lacked
the acrid taste of pine. The most complex machines of wood
were looms, spinning wheels, and presses for wine and
molasses.

Late in autumn the villages echoed to the sound of wooden
mauls crushing the sweet sap from cornstalks to make molas-
ses. The work continued day and night, for the task had to
be finished before the cane soured. Abert has outlined the
process: "They cut the stalks of the maize, or Indian corn, and
after stripping it of the leaves, pound it with heavy wooden
mallets until it is reduced to a pulp; after steaming it suffi-
ciently, they express the juice by means of a rude press, and
then evaporate it to the proper consistence in earthen jars."

At last one clever man devised a mechanical crusher, which
caught Emory's amused attention:

"Below Zandia we were attracted by a great noise. It pro-
ceeded from a neighboring rancheria, where we saw eight or
ten naked fellows hammering away in a trough full of corn-
stalks, as I had never seen Mexicans exert themselves before.
The perspiration from their bodies was rolling off into the

trough in profusion, and mingling with the crushed cane. This was then taken out, boiled, and transferred to a press, as primitive in construction as anything from the hands of Father Abraham.

"The hopper was the trunk of a scooped cottonwood tree, into this was inserted a billet of wood, upon which the lever rested about midway. Men, women, and children were mounted on each end; all see-sawing in the highest glee. I suggested, as an improvement, that one end of the lever be confined, and the whole of the living weight be transferred to the other end. 'No! No!' said the head man, 'if I do that, the fun of see-sawing will be over, and I can't get any body to work.' "

The United States soldiers who came to New Mexico in 1846 rarely failed to remark with pleasure the native wines and liquors, but Susan Magoffin and George F. Ruxton expressed annoyance at the effect of the beverages upon these same soldiers. "Crowds of drunken volunteers filled the streets, brawling and boasting, but never fighting," Ruxton complained of Santa Fe, but Officer Abert's reaction was more favorable: "At this dance I had the pleasure of tasting some of the wine from 'El Passo del Norte,' which in its delicious flavor realized all I had anticipated." W. W. H. Davis, ten years later, was even more extravagant in his praise of this Rio Grande enterprise, and quoted a contemporary authority to the effect that the Mesilla area produced annually "not less than two hundred thousand gallons of perhaps the richest and best wine in the world." New Mexico's grape brandy was famed the length of the Santa Fe Trail. "Pass whiskey" it was called jokingly, because it was the principal revenue of the city of El Paso, selling for two dollars the gallon.

The wine-producing region fringed the Rio Grande from Bernalillo to below El Paso. "Along the roadside were beautiful vineyards, surrounded by high walls of adobes," began Lieutenant Abert's entry in his diary for October 13, 1846, at Bernalillo. "We rode up to one of them, and looking over, saw some pretty 'donacellas' plucking the fruit. They had round flat looking baskets, placed on their heads; these were piled with thick clustered bunches of purple grape, from beneath which the bright black eyes of the 'donacellas' were sparkling." To the soldiers' disappointment, a male relative of the "donacellas" took over the business of selling grapes to Kearny's men.

Cuttings of vines from Spain were transplanted to New Mexico in the days of the first missions. Two kinds of grapes were grown: a light red and a purple, from which white and red wines were made. Following the Southern European practice of viniculture, trellises were not used; instead the new branches were trimmed back sharply each year, leaving the parent stock close to the ground, rarely more than four feet tall. Late in the fall the vines were covered with mounds of earth to protect them from frost. New vineyards were started from cuttings, which were set out in trenches four feet apart; these began to bear the third year after planting. The kinds of grapes and methods of cultivation familiar a hundred years ago are still known in the Rio Grande Valley, but home distilling has been modernized somewhat.

Distilling techniques were primitive but effective, according to those who sampled the wares in Hispanic days. Both Indians and Spaniards were brewers, and at Isleta, Abert saw "extensive vineyards, with long sheds, under which were arranged huge bags of ox hide, where several of the Indians

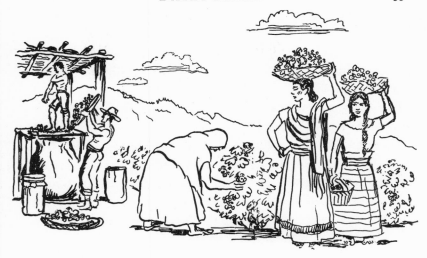

were at work, distilling the liquors from the vats." From Davis
we learn the process in detail:

"The grapes are picked from the vines and carried to the
vats, where the juice is pressed out of them. The vats are
made of bull-hide while green, and to keep them in shape
while drying, they are filled with dirt, which is thrown out
when they have become thoroughly dried. The top is covered
with the same material, perforated with small holes, upon
which the grapes are thrown as they are brought from the
vineyard, and trod into a pulp by the feet of peones, the juice
running into the vat below. The pulp that remains is made
into excellent vinegar. The vats are then covered with plank,
the cracks being smeared well with mud to keep out the air;
and the juice is allowed to remain thus sixty or seventy days,
when it is drawn off in casks, and put away for sale or use."
This was said to produce "a better article of claret than that
imported from France."

Taos whiskey, which came to Santa Fe in kegs loaded on burros and sent the Missouri Volunteers reeling through streets, derived its potency from grain alcohol made in a crude copper still. Currant cordials and grape brandies also had a place in the brisk liquor trade up and down the Rio Grande. Though very few of the beverages went outside the territory because of a lack of bottles, the specialties of certain communities were circulated within the province. The *Alcalde* of Isleta Pueblo was renowned as "the most honest man and the best brandy maker in the territory," a distinction which could be only half true under the former federal prohibition of liquor to Indians.

The kegs and barrels made in New Mexico were unsuitable for distant transport, since they consisted of hollowed-out sections of cottonwood log with rawhide lashed over the mouth. Wineskins and leather canteens were in common use. Tin bottles held sacramental wine, shipped from Mexico. Since Indian pottery was porous, glass bottles and stoneware jugs from the Atlantic States were prized by wealthy *rancheros* to hold table wines. Despite the excellent reputation of local vintages, French wines were imported for the military receptions in Santa Fe, champagne at fifty, and claret at thirty-six dollars the dozen, exorbitant prices a century ago.

The Indians invented a basket coated with pitch which held water and was carried by travellers as a canteen. This wicker bottle was unsatisfactory for liquors, because alcohol dissolved the pine gum, an accident which might have led to the discovery of a formula for spirit varnish. Indians also wove containers which were virtually watertight when the fibers swelled with wetting. As with ceramics, the Spanish villagers depended upon the Indians for household baskets.

The aboriginal peoples, whose basket-making preceded their pottery, had developed basketry to a technical and artistic level seldom surpassed. A variety of materials was used— yucca, corn husks, devil's claws, and grasses—dyed or painted in several colors. Leaving the more complex phases to experienced Indian fingers, the villagers put plant fibers to everyday service in brooms of *chamizo* brush and cords of the long, tough strands obtained by pounding yucca leaves. To make a rope, particularly the lasso which New Mexico *vaqueros* swung with superb skill, men braided strips of rawhide. An especially vain horseman plaited himself a lariat of horsehair, the pattern alternating black and white.

That the adobe oven has resisted the inroads of civilization successfully speaks for its efficiency and close association with New Mexican food habits. The outdoor oven, or *horno,* is cone-shaped, and has been described accurately as resembling an old-fashioned beehive. The native woman who constructs an *horno* begins with a platform of mud and stones about four feet square and a foot high. Upon this raised surface she builds a hemispheric structure of earth in much the same way as a Pueblo potter works up a pot with a coil of clay. Hunks of broken adobe brick and stones are laid round and round in rising layers, mortared with mud and tapering gradually inward until a dome four or five feet high is completed. An arched opening is left on one side to serve as a door. A small hole is made near the top for a smoke escape, and another is cut at the base as an air intake. The woman plasters the hollow inside with fire-resistant clay, leaving a smooth flat surface as the floor of the oven.

When the housewife wishes to bake, she first builds a fire inside the oven. When the mud walls are thoroughly impreg-

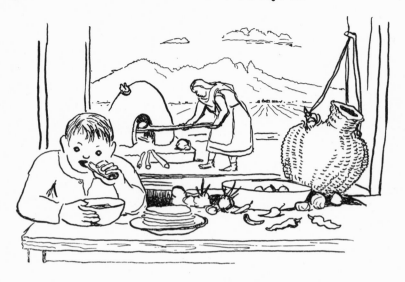

nated with heat, she rakes out the coals and brushes the floor clean. Wielding a long wooden paddle she places raw dough on the hard earthen floor of the hot oven. She closes the doorway with a slab of wood or stone, plugs the airholes with rags, and leaves the loaves to bake in the slow, even heat. Before the days of commercial yeast, leavened bread was made by saving dough from the previous baking. The dough was kneaded and allowed to rise three times; it baked in about one hour. Until commercial bakeries were established, quantities of homemade bread were offered for sale in the open-air markets of Santa Fe and other towns. Not only bread but green chile peppers, green corn in the husk, and pies made with dried fruits were baked in the adobe oven. In Autumn the ovens were redolent with the smell of roasting *piñones* (pine nuts), a delicacy acquired from the Indian. Even today, *piñones* have a seasonal popularity among local children, and the

crunch of nutshells on the floors of school and church is a great annoyance to oldsters.

The outdoor oven is the consummate form in adobe, and is almost the sole example of dome construction, although old drawings suggest small domes on the towers of the churches at San Miguel and Old Albuquerque. The absence of the dome in churches built by Pueblo Indians is perhaps attributable to strong taboos surrounding the handling of basic materials, and the traditional division of labor between the sexes according to strength and danger. Earth is the woman's material, she shapes pottery, builds in adobe. The Pueblo man is the woodworker, making tools and weapons, religious sculpture, and the roof of pine timbers. When the Spanish priest asked him to extend this into a dome, a structure which not only looked like an inverted pottery bowl, but was made of the same material, he may have had the reaction of a European male asked to make a tent from a petticoat.

The hemispheric oven, made by the women of Pueblo and Spanish communities, is of European origin. The form, once common, is seen today in France, Spain, and the Gaspé Peninsula of Canada. It is widespread in Latin America, being known as far south as Peru. Colonial New Englanders knew the outdoor oven as an iron-doored brick box sitting in the back yard. Often, to save fuel, New Mexican women build three adobe ovens side-by-side, a small one perhaps three feet in diameter for daily bread, a middle size, and a large *horno,* five feet high, for baking great quantities of chile and corn. This custom of multiple ovens prevails also at farmhouses in the Balearic Isles. Housewives take pride in plastering the ovens with fresh clay each year. The texture and proportions of the *horno* are so pleasant as to be called poetic, and its con-

stant attraction to artists and photographers attests its beauty. There are slight variations in shape; as a general rule Spanish villagers prefer a taller, conical form, while Pueblos like their ovens spheroid. The bases may be round, square, or almost non-existent. In multi-storied Pueblos, ovens are sometimes built on the rooftops which serve as balconies. In Spanish houses, the *horno* has influenced the shape of the corner fireplace, which is quite rounded and equipped with a small arched opening similar to that of the oven.

In the division of labor between men and women in village economy, women were responsible for the preparation of food and the care of the house. They made and mended clothing, although men prepared hides and cobbled shoes. Spinning was done by both sexes, especially older people otherwise little occupied, while weaving was a special trade which men normally followed. Men, women, and children shared the labors of planting, weeding, and harvest, but the heavier duties of agriculture—plowing, ditching, irrigating—were jobs for grown men. The gross work of house building was performed by men, and women added the finishing touches of plastering and painting with gypsum. Women were skilled in the making of fireplaces and outdoor ovens. All work in wood was reserved for men, from the initial chopping of a tree to the roof and doorways of a house, and tools for kitchen and farm. The artists who made religious paintings and sculpture were always men. In addition to hoes and shovels, two important farm implements fabricated almost entirely of wood were the primitive plow and the crude two-wheeled cart.

In his *Memorial of 1634*, Fray Alonso de Benavides listed "twelve plowshares with steel edges" among the supplies

headed for New Mexico. These iron points, later made by
native blacksmiths, were for attachment to homemade
wooden plows. Local farmers constructed a much simplified
version of the old European plow, and this type was adopted
by both Spaniards and Indians, changing little from the time
of the first colony until twenty years after American occupa-
tion.

The body of the plow consisted of a short treetrunk with a
large limb left attached to serve as a handle, cottonwood
being preferred for its toughness. The farmer sharpened the
lower end of the trunk and bolted a piece of iron on it as a
point. Just in front of the handle a hole was cut in the body of
the plow, and equipped with a strong peg on which was
hinged the long straight tongue, or beam, of the plow. The
pitch was adjusted by a short upright post set in the body and
running through a hole in the beam. By placing pegs in this
post, the farmer changed the angle between the beam and the
plow body for deep or shallow furrows.

The beam was attached directly to a stout pine pole lashed
across the horns of a pair of oxen in lieu of a yoke. The shoul-
der-fitting yoke with U-shaped wooden collars was introduced
very late, being copied from equipment of Yankee ox-drivers
on the Santa Fe Trail. Harness, as such, was scant, and the
animals were driven with "a villainous looking goad."
Wooden pegs and strips of rawhide held together the various

pieces of the plow and yoke. At best this primitive plow cut only a shallow trench; its point was small and lacked a moldboard. Having but one handle, the machine was extremely cumbersome to manage. Outside of museums, models of early Southwestern plows are to be seen in the sculptured representations of Ysidro, the farmer saint.

Equally ingenious, and just as inefficient as the plow, was the *carreta,* or cart, also constructed with little benefit of metal. Like the plow, the two-wheeled cart derives from a European ancestor, and its duplicate may be seen in use today in Spain and Mexico. Oñate employed eighty-three *carretas* to carry the equipment for the first colony in 1598, and about thirty lumbered up from Mexico in the triennial caravans which supplied the seventeenth century missions. Because of the absence of markets, these crude vehicles were not very generally used in the province except by the military and merchant classes.

Two thick sections of a cottonwood tree were sawed for the wheels of the *carreta* and pierced with holes at the center to accommodate a large wooden axle. The bed of the cart was a framework about four feet square, of pine planks, often covered with a bullhide instead of solid flooring. This bed rested on a pine log which extended to form the axles. Wooden pins held the wheels in place, and a wickerwork of light poles enclosed the sides of the *carreta* in a huge basket. A single pine shaft connected with the yoke of the oxen. Despite its heavy construction, this vehicle could convey only a small load, yet it was cumbersome and easily mired. Because, when the cartwheels turned, one heard "the most horrible screechings and groans, as if one was approaching the portals of Erebus," United States soldiers swore that the

wheels were never greased, although the villagers did manufacture a lubricant of doubtful efficacy by mixing lard or tallow with tar obtained from the roasting of green pine branches. The *carreta* served to carry wild hay from the river marshes and grain from the fields, and to make the long trip for salt from lakes in the Estancia Valley. Emory has divulged its social aspects:

"It was the eve of the fête of Tomé in honor of the Virgin Mary, and people from all parts of the country were flocking in crowds to the town. The primitive wagons of the country were used by the women as coaches. These wagons were heavy boxes mounted on wheels cut from large cotton wood; over the top of the box was spread a blanket, and inside were huddled, in a dense crowd, the women, children, pigs, lambs, and 'everything that is his.' The man of the family usually seated himself on the tongue of the wagon, his time divided between belaboring his beasts and scratching his head. In one of these a violin was being played, and the women who were sitting on their feet, made the most of the music by brandishing their bare arms and moving their heads to the cadence."

Handmade implements were the first to be discarded when general merchandise stores opened in the Territory and extended liberal credit over mortgages signed with an X. Village women sought metal stoves and kitchen utensils. Men were pleased to have steel hoes, spades, and moldboard plows to ease their tasks. Table manners changed in the presence of stoneware dishes and conventional knives and forks, but the old basic diet was retained, with the addition of potatoes, pork, and other standard American foods.

Corn, chile, and beans have been cultivated in New Mex-

ico for centuries. Their use is ingrained so deeply in the lives of the Spanish and Indian population as to perpetuate the use of handmade objects associated with them. Just as the Boston housewife feels there is no substitute for a crockery beanpot, and the Englishman rejects the teabag, the New Mexico villager believes that no metal invention can duplicate the flavor of *tortillas* from corn ground on a stone *metate,* chile baked in an adobe oven, and beans cooked in an earthen *olla.*

CHAPTER SIX

THE WARMTH OF WOOL

THE COMMON PEOPLE of New Mexico wore clothing of simple peasant design cut from plain materials, yet their costumes expressed great love of color and personal adornment. Textile arts were well understood in the province, spinning, dyeing, and needlework being standard accomplishments for women, while many men were skilled in weaving and the processing of skins. Traders did a lucrative business in the brilliant dyes, colored silks, fine leathers, and precious metals which they brought from the outside world to enhance New Mexican dress.

For centuries Spanish men have been justly famous for their dashing appearance, and the caballero of New Mexico

was no exception. His wealth could be gauged at once from
the spirit of his horse, the amount of silver on saddle and
bridle, the fineness of the rider's sarape, and the number of
silver buttons on his clothes. The young señor of means wore
a low-crowned felt hat of Spanish cut, or a heavy, red or
brown, peaked sombrero of American beaver. In either case,
the brim was very broad, with silver braid and buckles around
the crown, and sometimes metallic stitching in the fabric. He
wore a white cotton shirt which had pleats or drawnwork
panels down the front, and puffed sleeves with tight, ruffled
cuffs. His trousers of blue or brown wool fitted tightly, and
were split at the sides, revealing white underwear. A row of
silver buttons or chains fastened each side of the trousers, and
a sash of pink or magenta silk with fringed ends was tied
around the waist. During the eighteenth century, short
trousers and white stockings were the fashion, but around
1840 long pantaloons, flaring at the bottom and gored with
colored cloth, came into style. When riding, the caballero
protected his legs from knee to ankle with yellow buckskin
leggings called *botas,* which were incised with designs in the
manner of saddle leather. A professional *vaquero,* or cowboy,
had *armas de pelo,* which we would call "chaps," to cover his
legs during storms or when riding through sharp brush. For-
tunes were spent on saddles of tooled leather and wildcat fur,
flashing with silver and flying with fringes. Bridle and huge,
jingling spurs were ornamented to match.

The laboring man imitated this bold costume to the extent
of his purse, but always he owned a colorful woolen blanket
with a split in the center, through which he thrust his head in
"poncho" style. His sombrero was likely to be of coarse straw,
a cumbersome affair imported from Mexico, sometimes water-

proofed with a covering of oiled silk. Often his breeches, "tight around the hips, and open from the knee down," were of leather, and the villager might also wear a tanned deerskin shirt, which gave him, except for sombrero and poncho, the appearance of an American frontiersman. Shirts of locally-woven cotton or wool were usual male apparel, as were trousers of coarse native serge. Like the *rico,* the peon wore buckskin moccasin-boots, with hard rawhide soles, and toes pointed in the Moorish manner. Until the nineteenth century, when short hair and sideburns became the fashion, men braided their hair in a single queue. Moustaches and beards were customary, and a man seldom shaved except before attending Mass.

The New Mexican woman wore a knee-length chemise of coarse cotton, which served as both blouse and petticoat. This loose garment was cut low at the neckline and short at the sleeves, exposing much of the shoulder and arm. It is derived from the *huipil,* the primitive dress of Mexican aborigines. Over the chemise the woman wore a skirt of "monstrous width and fullness," tied at the waist with a colored sash, and falling to the ankles. The skirt was of heavy, homespun flannel, and cochineal red was the favorite dye. This costume is known romantically as the China Poblana, "the Chinese woman of Puebla," after a pious East Indian woman who came to Puebla, Mexico, at the end of the seventeenth century, and joined a sisterhood of nuns who affected the dress of the peon class as a badge of humility. The China Poblana, elaborated with embroidery, ribbons, and spangles on skirt and blouse, later became the badge of a prostitute, was widely copied in the theater, and is today a popular fiesta costume.

Just as the blanket was the universal outer garment of the man, every village woman wore a *cobija,* or shawl. She folded a square of colored cloth into a triangle and tossed it over her head and shoulders as bonnet and cloak. Two corners hung loosely to her waist in front, but when the woman went into the street, she draped a corner of the *cobija* over her left shoulder, muffling her face to the eyes in the manner introduced by Mohammedans to Spain. The *cobija* was somewhat smaller than the famous "Spanish shawl" of Chinese origin, and instead of being embroidered, the colors were woven or dyed in the cloth. An oblong shawl, called a *rebozo,* also was worn by New Mexican women. Silk or cotton, or a mixture of the two, was preferred for these garments. Cotton shawls were woven in the province, although the better grades, and all silk pieces, of course, were imported by way of Mexico. In the nineteenth century New Mexicans began receiving cotton prints and finer materials from the United States. Nowadays one sees only the *tápalo,* or black shawl worn by elderly widows.

American soldiers were quick to observe that New Mexican señoritas wore no corsets, and usually no stockings, although a few had white hose of crocheted cotton. Women sometimes went unshod, but Pueblo moccasins, as well as heelless cloth slippers in Spanish style, were acceptable footwear. The ladies of official families owned silken slippers, perhaps embroidered. On all occasions, village women exhibited as much jewelry as they could afford. Native women painted their faces with various white cosmetics; and travelers recorded that their noses were shiney. Old and young applied liberal patches of the crimson juice of pokeberries to their cheeks. On ordinary occasions a woman plaited her hair in long braids, but

for a dance she might pin up her hair in Continental style, and crown it with her grandmother's tall Spanish comb.

Children of both sexes wore nothing at all, or only a little shirt, until they were about eight years old, at which time they assumed the costume of their parents. Boys went hatless and shoeless until early adolescence, when they were able to earn these symbols of manhood. The wealthy families made lavish expenditures on children's clothes, and took pride in dressing their sons and daughters in the elegance of miniature caballeros and señoritas.

Except for such accessories as jewelry, ribbons, and sashes, the poor rarely had any change of costume. Laundering seems to have been an annual affair, when the women stripped to their chemises and sudsed the bedding and family clothes in the river or the nearest hot spring. Fortunately the New Mexicans did not lead an urban existence, and being out of doors much of the time, were exposed to the purifying elements of sun and wind. They shared the aversion to bathing universal in the last century, and one visitor experienced in church "an odor which the incense from the altar failed to stifle." The *hacendados,* although not much more sanitary in their habits, had more extensive wardrobes than laborers, and seized upon church-going, fiestas, and parties as occasions to display their clothes. Womenfolk of the ruling class varied the plain chemise with *indianilla,* a cotton print made in Mexico in imitation of East India block-prints. They brightened the blouse with ribbons and lace, and added bands of violent color to the China Poblana skirt. Traders brought them hoopskirts and silk and velvet from the Chihuahua Fair, and during Santa Fe Trail days ladies copied the styles of New York and Paris, except for hats, since the New Mexi-

can señorita was loath to forsake her convenient shawl.

When the Spanish colonists settled among the Pueblo Indians, they found these peoples possessed of a brilliant textile tradition which expressed itself in practical everyday clothing and exotic ceremonial garb. Cotton was grown by the Indians, and weaving techniques had reached a high standard of perfection in pre-Hispanic times. Chronicles of the sixteenth century make frequent mention of cotton *mantas* of Pueblo manufacture, which were squares of cloth painted with decorative devices, blue being a favorite color. Indians ginned their cotton by picking out the seeds with their fingers, although the Zuñi had the ingenious method of beating cotton boles between two blankets, so that the fiber clung to the fabric, while the seeds fell free. To make yarn, the elementary spindle was used, a smooth, straight stick thrust through a wooden disk or whorl. The base of the spindle was placed in a bowl, and the spinner twirled the stick so that it pulled the long fibers into a continuous strand. The Hopi still roll the spindle against the right leg, a motion recalling the primitive method of spinning by rolling fibers between bare hand and bare thigh.

Indian weavers worked at a simple vertical loom, the principle of which survives in contemporary Navajo weaving. The Navajo worker makes a weaving frame by setting two timbers in the earth, and tying horizontal poles at the top and bottom to form a rectangle. The warp is strung vertically between the cross poles. Individual warp threads for a desired pattern are tied with strings to a stick, and when the weaver pulls toward herself this stick, or heddle, certain warp threads stand out. She thrusts in a blade of wood to hold this gap in the warp, and pulls a ball of weft yarn through the opening. Hold-

ing a wooden comb in her fist, the Navajo weaver beats the weft firmly in place. Deviations in pattern are possible with additional string heddles, and the woman controls the details of the design by plucking individual strands with her fingers.

Mantas and cotton yardage became a valuable export of Hispanic New Mexico, and Indians were taxed in blankets and forced to work at the production of textiles. The invaders applied mechanical looms to the making of cotton sheeting and shawls, as well as woolen goods. Sheep were brought into the province by the Spaniards, who introduced the Indians to techniques of wool. Indian slaves, captured from members of nomadic tribes, were given the tedious work of carding and spinning, but much of the weaving of cloth and sarapes, as distinguished from Indian blankets, seems to have been done by Spanish professionals, usually men. For their own use, the Indians never willingly adopted the European loom, because of its complexity, and because of taboos surrounding aboriginal arts.

The villager's loom was of the horizontal or low-warp type. "These looms are similar to those one meets in the United States, except in the construction, which is of the crudest kind," wrote J. W. Abert of blanket weaving at Torreon, New Mexico. The machine consisted of two rollers made of logs fastened in a frame. Warp threads were stretched between the rollers, lying flat like a table for the weaver. Warp fed from the rear roller, through heddles, and on to the front roller as a finished textile. In Europe the loom was equipped with a reed heddle, an oblong frame filled with metal rods or reeds pierced with holes, which served to lift sections of the warp in a pre-arranged pattern. Lacking both metal and proper reeds, New Mexicans ingeniously adapted the Indian string

heddle idea to a mechanical arrangement. Instead of reeds, the weavers tied strings knotted in loops on oblong wooden frames. These heddles were attached to ropes connected to foot treadles, which, when depressed, lifted a portion of the warp. Boat-shaped shuttles or flat sticks with notches at the ends were wound with weft yarn and thrust between the warp threads at the opening made by the lifted heddle. Instead of the hand beater used by the Indian, the village loom had a narrow wooden frame threaded with stout cord or metal wires and swung on hinged levers in such a way as to press down the weft in a single, swift operation.

In former times, two sizes of looms were in general use. The large loom was the full width of a sarape, four or five feet. The narrow loom, still used in parts of Mexico, was the breadth of half a blanket, about two feet. To make a blanket with the small loom, the worker wove two long strips of matching pattern, afterwards sewing them together. If a

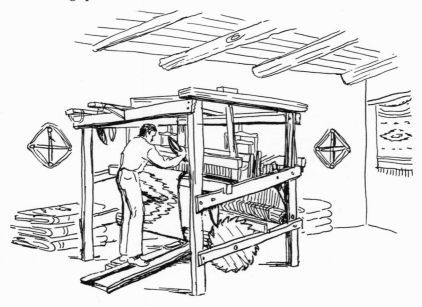

poncho was desired, the weaver left an open slit about a foot long in the center of the blanket, through which the wearer could insert his head.

Little Spanish communities in the Truchas Valley, north of Santa Fe, were the center of commercial weaving. In particular, the village of Chimayo was so productive that New Mexican textiles commonly are spoken of as "Chimayo weaving." Hand-woven blankets were the most highly valued items New Mexicans took to trade at the Chihuahua fair. Old Chimayo sarapes are reckoned among the most intricate examples of New Mexico weaving, the patterns being similar to those made at Saltillo by the best weavers of Mexico. A maze of concentric diamonds in six or eight colors supplied the motif, worked out by the individual weaver according to his skill and ingenuity. The method was complex, involving several shuttles of different hand-dyed yarns, and close attention to the mathematics of the pattern. A rich harmony of reds, yellows, and tans was a frequent color scheme, the weaver employing fine wool, and carefully concealing the terminal ends of yarn in the smooth tight texture of the blanket. The resulting piece was elegant and durable, selling to a wealthy caballero for forty or fifty dollars.

Much simpler than sarape weaving was the manufacture of ordinary blankets and domestic cloth. Of plain colors or horizontal stripes, most of these pieces were produced with a simple basket weave, although the better grades were given a firmer texture with twill or herringbone pattern. Early Rio Grande blankets featured stripes of white, grey, or brown natural wools alternated in various combinations with brazilwood red and indigo blue. As might be expected, the imported dyes were used somewhat sparingly. Such blankets

served as ponchos for poor men, and as bedding and floor coverings for the wealthy.

The fabric most used by the common people was called *jerga,* a coarse woolen cloth resembling rough serge. Depending upon the fineness of the yarn and the tightness of the weave, *jerga* was employed variously for skirts and trousers, carrying cloths, and saddle blankets. For suitings, the material was dyed red, dark blue, or cocoa brown, and worn pieces were pieced together in checkers for carpeting. *Jerga* also was one of the chief New Mexican exports; in 1846 it sold at twenty-five to forty cents a yard. Although the manufacture of blankets has continued until the present time, very little *jerga* seems to have been made after 1850, when machined fabrics from New England began to replace it. With the revival of New Mexican arts in recent years, a limited amount of *jerga* has been reproduced for use as upholstery and draperies, and a particularly handsome variety is woven with angora wool.

In an order dated April, 1777, Pedro Fermin de Mendinueta, the Spanish military governor of New Mexico, forbade the exportation of sheep and raw wool, because the supply was inadequate for the local population. It is said that merino sheep with long-staple wool had been brought by Oñate's colonists in 1598, but a nineteenth-century observer noted that the native sheep were small, having large horns and inferior wool. Although quantities of woolen textiles were manufactured, sheep were kept in New Mexico primarily for use as food. Wool was so unremunerative by 1846 that *rancheros* permitted anyone to sheer the wool from their sheep for one dollar the thousand animals, while a poor villager had to pay the relatively exorbitant price of four cents

a fleece. Pasture lands were so extensive that the owner could sell sheep for butchering at a dollar a head. The labor cost was extremely small, since a single herder with the aid of shepherd dogs could manage several thousand sheep. Navajos and Apaches found sheep desirable for mutton and wool, and their numerous sheep-stealing raids were probably a significant cause of that eighteenth century decline in the grazing industry which prompted Governor Mendinueta's order forbidding the export of sheep. The Spaniards retaliated with raids in return, destroying Indian crops, and enslaving the women and children they captured. The Navajos learned to process wool, and developed the blanket-weaving for which they are now world-famous. The ownership of sheep and the manufacture of rugs and blankets are now prime factors in Navajo economy.

By the end of the eighteenth century the textile industry, so essential to New Mexico's trade with provinces to the south, had diminished seriously. To rectify this situation, the local government brought weavers from Saltillo, Mexico, to revive their trade in the Santa Fe area. The venture seems to have been successful, for during the next forty years New Mexican weaving reached a new peak of excellence.

After American occupation, many natives ceased to operate their looms. But the interest shown by tourists in Navajo blankets gradually spread to village weaving, and toward the end of the last century there developed a substantial souvenir market. Curio merchants, who dealt principally in Indian goods, suggested so-called "Indian" designs to village blanket-makers, and there appeared a rash of arrow and swastika compositions. The dealers, as they did with the Navajos, supplied

not only the patterns but the materials, and to this day village blankets normally are woven from machine yarn on cotton carpet warp. Ordinarily these "Indian" designs which occur in both Navajo and Chimayo examples, are not Indian at all, but white men's ideas of what Indian art should be. It is small wonder that many persons have been led to believe that native goods are of Indian manufacture, and shopkeepers have been known to sell the products of Spanish villagers under the misnomer "Chimayo Indian blankets."

In their search for novelty with tourist appeal, Chimayo weavers even copied postcards, and there is in existence a blanket decorated with the woven likeness of the Palace of the Governors, dated 1913, another with a replica of San Miguel Church, as well as grotesqueries with personal names, Merry Christmas, and other legends. From the standpoint of the collector, many of the pieces pre-dating World War I are worth owning, since in both weaving technique and quality of commercial yarn, they are superior to most present-day examples.

Early in the 1930's, several private companies were organized to manufacture and sell handwoven textiles. These commercial firms provided factory-made looms, and hired and trained native workmen to operate them. While some hand-spun, hand-dyed yarn was used, most of the weaving was done with machined wool, and only a few of the patterns stemmed from the native tradition. Although neckties were the principal item of sale, now attracting interest in the national market, the workers also turned out fine suitings, draperies, and other textiles. In addition to the weavers who put in regular hours under the supervision of shops, there are today many

individual workers, especially at Chimayo and Cordova, who operate looms in their own homes. While present-day New Mexican woven stuffs have little resemblance to their ancestral forms, the craft remains an effective employment for the nimble fingers of village craftsmen.

One hundred years ago, when the sarape was still an item of daily dress, the buyer insisted upon high standards. Although suggestions of the old Saltillo stairstep-diamond design are still to be seen in modern New Mexico blankets, the former careful and complex technique has all but disappeared. The tourist, who wishes something bizarre for his floor or wall, seldom has any criterion but price. Rarely can he afford the painstaking workmanship, much less the superior handspun, hand-dyed wools that once went into native weaving.

Dyestuffs, formerly received from the Orient, became a significant item of commerce when Spain began to exploit the resources of her New World colonies. Central America and Mexico furnished cochineal, a pure red dye ground from the bodies of the female of a species of cactus louse. Brazilwood was the source of rose and other shades of red. From the West Indies came anil, a variety of the indigo plant; its strong blue dye was concentrated into balls which had to be dissolved in acid.

There was no local source of dye which matched the clarity of the reds and blues available from cochineal, brazilwood, and indigo; therefore the housewives of New Mexico made a constant demand upon Chihuahua traders for these substances. Indians were as eager for these colors as the Spaniards, since the scarlets and intense blues with which they decorated their textiles were paints rather than true fiber-penetrating

dyes. Pink dye from the tag-elder, azure from larkspur, and turquoise from copper sulphate were pale substitutes.

The Spanish colonists had brought from Europe some knowledge of vegetable dyes and the preparation of wool to receive color. Along with their garden seeds they imported medicinal and dye plants, such as saffron, and they recognized familiar sources of dye—oak and lichen—in New Mexico vegetation. From the Indians, and by experiment, village women learned to produce a wide chromatic variety from Southwestern plants. They obtained yellow dye from the golden flowers of the *chamiso,* or rabbit brush, and its relative the *rosillo,* or shrubby cinquefoil. By adding indigo blue to the *chamiso* formula, green was produced. The tuberous roots of the dock, called *canaigra,* were gathered for tawny yellows and tans, and stone lichens and apple bark yielded yellow-green. Many plants were a source of brown—juniper bark, onion skins, and black walnut hulls, the latter an item of inter-Indian trade before the Spaniards arrived. To produce jet black, wool was soaked first in a potion of sumac leaves and then in water containing rusty iron.

Before being dyed, it was necessary for wool to be carded, spun, and washed. The women combed the wool into bundles of parallel strands with imported cards of stiff leather set with fine wire; however, wild thistles and domestic teasel plants may have been used for the purpose. Most women spun the yarn on elementary rod spindles, but toward the close of the eighteenth century enormous, clumsy, handmade spinning wheels sped the output of a few workers. In preparation for dyeing, the worker washed hanks of wool yarn in lukewarm water with suds of *amole,* or yucca root, the standard soap of Southwestern Indians. Since wool does not have a

natural affinity for dye, it was necessary for the villager to dip it in a mordant to open the pores of the fiber. Weak acids are a satisfactory mordant, and the acidic solution most easily obtained by the Spanish colonist was human urine. This factor, and the necessity of using urine to dissolve indigo, caused the New Mexicans to accept quickly the aniline dyes (which contained a mordant) when they were introduced by American salesmen late in the last century. The wide range of bright colors and the simplicity of using commercial dyes banished the immense labor of gathering and brewing native herbs. Before 1900, machine-made wools, the so-called "Germantown yarns," which eliminated the whole tedious process of carding, spinning, and dyeing, had come into common use among rural weavers.

While the busy housewife could hardly be blamed for abandoning her old-fashioned methods, the quality of textiles was not improved by commercial dyes and yarns. Wool dyed with local plants was more beautiful and subtle in the natural harmony of its colors. Many native dyes were less subject to fading, and the handspun wool had a tensile strength and a pleasing irregularity of texture often absent from machined yarn.

"We were shown into his reverence's parlor, tapestried with curtains stamped with the likenesses of all the Presidents of the United States up to this time. The cushions were of spotless damask, and the couch covered with a white Navajoe blanket worked in richly coloured flowers." What Emory must have seen in the priest's house at Santo Domingo on September 3, 1846, was not a "Navajoe blanket," but a piece of New Mexican *colcha* embroidery.

New Mexican embroidery is much coveted by museums and collectors because the generous use of soft wool yarn in warm vegetable colors gives it a richness and intimacy rarely encountered in textiles. Designs are free and graceful, executed with little of the tedious detail which characterizes most needlework. More often than not, native embroidery was an act of devotion, an altar cloth lovingly planned to ornament a little village church.

The name *colcha* was given to embroidered coverlets, and hence to any embroidery done in the characteristic native style. Wool yarn, dyed in soft, harmonizing colors, was applied to a plain woolen or cotton base, with much the same effect as crewel-work. The wool dictated large figures and coarse stitches, and the resulting pieces were thick but without stiffness. The embroiderer chose one or two styles: She could decorate a white fabric with running designs and isolated figures, or she could cover the base completely with close-packed stitches.

The typical *colcha* is made with a long, coarse stitch in wool yarn, caught in the middle by a short, horizontal stitch. The needle is pushed through from the underside of the fabric, passed across the top of the design, and pulled through, leaving a long, straight line. Then the needle is brought to

the middle of the stitch and passed over it at right angles in a short "step-over" to hold the long stitch flat. The needle is returned underneath to start again beside the first stitch. Sometimes more than one "step-over" is used to fasten very long stitches. The method is not economical, for as much yarn is hidden on the back of the material as appears on the front, but it works up rapidly, and when *colcha* embroidery came into flower, wool had little monetary value.

The embroiderer outlined each motif with a dark color, and for this the chain-stitch served. Thin lines, such as flower stems, were made with a single or double outline stitch. The *colcha* threads were worked in various directions—vertical, horizontal, and diagonal—to shade the same bit of design.

Altar cloths are the finest examples of *colcha* embroidery, for in New Mexico the best native art decorated the church. Ecclesiastical symbols, such as the Cross and the Sacred Heart, provided central themes for altar linen, but wide floral borders in rich colors were the chief ornament. Plant forms were gracefully stylized in linear patterns of curves and scallops, placed at rhythmic intervals. Ideas were derived from age-old patterns, chiefly Asiatic, and there are strong suggestions of Chinese shawls in *colcha* embroidery. These silk shawls reached a few wealthy New Mexicans by way of Spain from the Manila Galleon trade.

The flood of goods from the new sea trade with the Orient —silks, embroidered stuffs, jewels, tin, porcelain, and furniture—left its mark on the everyday arts of Europe, and reverberations in style were felt as far away as New Mexico. On the Continent, men and women of fashion made a fad of the finer things, and tradespeople, like Dutch potters and Spanish furniture makers, found themselves hard put to match the

price and quality of the imports. In a frenzied bid for cus-
tomers, European craftsmen copied Chinese designs, while
the Orientals were taught popular Occidental patterns by the
sea merchants who traded firearms, clocks, and glassware for
the products of the East.

Portugal's supremacy in the Indian Ocean forced Spain's
ships to take the Pacific route. Operated under strict license
from the Crown by Spanish residents of the Philippines, the
Galleon left Manila with the southwest winds of mid-summer,
sailing northeast past Luzon and Japan, thence eastward to
the coast of California, where more than once she fell booty
to buccaneers like Cavendish.

At the end of a six-month's voyage, the Galleon was un-
loaded at Acapulco. Sealed with royal insignia, the goods,
unopened, were carried by land across Mexico to Vera Cruz.
There the boxes were placed on shipboard for the Atlantic
trip to Spain. From Spain, therefore, only such Oriental mer-
chandise as the Crown could spare to its wealthier colonists
returned to the New World. Despite these precautions, black
markets existed then, as now, and a steady trickle of lucrative
Oriental treasures seeped into the Americas. Legally or ille-
gally, a few embroidered Chinese shawls came into New
Mexico, and were an inspiration to native needleworkers.

Openwork embroidery, in which the white base material
serves as a background for designs, was usually done on
cotton cloth. Flowers and trailing plants were perennial fav-
orites, and however much indebted to the Orient for basic
elements, the New Mexican needleworker invented endless
variations on the theme. Each leaf or flower became a contra-
puntal exercise in harmonizing colors. A leaf the embroiderer
divided lengthwise, making one-half red, the other brown.

What began as a morning glory became a gorgeous fan with a feathery red base and fantastic petals in orange, pink, and shades of tan. Eagles and roosters and deer likewise were camouflaged with zig-zags and bands in colors that women loved best. Even in the repeated part of a border, each motif, drawn freehand, varied slightly from the next, creating liveliness and informality.

Solid embroidery, which hid the base under tapestry-like designs, customarily was worked on woolen cloth. The lack of convention in many pieces would suggest that this type is older in New Mexico than openwork embroidery. The first pieces may well have been done in imitation of the embroidered vestments and sacramental cloths imported for the church. In addition to allover patterns of plant forms, there are many original pictorial pieces derived from New Mexican life. One embroiderer chose a wagon train for her theme; another depicted a *Penitente* flagellation procession. Since many of the embroidered pieces were intended for the church, religious elements were frequent.

Colcha embroidery cloths were made quite large, many measuring more than six feet in length and four or five in width. Coverlets to fit a single bed were not uncommon. In solid embroidery, the backgrounds were filled with plain colors of yarn, often tan or brown, but the natural variations of hand-dyed yarn, and the working of stitches in different directions gave life to these areas. The elements of openwork embroidery were tied together with curving lines of dark thread, which served as the stems of flowers and leaves.

"Drawnwork" was less colorful than embroidery, and depended upon lace patterns for its decorative effect. By pulling certain parallel threads from a piece of cotton or linen cloth,

the native needleworker created pierced designs. Sleeves of
drawnwork ornamented the gown of Our Lady of Guadalupe
in her miraculous portrait in Mexico, and the art of drawn-
work was once very popular for the white surplices of priests,
and snowy cloths for the altar. Men had drawnwork inserts
in their shirts, and women decorated China Poblana blouses
in a similar manner.

Crochet, resembling drawnwork, but different in tech-
nique, is an art still practiced by village women. The altar
tables of small churches are worth mentioning for their extra-
ordinarily fine crocheted covers. These white altarcloths,
always prim and starched, have a wide scalloped border of
religious designs. Often there is an altar frontal to match.

In the window above the church door at Corrales a large
crochet panel represented Our Lady of Guadalupe. This
design, as well as delineations of the Holy Child of Atocha
and various saints, is to be seen in almost every village as a
curtain for glass doors. Nowadays women follow printed
directions for crochet patterns, but original adaptations are
not uncommon. Crocheting is enjoyed by Indian women as
well, and very fine examples of their work may be seen in the
churches at Isleta and Sandia. Inserts of crochet are charac-
teristic of the puffed sleeve shirts worn by Isleta men, the sur-
vival of a style worn by Spanish gentlemen a century ago. Be-
fore manufactured stockings were easily obtained, both Span-
ish and Indian women crocheted and knitted footwear in
cotton and wool. Leggings in cotton crochet are still worn by
men in ceremonial dances of the Rio Grande Pueblos.

The Santa Fe Trail merchants found a ready market for gay
cotton prints. Calicoes which cost them a dime a yard at the
Ohio, sold for thirty-seven and one-half cents on the Rio

Grande. Changes in the style of dress, and separation from the Mexican market, turned village weavers toward an increasing souvenir clientele. Embroidery silks and cloths stamped with Parisian patterns superseded the less brilliant *colcha* work. Men no longer appeared in buckskin and blanket, but the Stetson still marked them as Southwesterners. Village women came to dress like other women of the United States, but, like the men, they retained headgear suited to the New Mexican sun—the practical shawl.

CHAPTER SEVEN

TRINKET TRADE

HANDS AND WITS WERE the frontier metalsmith's security. His income was not from the land, and he went, therefore, wherever the prospect pleased. Sometimes he deserved only the title of blacksmith, but a clever man kept his eyes open in his travels and discovered many things he could do with a basic knowledge of metals. He made his living among the small New Mexico villages, not only by shoeing the caballero's horses, but by mending copper kettles and cutting punched-tin frames for printed saints' pictures. From a few silver pesos he might fashion a pair of earrings for the señorita to whom flash and gaiety meant more than precision and fine materials.

These itinerant craftsmen, who picked up ideas wherever they saw them and substituted ingenuity for standard tools, confuse the paths of art history. John Adair records the story of a silversmith and leather worker, Juan Andres Apodaca, who was trained in his native Valencia, Spain, during the 1850's. He worked in Mexico City for a time, and then removed to Peralta, New Mexico, where he made saddles and silver jewelry for the villagers. Apodaca stamped his silver with metal dies like those used to tool Spanish leather, and he may even have invented this style now characteristic of the silverwork of Southwestern Indians. It is known that he trained apprentices and hired Pueblo silversmiths, so it is equally possible that stamped silver was suggested to this Spaniard by an Indian. Punched tin seems to have influenced early Navajo silver, and certainly Indian jewelry has modified modern New Mexican tinware.

When the Yankee merchant unpacked his wagons at the end of the long, hard trip from St. Louis, colored lithographs caught the eye of the Santa Fe señora. Here the trader made not one sale, but two; to protect the print he offered a little pane of Pittsburgh glass. The lady took her purchases to the neighborhood metalsmith, and asked him to fit them with a fashionable tin frame. The smith himself was the trader's customer for files and snips, and even sheets of tin-coated iron, although sometimes he could buy Mexican tin. When the American Army began discarding oil cans and food containers, "Pure Leaf Lard" and other manufacturers' symbols impressed in the metal began to appear in the tinsmith's products.

Looking-glasses were among the best-sellers carried by the Santa Fe Trail peddlers. To guard these mirrors from

breakage in transport, Americans had covered the back and bound the edges with a sheet of tin, adding an ornate frame of the same material, which increased the price considerably. Thus New Mexicans were introduced to the techniques and designs of early nineteenth century New England tin, and even today it is the custom for village smiths to strengthen the reverse of a glazed piece with as much care as they devote to decorating the front. We find the very same patterns—star, rooster, scalloped wheel—so well known in Pennsylvania tin, repeated over and over in its Southwestern cousin. Itinerant tinsmiths, who found their popularity waning in the Atlantic States, may have visited New Mexico. Spanish housewives were little interested in the practical coffeepots and teapots, trays and boxes preferred by the plain folk of Lancaster County, but they delighted in having bright frames and crosses made to order. Once tinware had captured popular fancy, village metalworkers learned the craft, and in conceding to local taste, brought it to the status of a native art.

Although New Mexican tinwork reflected the main currents of New England styles, derived in turn from Wales and the Orient, it also had Iberian antecedents. The Moorish craftsmen applied the techniques of copper to tin, and tinware is for sale today in the markets of Spain and North Africa. The Mexicans, expert goldsmiths before Cortez, took readily to metals introduced by Spain, and may have made some of the "eleven small tin coffers, with compartments, containing three chrismatories of tin in each," which Benavides purchased in 1625 to ship to New Mexico. The father also ordered tin host boxes and wine bottles, tin-coated nails, as well as copper holy-water vessels, kettles, pans, and ladles. It became the custom in Mexico to paint *ex votos*, pictures re-

M. Sma Dn Pannia

cording a religious vow, on sheets of tin, and some of these found their way into New Mexico and were imitated here. Mexican tinwork has lost popularity except in Oaxaca.

The rectangular sheets of tin and glass introduced a mathematical precision otherwise foreign in New Mexican arts. The play of light upon the shimmering surface was a challenge for the artist to exploit it by cutting, bending, crimping, coiling, piercing, and indenting the tin.

One of the most frequent commissions of the metal smith was to make a frame for a mirror or a picture. He cut a sheet of tin slightly larger than the glass to be framed, laid the glass upon it, and bent the edges to form narrow bands around the face. To this base the smith soldered a frame consisting of strips of punched tin, hiding the corner seams beneath raised medallions or simulated leaves. The tinsman created his decoration by hammering a sharp piece of iron, usually a nail, to make a dotted pattern in the surface of the metal. He varied the texture by punching on both sides of the sheet. Only rarely did he pierce the tin with holes, because these exposed the underlying iron to rust. The tinsmith liked simple border patterns—scallops, zig-zags, serpentines—and invented many combinations of radiating lines and straight channels produced with a cold chisel.

Familiar with melting lead for bullets, the metal smith assembled the parts of a frame with lead solder and resin flux. Except in utilitarian items, he seldom interlocked the joints or turned the edges under. For this reason decorative tin is often fragile. One artisan, lacking solder, designed an effective frame by cutting tabs around a rectangle of tin, bending every other tab over the front of the glass to hold the picture in place.

Like woodcarver and painter, the village tinsmith liked to concentrate his ornament at the top and corners of a rectangle, and this he did by cutting a wide half-moon for the top of a frame, giving this an indented border around a central hex-like design. He utilized scraps of tin to cover the corners with crimped fans, spiral twists, and all manner of scrolls and foliage forms which projected beyond the body of the frame like wings or ears. A few workers made round frames, following the New England pattern of a circular daisy chain cut from discs of tin, perhaps alternated with a parade of little roosters. Victorian intricacy affected native tinwork after 1850, but the indented patterns remained uncrowded, and the laborious American style of close-set punchings filling a motif was seldom copied. When the housewife hung the tin-framed picture on her earthen wall, she was pleased by the clean, sparkling effect.

The "courtin' mirrors" Yankee sailors brought their sweethearts from the Far East may have impelled the Pennsylvania artist to try his hand at painting tulips, birds, and little scenes on the reverse side of a glass. In New Mexico, this fashion appears as "combed" glass. While the pigment is still tacky, a comb is raked over it to remove the paint in wavy or scalloped patterns. The glass is then backed with tin so that the metal shines through the wavelets. A few artists painted tulips and roses on glass, but even the unskilled could achieve handsome effects with a comb. Religious prints were framed in narrow strips of painted glass edged with punched tin. Another favorite wall decoration, and characteristically New Mexican, was a cross made of painted glass panels, the center holding a tiny print of the Chalice or the Sacred Heart, and the arms ornate with large finials cut from tin. Colored wall-

paper, lace paper, or foil, frequently substituted for paint on glass.

Tôleware, the painted tin trays, pots, and other household items so eagerly sought by collectors of English and American antiques, was not done in New Mexico, probably because the fad died before it could be imitated here. Japanning was difficult, and required special materials expensive in the Southwest. Locally, surface painting is associated only with indented tin, and it consists of filling in punched flowers and borders. As in Pennsylvania, Christmas red and green are chosen colors. The custom of retouching old pieces with house paint to hide rust is quite recent.

Villagers knew how to make tallow candles by dipping strings in hot mutton fat. Candles were used principally at church and public gatherings. Ordinary folk had little access to reading matter, but officials and priests had need of wood or iron candlesticks of the type which impales the candle on a sharp spike. Brass and silver candle holders were imported for the church. The socket-type candle holder popular in the United States was copied easily in tin. To light the Stations of the Cross, tinsmiths made simple sconces, consisting of a flat, punched-tin reflector and a short bracket for the candle. These are found in both Spanish and Indian churches, and Bourke also noted tin sconces in the kiva at San Juan. Pueblo women have imitated the form in pottery. Chandeliers resembling those in Pennsylvania meetinghouses were fashioned to hang in the church sanctuary. These consisted of hoops of tin in one or more tiers, with candle sockets soldered to the rim. The designs of various tin pieces have been applied to modern electrical features, and native tinsmiths have executed large tin-and-glass chandeliers for homes and public buildings.

Lanterns are made also, most of them copied from Continental models.

Recent years have seen a commercial revival of native work in tin and glass. Not only electric fixtures, but mirror frames, boxes, and trays continue to find a market. Since many tin articles are small, clever, and inexpensive, they attract the interest of tourists. Few of these items have any genuinely Hispanic antecedent, but Southwesterners with regional furnishings find them appropriate. Mexican imports are a stiff competitor, even though New Mexico craftsmen employ superior tin and better workmanship. Painted and combed glass, still made for jewel boxes, has survived as a decorative means of securing privacy to the windows of homes, bars, and public buildings. A coat of varnish or other paint, combed or scratched with designs, admits light while screening against prying eyes, a use inconceivable to the Spanish colonists, for whom glass was far too precious to risk in a window.

In pre-Hispanic times, Indians found raw copper and made it into dance-bells and other personal adornments. The copper and brass vessels used in well-to-do New Mexican homes were imported from Mexico or made locally from sheet metal processed elsewhere. Shapes and techniques were similar to those introduced to Mexico by Franciscans from Italy. Soldering of copper was not well understood in New Mexico, and repairs were made by riveting, often substituting iron. Copper and brass jewelry were worn by the poor and had great vogue among Pueblo and Navajo Indians before silver came into fashion.

The local *platero,* or silversmith, worked his metal with homemade tools. To melt silver, he built a small forge of adobe mud and stones, pumping air through it with a bellows

to make his charcoal fire glow. This bellows, which resembled a round concertina, was composed of two boards connected by a goatskin bag, with willow hoops inside for springs, and leather flaps for valves. A three-cornered cup made by a Pueblo potter served as the crucible in which the *platero* melted coins and scraps of silver. He poured the molten metal into clay molds to form ingots and the cursive shapes of cast ornaments. The smith made wire by hammering a rectangle of silver into thin ribbon, which he drew through successively smaller holes in an iron bar. Tiny bits of silver and borax were his solder and flux. He shaped a blowpipe from a strip of brass and produced a hot flame for soldering by blowing upon a lighted cotton wick soaked in grease. The hollow parts of spoons and beads he hammered in holes cut in a cottonwood block.

Silver rosaries with hollow beads and flat crosses were among the silversmith's most popular items, and by evolution these became the so-called "squash blossom" necklaces worn by Indians today. New Mexican ladies were more likely to go without shoes than without earrings, and the *platero* made these according to the wearer's ability to pay, from simple hoops of silver wire strung with one or more beads to lacy creations in silver filigree. Men were customers for tobacco canteens and powder measures of silver or copper. The jeweler also designed silver buttons to latch the dandy's slit-side pantaloons, sometimes linking pomegranate-shaped beads (the "squash blossom") with bits of chain, like cuff-links. A *ranchero* able to furnish sufficient silver might commission a heavy headstall and saddle ornaments for his favorite horse.

About a hundred years ago, the poor began to buy American paste jewelry, while the rich patronized the superb skill

of native goldsmiths. The fashion of silver ornaments gradu-
ally passed to Navajo and Pueblo Indians, who had learned
from the *plateros* how to make it, and in time brought such
talent to the craft that it has put the goldsmiths out of busi-
ness, and outsells all other jewelry in the Southwest.

Legal documents in Spanish reveal that a remarkable
amount of silver service was brought into New Mexico for
use in the church and on the tables of the well-to-do. The
pieces extant, notably in the Field Silver Collection at the
University of New Mexico, are mostly of eighteenth-century
vintage. Some articles bear Spanish hallmarks; many were
made in Mexico and Latin America. It is known that knives
and forks, and perhaps plates and drinking cups, were made
and repaired by *plateros* working in the Rio Grande Valley.
Severe simplicity characterizes Spanish colonial silver. Its
beauty lies in elegant proportion and fine patina, for incised
ornament is almost totally absent. The *platero* used silver
plate of unusual thickness, strengthening it further with ribs
and flutings, finishing the edges with moldings of one piece
with the body. The basic shapes are those most common in
European silver. Drinking cups are essentially beakers mod-
eled from medieval drinking horns, with handles added in
concession to a later fashion. The spoons and forks are some-
what larger and much heavier than those of today. Handles
are simple variants of the fiddle design, flat or turned up, and
bear a ridge down the center. Forks have three or four tines,
and spoon bowls are shaped like an egg or an elongated pear.
For plain masculinity and integrity of form, New Mexican
silver compares favorably with any made elsewhere.

"The gold and silversmiths excell all other workmen,"
wrote Davis in 1855, "and some of their specimens in point

of ingenuity and skill, would do credit to the craft in any part of the world." No less than two dozen New Mexicans who worked in gold filigree are known by name. Their work—precise, realistic, and intricate—was peculiarly attuned to the demands of the Victorian Age. The stylized birds, fish, and flowers created in microscopic gold wire had great appeal, not only to local ladies, but customers as far away as New York and London. Filigree is one of the oldest and most widespread of European arts. Germanic tribes are said to have brought the craft to Spain, where it is still practiced. Gold- and silversmiths made up the strongest medieval guilds, and it is interesting to recall that Lorenzo Ghiberti, long before he cast the famous bronze doors, was apprenticed to a goldsmith, and made pear-shaped filigree ear pendants like those fashionable in Santa Fe three centuries later. Aztec and Peruvian goldwork was admired by the Spaniards, who copied some of this New World jewelry. After 1850, many village goldsmiths worked for the local American jewelers, contriving fanciful brooches, bracelets, rings, and necklaces to order. Silver filigree was utilized in large pieces, such as card cases and tall combs, and it remains an important item in the souvenir trade of modern Mexico. By 1910, in keeping with the trend toward simpler dress, filigree was out of fashion, giving way to plain and heavy Indian silver.

The man with skillful fingers and an inventive turn of mind is still the village metalsmith, but today he applies his genius to the intricacies of gasoline motors.

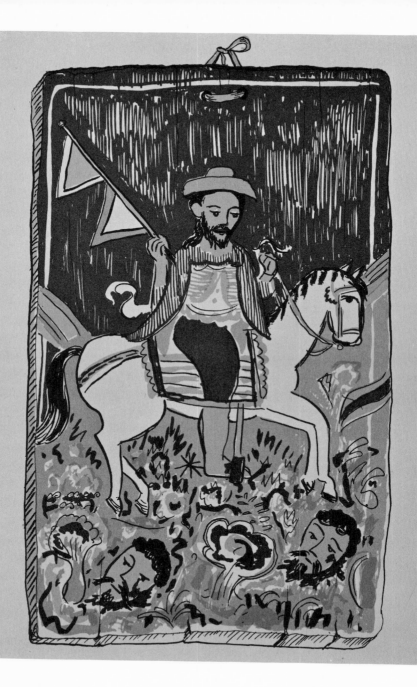

IV. HEAVEN on Earth

CHAPTER EIGHT SAINTS ARE PAINTED

"FEARFUL ARTISTIC abortions," was Bourke's first reaction to New Mexican religious portraiture, and many a Yankee visitor has been equally depressed by its lack of anatomic realism and technical finesse.

But John Bourke was a sympathetic historian, and he softened his judgment. "To the traveller," he wrote in 1881, "the greatest charm of New Mexico will be lost when the relics of a by-gone day shall be superseded by brighter and better pictures framed in the cheap gilding of our own time. Because New Mexico is so archaic, because in language, manners, and customs it differs so completely from our own people, and because its religious observances are so crusted over with a picturesque mediaevalism, or savagery, if you will, —the traveller endures uncomplainingly bedbugs, fleas, curoquis,—sand, grease and chili colorado."

And indeed, in these sixty-odd years, most of the little churches in New Mexico have given up their native arts in favor of "better and brighter pictures." Bourke would be

gratified to learn that at Trampas, the village he was describ-
ing, many of these "relics of a by-gone day" are still preserved.

Artists and antiquarians collect these waning folk arts of
the Southwest, and bring them increasingly to the attention
of the general public through exhibitions, photographs, and
writings. The word *santo,* "holy," already familiar in such
geographic connotations as "Santo Domingo," has taken on
special meaning in referring to New Mexican religious por-
traits in any medium—painting, sculpture, or print.

Santos, then, are the saints, divine persons and events of
the Catholic Church, as painted or carved in New Mexico.
Retablos are pictures by native artists, usually painted on flat
tablets or boards.

Oil and canvas were far too expensive for the artist of
the Spanish frontier, and it was natural for him to turn to
local materials. The European priests who came into the
Southwest were familiar with the techniques of painting on
wood with egg tempera. This method was popular in Europe
by the thirteenth century. Vasari's implication that egg tem-
pera predates oil painting has been questioned, though the
oil techniques perfected by the Van Eyck family became wide-
spread after 1550.

New Mexico had the necessary ingredients—wood for the
panel, gypsum to make a smooth white painting ground,
natural mineral colors, and egg with which to mix them.

The New Mexican *santero,* or religious artist, when he
wished to make a picture, hewed a slab of seasoned pine or
cottonwood into rectangular shape. He squared the edges
carefully, and thinned the top part of the back so the board
would hang flat when suspended by a leather thong. Some-
times a semicircular "lunette" formed the top of the panel,

patterned from the fluted shell of European niches for statues.

The artist then prepared his board to receive paint. Over the raw wood he spread a thin coat of gesso; *yeso* he called it. This he made from local gypsum rock, baked, pulverized, and dissolved in water. Animal glue, or less successfully, wheat flour, was added to the gypsum mixture to form a thick paste. The gesso dried quickly to form a hard, smooth, absorbent surface. A rubbing with fine sand evened the gesso coat, and a careful workman would build up several layers of gesso before painting. The final coat was given a thin wash of water containing egg or glue to hold the paint. Whether he used it or not, the materials of an early European formula for casein glue were available to the villager—goat cheese, lime, and water.

For his pigments, the *santero* pounded to powder various colored materials—charcoal for black, iron ochre for red, brown, and orange. Certain clays gave creams, yellows, and reds. For blue and green he depended upon the same dyes his wife used for cloth, but these were unsatisfactory and faded in the paint medium. The presence of clear blue or green on a *santo* is often an indication of oil paint, and therefore post-1850 application. The *santero's* palette was extremely limited, low in hue, and he betrayed little knowledge of the science of blending colors.

Pueblo Indians used oil pressed from squash seeds as a vehicle for colors made by pulverizing rocks. The village artist had various recipes. He could mix water and egg yolk, which contains an oil, with mineral colors to make a tempera paint, adding a bit of vinegar to keep the mixture from spoiling. Animal fats were unsatisfactory because of low viscosity, but pine resins dissolved in grain alcohol were a dependable

medium. The painter applied the colors to the gesso panel with a brush of yucca fiber, a feather, or chewed willow stick. Larger areas he painted in with swabs of cloth or wool. The painstaking artist protected his finished work with a coat of egg yolk, thinned with water. Some artists used a native spirit varnish made of resin in alcohol.

More of a cartoonist than a colorist, the New Mexican painter drew the main outlines of his picture in black or brown, forming silhouettes which he filled with color. He did not understand the principles of shading and highlights, and linear perspective was beyond his ken. He used color in its simplest terms—dark and light contrasted. The face and hands, and the lower limbs, if the saint were male, he rubbed with sallow color, then sketched in such details as the features and the digits. He added the necessary identification—a halo, a skull, a Franciscan cord—in dark color if they fell against the light background, in light color if they were set against the somber robe.

Ecclesiastic dictates finished, the painter was free to embellish the picture as his skill and imagination prescribed. He might labor over the crenelations of the Virgin's crown, or suggest the rich embroidery of her dress with loops and pendants of color. He gave St. Joseph a neat Van Dyck, and laced high the military sandals of Archangel Michael. He dwelt upon the emaciated anatomy of Christ Crucified and reddened the sacred limbs with streams of blood. The decorative elements, the border and corner designs, he drew in his own way.

For a model, the artist chose a wood engraving from the priest's books, a framed print, or an imported canvas in the

village church. After Mexico revolted from Spain, the New Mexican churches received fewer refinements, and the colony became increasingly dependent upon religious art made locally. This sharpened the development of a New Mexican style, for one *santero* copied from another. Always the *santero* simplified patterns, incorporating his own ideas. Inevitably he recorded faces, costumes, and everyday objects from the life around him, transfixing them with religious formality.

The *santero* was not a painstaking copyist, and he abhorred geometry. His accuracy depended upon the limited tools and materials with which he had to work, and his own skill as a draftsman. The finished *retablo,* therefore, was a freehand composition in the spirit of the original model.

The first *santeros* in New Mexico, as in Mexico, were missionaries and priests. Supply caravans were slow and infrequent, and there was never enough ecclesiastic art to satisfy the great demand. Busy as they were, the men turned part of their talents to the reproduction of pictures and statues to help their congregations understand the messages of Christianity.

The efforts of these priest-*santeros* must have gone mainly into the decoration of churches, especially Indian missions, but the homes of the faithful were likewise in need of sacred reminders. To meet this latter demand, certain laymen with

skilled hands worked under the tutelage of the priests, and learned to paint and to carve. These artists, professional in the sense that they earned their living thus, and passed experience on to their sons, traveled from village to village, selling homemade *santos,* and taking orders for others.

Some of these native *santeros* were commissioned to decorate churches, and their best work may be seen in the Santa Cruz Valley of northern New Mexico. Like most New Mexicans before 1850, very few of them could read and write, and only two or three are known by name. Several are recognized by characteristic tricks of style, and are identified as "the chile painter," or "the Santa Cruz School."

For the subject of his *retablo,* the artist chose a saint popular in New Mexico and appropriate to the occasion. The person for whom the picture was made might wish a portrait of the patron saint for his birthday. Likenesses of St. Michael were suitable for San Miguel Parish. Sometimes an emergency or a personal experience prompted the selection of a saint. St. Isidore would help a farmer. *Penitentes* preferred crucifixes and Santa Rita. The bereaved needed Our Lady of Sorrows, and the power of the Holy Family or the Trinity could be counted on in any event.

Every devout Catholic needed these religious portraits to remind him of his friends in Heaven, much as photographs serve to refresh remembrance of our mortal friends. Concentration upon daily devotions was made easier, and it was a great comfort to feel the presence of a saint in the house. It was an act of piety to copy a *santo* with one's own hands, and in New Mexico the art became almost as popular as rural American whittling.

Because *santos* were an integral part of the daily life of the

people, simple portraits and manifestations of the divine persons were preferred to historical scenes. St. Francis was depicted standing alone, identified by a skull and a knotted cord, rather than preaching to the birds. A straightforward portrayal of the Holy family—Mary and Joseph solemnly holding the hands of the Child—was more appealing than such a composition as "The Nativity," with its distracting elements of animals, shepherds, and Wise Men. The technical difficulties of reproducing a complex work of art may have required this simplicity of theme, but Mitchell Wilder has suggested that in a historic tableau, the saints are busy with matters of their own, and it would be impolite to interrupt the scene with one's private petitions. The villager, therefore, preferred his *santos* singly in the attentive attitudes of listening to the beholder or addressing their thoughts to God. The documentary decoration of European churches was planned by sophisticated artists for an audience sated to the point of needing novelty in Christian art.

The ideographic drawing in New Mexican *retablos,* broad curving strokes and outlined shapes, was influenced strongly by the wood engravings which had wide circulation in the Spanish colonies. The fragile nature of wood under printing pressure, long ago taught engravers to thicken their lines and simplify all the aspects of their drawing. The Spanish and Mexican artists who printed multiple copies of religious art, took their themes from contemporary paintings and sculpture. The *santero* of New Mexico thereby received some of his pictorial ideas already stylized in a form he could follow. Using standard symbols rather than individual representations, he quickly picked up the conventions of oval face, almond eyes, single stroke for eyebrow and nose, parentheti-

cal kneecap, and parallel loops for drapery folds. The artist
had difficulty in drawing hands, but often he achieved delicate
and sensitive gestures. Sketching the feet required even more
skill because of the foreshortening involved. Intuitively he
finished his *retablos* with lines and spots of color to give them
a pleasant balance. In the barren corners of his pictures he
drew peek-a-boo curtains, a convention derived from the
draperies put on saints' niches so the figures could be
shrouded during Holy Week. As is characteristic of European
art, the *santero* enclosed his compositions with a border.

Because larger boards were difficult to obtain, an average
painted plaque might measure fourteen by twenty-one inches.
There were, however, no standard sizes, but the proportion of
length to width was esthetically pleasant. Households often
had one or more portable *retablos* about the size of a child's
speller. When the shell-shaped lunette was a part of the *retablo*
board, it varied in size, being sometimes the same diameter
as the width of the board, and sometimes smaller and centered
above the picture. Different *santeros* treated the shell pattern
in various ways, by gouging out the fluted sections, raising
them with gesso relief, or simply painting half a scalloped
wheel. Whether plain or carved, the design was usually
painted in contrasting colors. The arc of the lunette might
be smooth or cut in scallops, but otherwise the perimeter of
a *retablo* board was straight-edged and unbeveled. Circular
and oval *retablos* were rare; the rectangular shape was the
usual choice.

Logically, the largest and most professional of New Mexi-
can *retablos* ornamented churches. Panels, a yard or more in
area, were made by fastening several boards together with
pegs and glue. The painting was done with a boldness com-

mensurate with the size. Such pictures often were framed in groups to form a reredos behind an altar. Saints popular in the community, with the patron saint in the center, were selected for these altarpieces. Good examples may be seen at the Santuario in Chimayo, in Trampas, and in the large church at Santa Cruz. A reredos in similar style, as well as statues, painted hides, and other examples of native religious art, is on exhibit in the Palace of the Governors in Santa Fe.

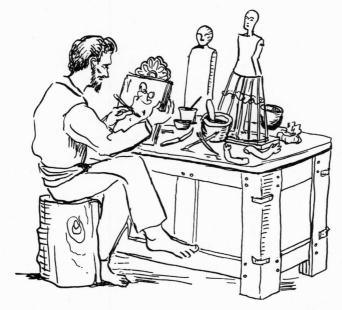

The moldings which make up the framework of a reredos are always interesting for the details of their design, for New Mexican craftsmen often carved and painted these supports in imitation of twisted stone columns and sculptured relief. In the reredos is found the most rococo of New Mexican art. Vacant spaces in the *retablos* often received lush treatment in

exotic flowers and swags of drapery, always more subdued, however, than their Spanish and Mexican forerunners.

Some of the reredos frames made locally were designed to hold imported paintings, as in the tall central altarpiece at Santa Cruz. These more polished paintings were sent up from Mexico at the request of missionaries, and in the late eighteenth and early nineteenth centuries, wealthy patrons commissioned non-local artists to work for New Mexican churches. In a few cases, as for the stone reredos in Santa Fe, the artisans came to New Mexico to execute a particular work, and perhaps obtained additional assignments.

Benavides, preparing for his official visit to New Mexico in 1624-26, shipped "Five oil-painted images, with gilded and ornamental frames, 2½ yards high by 2 wide." Evidently the canvases were rolled and packed in large boxes. Most of the early pictures must have been destroyed in the Pueblo Insurrection of 1680, but church records, and the eighteenth and nineteenth-century oils still to be seen in older chapels show that New Mexico was not entirely isolated from European art. One hears of "genuine Murillos" and other European masterpieces reposing in New Mexico churches. There is little evidence that other than second-rate copies found their way into this area. However, many of these foreign paintings are worthy of notice both for the historic record and their own esthetic values. Some, at San Miguel in Santa Fe, for example, have been so much retouched as to lose their original characters. Others, as in Isleta, are so damaged that study is difficult. The large canvases in the churches at Socorro and Tomé are in good repair, and reasonably typical of the art which came into New Mexico from the Latin world. A careful photographic record and x-ray analysis of these imported

oil paintings would provide a valuable chapter in the art history of the Spanish colonies.

Without doubt, the foreign canvases in oil influenced the iconography of New Mexican *santos,* but lacking subtly graded colors and formal education, the local artist found them difficult to imitate. Left to his own devices, the native *santero* invented an art form that was not only esthetically satisfying, but was appreciated and understood by the people among whom he lived.

The first explorers noted paintings on cloth in the cotton *mantas* of the Pueblo Indians, but like many other Indian arts, the technique seemingly was not copied by the Spanish colonist.

Among the oldest and most proficient of New Mexican arts are drawings on the skins of buffalo, deer, and elk. Because painted hides were a highly developed art form among both Plains and Pueblo Indians—masks, shields, and pictorial compositions—many students have credited *santos* painted on leather to Indians. Nevertheless, craftsmen in Spain were celebrated for their skill in painting, dyeing, and gilding leather. Religious subjects were frequent in fourteenth and fifteenth century leathers, the outlines being stamped or burned and the spaces filled with paint. The Spanish tooling and stamping of leather was to influence Navajo silversmithing late in the nineteenth century. Certainly Spanish painted leather came into the Southwest on shields, saddles, chests, and book covers. The drawing of the *santos* on hide is akin to seventeenth- and eighteenth-century engravings, and their close attention to detail indicates the supervision of an educated clergy. In some cases the lines are burned into the hide with hot irons, a process not unlike branding. E. Boyd, in

her book *Saints and Saint Makers,* makes an analysis of paint-
ings on leather, based on the collection of the Museum of
New Mexico and the few examples remaining in churches
and private hands. She concludes that many were done by
Spanish craftsmen in New Mexico. Undoubtedly the inher-
ent durability of tanned skins helped to preserve them longer
than the fragile gesso-and-tempera *retablos.*

Various techniques are found in *retablos.* A few *santeros*
built up salient portions of their paintings with gesso, model-
ling in low relief the face, hands, and the costume. This type
was known in Italy, and much copied in the rococo period of
Spain and Mexico, where it was accompanied by gold and
brilliant color. Gilding seems not to have been done in New
Mexico during Spanish times, and the presence of luster on
a *santo* is an immediate index of importation or recent refur-
bishing. Several older pieces, notably the San Miguel at Tay-
lor Museum, have been touched up in recent years with
metallic paints of American manufacture. The collector occa-
sionally finds a painting done on a sheet of tin. In most cases
both the style and pigments indicate origin in Mexico, where
ex votos, or commemorative pictures fulfilling a vow, were
painted on tin and hung in the shrine of the saint to whom a
miracle was attributed. The use of tin normally indicates the
last period of New Mexican arts.

Although most *santos* portrayed specific holy persons, sym-
bols were sometimes reproduced. The cross was used in all the

arts—paint, sculpture, and textiles—and in designs varying
from the cross of Malta to the cross of Jerusalem. The Sacred
Heart, in chile-red on a cream ground, was a favorite subject
for small domestic *retablos*. On either side of the principal
altar in the Santuario at Chimayo are painted panels of
wheat and grapes—the Bread and Wine of the Sacrament.

The Holy Dove, its wings outspread, beams of light radiat-
ing from its body, often appears ascending or descending
in an altarpiece lunette, or fixed like a tattoo on the breast of
a personified representation of the Holy Ghost.

Angels could serve as decorative Christian symbols, since
they represented no specific divinity. Often sketched as no
more than a round face and stubby butterfly wings, the New
Mexican *angelitos* were a far cry from Raphael's cupidlike
putti. Secular subjects are virtually unknown in *retablos*,
although a single example exists in which the design of a
classical Roman bust has been reproduced in paint.

Slow to stand on its own feet as an art style, the *santo* school
seems to have reached a peak of originality and freedom by
the first quarter of the nineteenth century, and to have fallen
into progressive decadence under the importation of mass-
produced pictures and statues. By 1880, there was no place
for the professional *santero*.

Art history still suffers from the standards of technical
perfection, heightened realism, and moral values demanded
by the Victorian critic. Measured by these pseudo-intellectual

criteria, the *santos,* and the whole realm of folk arts, do not toe the mark. But the present generation of critics is more kind, and recognizes in New Mexican religious art the simplicity of line, intensity of emotion, and inherent decorative sense that many modern artists strive to express.

The artists who created the *santos* distilled in paint and sculpture the religious emotions of their people. With local materials, they perfected a distinctive regional style which was esthetic, imaginative, and meaningful.

CHAPTER NINE
SAINTS ARE CARVED

SCULPTURE IS MORE REAL than painting in its dimensions, and statues are a point of intimate contact between the devout and the inhabitants of heaven.

The New Mexico villager colored his carvings of saints to heighten the impression of realism. As in Greek and Gothic sculpture, the artist painted not only the eyes and hair, but the details of the costume. He sometimes affixed real hair, and eyes of painted mica. His wife made clothing for the statue, following the current styles.

In technique, sculpture was essentially the same as that of painting—wood overlaid with homemade gesso and painted in tempera colors.

Carved *santos,* or representations of holy persons, were

called *bultos*. Rarely was a *bulto* sculptured in all its details from a single block of wood. Using a knife, the artist roughed out the torso from a section of cottonwood root. He carved the head and arms as separate pieces and attached them to the body with wooden pegs and animal glue. He whittled the attributes from sticks of pine and glued them in place—a toadstool halo for St. Anthony, daggerlike flames about the Guadalupe, a tiny lamb for St. John. A plank of pine or cottonwood made a substantial base, and the sculptor left pegs on the bottom of feet or skirt to cement the statue in position.

The *santero,* or artist, made plaster of paris from local gypsum to complete the form of a statue. He spread a thin coat of this gesso plaster over the entire figure, molding it with his fingers into ears, beard and hair, eyeballs and nose, hands and feet. He suggested the outlines of clothing and hid the joints where the limbs were attached.

When the plaster had hardened sufficiently, the sculptor used his knife to sharpen the features, the cut of the beard, the style of the clothes. He smoothed the broad areas with a pumice stone and fine sand.

At this point the *bulto* was pristine and white, like an alabaster figurine. To make it as convincing as possible, the *santero* painted it. The painting of wooden statues was customary in Spain, where a similar gesso technique was used, and prominent painters were hired to color the figures in a realistic manner. The *santero* prepared the same medium that he used to paint *retablos*—powdered mineral mixed in egg yolk to form a tempera. With a swab of wool he blocked in the dark areas of the costume, using brown, red, or black. With a soft pointed stick or a brush of yucca fiber he sketched in the arched eyebrows, the wide, staring eyes. He left the flesh

areas white, or tinted them tawny cream. Alternating dark on light and light on dark, the artist suggested the details of the costume—knotted cords for Anthony and Francis, a lace surplice for Xavier, military jackets for the archangels.

Most statues were conceived as a whole, taking into account the necessary steps in technique to achieve a unified piece. The flowering staff slid neatly into St. Joseph's fist, and the figure of the Christ Child was notched behind and fitted with a little peg to attach him securely in his mother's arms. Gesso plaster was fragile, and knowing its limitations, the *santero* kept delicate surfaces to a minimum.

Emotional effect rather than accurate anatomy was the prime consideration. A saint was portrayed with a stiff frontal attitude, his feet, often quite large, were planted firmly under him. The arms, bent at the elbow, were held in expressive attitudes. The figures in a group rarely look at each other; both Mary and the Holy Child stare wide-eyed at the beholder, and in the San Ysidro composition, the saint, the angel, and the oxen all meditate on space like Egyptian carvings. The eyes are immense and hypnotic.

As indicated by the Old Testament, and in pagan and Christian documents, it has long been the custom to carry religious symbols in public processions. European statues of hard wood were hollowed out on the reverse side to decrease their heaviness. The statue of the Virgin, La Conquistadora, which De Vargas is said to have brought with him to the reconquest of New Mexico in 1692, has a hollow center.

Cottonwood, preferred to pine because it carves without splintering, is very light in weight. This problem of portability was also solved in other ways in New Mexican sculpture. Some *santeros* preferred to carve the bust in wood, and to

suggest the dress from the waist down with a wicker frame, not unlike a dressmaker's dummy. Leather, or cloth wet with gesso, was stretched over this frame, and painted to tie in with the remainder of the figure. Suggestion may have come directly from the once fashionable farthingale, its name derived from the Spanish *verdugado,* or skirt with hoops made from green willow shoots. This method was especially effective for the Virgin and the female saints, and with St. Francis and other holy men usually shown wearing a robe. The technique, incidentally, solved anatomical problems. The figure was based firmly by cementing the splint-ends into holes in a board. A dress so made was often wide and flaring, and offered a large area to be painted imaginatively with flowers and other textile designs.

As in Europe, large statues in New Mexico could be equipped with poles for convenient carrying. Smaller pieces were set in wooden bowers, or *nichos,* to be carried by one person. Fiestas and religious celebrations were not the only occasions the saints saw the open air. Little statues and paintings were often carried from the church to private homes for the comfort of the sick and the dying. A candle or a lantern was borne before the *santo,* and hymns were sung to accompany it.

Bultos tended to be tall, slender, and regal in posture. On both male and female figures, the waistline was small and the line from waist to toes elongated, with the chest quite short. Shoulders were often rounded and narrow, arms small, and heads abnormally large. These departures from conventional anatomy added emotional strength to sculpture, and focused attention upon the face of the saint and his position of dignity.

Composition followed various elementary patterns. The "columnar" type was tall, compact, and neatly balanced,

resembling a piece of lathe-turned wood. It was often set upon a round base. Somewhat similar, but less pronounced in its relation to a central axis, was the *bulto* carved with deeply indented skirts, swags of drapery, and a pronounced bosom. These two forms seem to have been influenced by the round shape of the logs from which they came.

A "flat" type statue had its proportions determined by being cut from a thick, rectangular board. Almost invariably such *bultos* had wide flaring skirts, the width from side to side three or four times the depth from front to back. A primi-

tive perspective was introduced by shortening the hemline at either side. In portraits of the Immaculate Conception, the Virgin's skirt repeated the contours of the upturned crescent moon on which she stood. However, *bultos* made by the "wicker" method always had straight hemlines, as it was necessary to fasten the willows firmly into a flat base.

In the "columnar" type, the emphasis was upon sculptural interest, while the wide expanse of skirt on the "flat" type made it an ideal space for painted decorations.

More complex was the free-standing figure in which the legs were unclothed—always a male saint. These figures often were given the extra support of a small post at the rear

of the base. Other involved sculpture included saints accompanied by animals: St. James, who is astride a horse, and St. Roch, whose knee is licked by a dog. Animals are portrayed with considerable realism, but size is on the basis of importance, for St. James is many times taller than the horse he rides, and St. Isidore would outweigh three of his oxen.

The simplest groups were those in which the Christ Child is held in the arms of His mother or one of the saints such as Joseph or Anthony. Like early figures of the Virgin in Spain, as at Rábida and Guadalupe, the Christ Child, overlarge because of his spiritual importance, did not fit smoothly into the composition, but was carved separately and attached in a practical manner. The Child sometimes gave the appearance of being held at arm's length, not cuddling against the protective bosom of sentimental Madonna sculpture.

Groups of figures were usually placed in a parallel row facing the spectator. An example is the Holy Family, in which Jesus is a half-grown child standing between the outstretched hands of His parents. Such a youth, which Wilder has compared to the Apollo in art, is known as *El Niño Perdido* when he stands alone—the Lost Child who is Christ in the Temple. A three-figured *bulto* is the Trinity, which takes the form of a stalk with three branches. God the father is in the center, flanked by Jesus and the Holy Ghost. God, sometimes identified by the blazing sun symbol, lifts His hand in the gesture of benediction, while Christ is marked by a cross or a lamb, and the Holy Spirit by a dove. Their robes blend at the skirt to form one.

The statue of Christ in Burgos Cathedral is popularly supposed to be of stuffed human skin, because the wooden anat-

omy is covered with white buffalo hide donated by a pious Conquistador. Long human hair falling over the shoulders adds to the conviction. Likenesses of Jesus, large enough to be appreciated the length of a church, were favored by Spanish missionaries; Benavides brought to New Mexico "Two figures of Christ, on wooden crosses, a yard and a half high."

Perhaps the most realistic of all New Mexican sculpture is the Crucifix. Here the Spaniard's overwhelming sense of tragedy and pain finds its sharpest expression. The pieces have the stark drama, the high color, and the delicate attenuation of the *Crucifixion* by El Greco in the Louvre. Often much larger than other sculpture, the Man of Sorrows received the *santero's* most ardent efforts and devotion.

The *santero* carved separately the arms, the legs, and head of a crucifix, and then attached these to the torso. The arms could be joined to the shoulder with strips of leather or cloth, so they could be moved. By this device, the same statue, during Holy Week, portrayed successively Christ in Torment, Christ Crucified, and the Deposition. For the first tableau, the statue was clothed in a Franciscan robe and the hands tied with thongs. For the second the hands and feet were fastened to the cross with wooden pegs. After the agonies of Black Friday were recited, the statue of Jesus was taken from the cross, laid in a bier and carried in a mourning procession.

These movable, puppet-like *Cristos* approached life size, and were made chiefly for *Penitente* communities. Smaller crucifixes normally followed the conventional technique of attaching the limbs with pegs and glue, and hiding the junctures with gesso and paint. The construction of a crucifix presented many problems to the artist. The size and shape made it necessary to use many pieces of wood, which would

hold together securely when the *Cristo* was suspended upon the nails of the Cross.

The face of Christ was the supreme achievement of the *santero*. The tortured dignity of *Ecce Homo* supplied the theme, and in an ecstasy of sympathy, the artist spared none of the cruelty, and lost none of the conflict between suffering and forgiveness.

Narrow planks were grooved at the intersection to form the Cross, with the top part much shorter than the arms. The ends of the Cross were often cut into decorative knobs or points, and some santeros liked to paint the Cross with decorative patterns. More rarely, small crucifixes were set in a base, accompanied by little figures of Mary and St. John.

Also known in New Mexico is the crucified figure of a saint in uniform, accompanied by two soldiers and the military drummers of execution. Known locally as *El Buen Ladron* (St. Dismas, the Good Thief), this group is a mislabeling of the Roman saint, Acasius. A somewhat similar example is "Santa Librada," a crucified woman with the curious history of confusion with a robed Spanish crucified Christ, which was identified incorrectly in the Netherlands as a female saint.

In former times, the rich robes of the Virgin of Guadalupe were changed by the Queen of Spain herself. In all Latin countries it is customary to present clothing to favorite statues of the saints, along with jewels, medals, and money, according to the wealth of the admirer. Examples may be seen in the Indian Pueblos of New Mexico today, where favorite *bultos* have many dresses, one over another, and gifts of beads and turquoise. La Conquistadora, the patroness of Santa Fe, has an extensive wardrobe, and in the remote villages the Virgin is dressed according to the means and piety of her devotees.

As in Spain, Christ on the Cross sometimes has His loincloth decently covered by a short skirt, and Christ in the Tomb has the funeral paraphernalia of little silk pillows and a lace pall.

In spirit, New Mexican sculpture suggests the Gothic carving of southern France and Spain, with its underlying base of Byzantine art. During the eighth and ninth century iconoclasm, artists of Byzantium fled the scourge of the image-smashing emperors, carrying their talents to France, Italy, and Spain, bringing the influence of that art to those countries. We find in the *bultos* the same ascetic faces, with high foreheads, long noses, and tiny mouths, and enormous almond eyes. There is the didactic posture, and the arrangement of clothing with little regard for supposed anatomy beneath. One finds the stiff, unnatural posture and the dignified reserve by which Byzantine artists distinguished the immortals from ordinary men.

The emphasis in *bultos* was upon emotional and symbolic values—the virtues of the particular saints, rather than their physical presence. Nevertheless, the *santero* endeavored to achieve realism within the limits of his style.

A variety of materials was used to make the attributes which identified the saints. Crowns were carved of wood in various forms, the older ones usually in the shape of the ermine-type crown, with four bands curving inward to a cross or knob on top. Others were simply pronged or crenelated models. Tin, silver, and even gold, were cut into crowns, as well as sword, balance, and fish for archangels. In the late period, staves and shepherd crooks were fashioned of wire. Leather was braided for the Crown of Thorns, and the quirt and lariat of Santiago. Baskets for the Child of Atocha, globes and hearts for Christ

and the Virgin, crosses for St. John—these were carved of
wood and perhaps coated with gesso and painted.

"The earliest stone carving of religious significance in
America," is Mary Austin's estimate of the great stone altar-
piece of 1761 which is the principal ornament of the church
of El Cristo Rey in Santa Fe. This reredos was designed for
the Castrense, or Military Chapel of Santa Fe, which fell into
ruins about 1830. When the Castrense, which was on the
south side of the Plaza, was sold in 1859, the stone was moved
to the site of the Cathedral; Fray Angelico Chavez sug-
gests that Archbishop Lamy may have intended the altarpiece
as a unit of the new building. Eighty years the reredos
remained at the rear of the Cathedral, concealed for much of
this time in a religious museum. In 1940 it was given a
special setting as the chief decoration of El Cristo Rey, a new
church built in the east section of Santa Fe, with architecture
following appropriate seventeenth century mission lines.

The altarpiece was carved from several large pieces of lime-
stone obtained near Pojoaque which were assembled to form
a unit thirty-five feet high and eighteen feet wide. It was
planned to include seven panels of religious portraits in bas
relief, each surrounded by florid stone moldings.

The top of the reredos is crowned by a semicircular panel
carved with a representation of God the Father. Immediately
beneath is depicted Our Lady of Valvanera, whose fame stems
from a tenth-century miraculous image of the Virgin, discov-
ered in a nest of wild bees in a hollow oak. Three portraits
compose the central section of the altarpiece, the middle octa-
gon displaying the dramatic figure of St. James riding down
the Moors on his white war horse. A pair of caryatids—and

very Aztec maidens they are—separate St. James from St.
Joseph and St. John of Nepomuk. The lower lateral division
consists of two panels—St. Francis Solano, known for his con-
version of the Peruvian Indians, and St. Ignatius Loyola,
founder of the Jesuits—on either side of a large niche just
above the altar table.

This central niche seems to have been designed originally
to hold an oil painting of Our Lady of Light, mentioned in
early records, but missing for many years. When the altar-
piece was installed at Cristo Rey, a sculptured stone rectangle
similar in technique was fitted into the niche. It is the same
piece Lieutenant Abert observed on the Castrense in 1846:
"In the façade above the door there is a large rectangular slab
of freestone elaborately carved. It represents 'our lady of
light' in the act of rescuing a human being from the jaws of
Satan, whilst angels are crowning her; the whole is executed
in basso relievo." The stone is not of correct proportions for
its present station, and leaves a conspicuous blank at the top
of the niche.

Wide entablatures, with richly carved friezes and keystone
medallions bearing cherubs, divide the reredos into sections.
Large stone fans, sculptured with angels lifting baskets of
flowers, form the upper right and left corners of the altar-
piece; these once had ornate finial borders, which disappeared
late in the last century. The base of the altarpiece bears oval
tablets with the year, 1761, and the names of the donors
responsible for its erection: Don Francisco Antonio Maria de
Valle, Governor and Captain General of New Mexico, and
his wife, Dona Maria Ignacia Martinez de Ugarte.

The pictorial panels in the Cristo Rey reredos have a dis-
arming simplicity, but the decorations and borders are in a

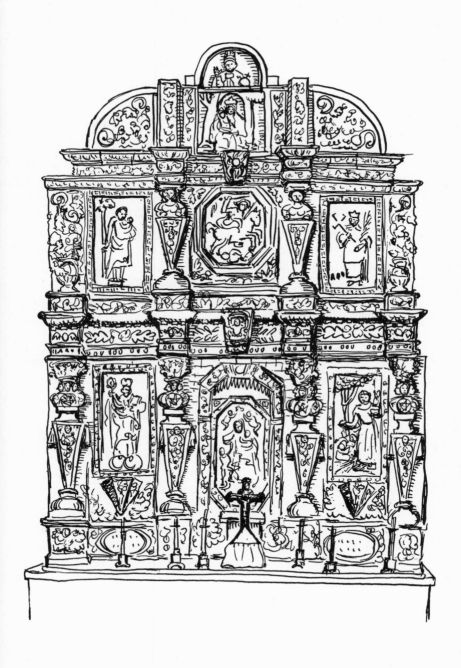

feverish arabesque. It is as if the portraiture and the framing were done by quite different artists—as was often the case. Because of the skilled execution, and the absence of similar examples in this area, it is believed that sculptors were imported from Mexico for the work. In its elaborate composition, and the weight of detail, the reredos echoes the pattern of churches in Old Mexico.

The stone altarpiece was once painted in natural colors, but has faded to mellow tints. El Cristo Rey Church has been designed with extreme simplicity, and light from a concealed clearstory window makes the stone reredos its focal point. The walls are of adobe color, relieved with Stations of the Cross framed in tin. The reredos is representative of a very lush architectural period, and though it clamors for color, it would look garish to us if restored to its original eighteenth century gaiety.

The Museum of New Mexico has on exhibit a section of architectural stone shallowly carved with religious emblems and an inscription. It is quite different in style from the Cristo Rey reredos, being intaglio rather than bas relief. The piece is incomplete, and as it was once a part of a postoffice wall, a letter slot is cut through it. Similar stone tablets are found now and then as an ornament of a church or public building; there is one above a doorway on the plaza of Tomé. Intaglio inscriptions, crudely lettered, also occur on the wooden doors and ceiling beams of churches, as at San Miguel in Santa Fe and El Santuario in Chimayo. Less formal are the examples of the tourist's impulse to be remembered in a strange land. New Mexico's caves and cliffs record visits from Spanish Conquistadors and American Dragoons, the names chipped upon far older Indian petroglyphs. The skilled en-

graver rarely wasted his time on such out of the way exhibits, so that most of these inscriptions reflect the customary handwriting of amateurs, begging to have their names and the year of their adventure spelled out by generations yet to come.

Penmanship was an art largely restricted to priests, governmental officials, and military clerks, who were proud of their ability to make huge capital letters and intricate rubrics. Many of the earlier church records are introduced by marginal quill drawings of flowers, fruits, and religious symbols. The first missionaries brought "Genoa paper," but under Armijo, the tyrannical governor ousted by Kearney's forces, all paper bore an official stamp and a tax of eight dollars the sheet. Three centuries in the history of lettering styles may be traced in the names and messages carved on El Morro Inscription Rock, beginning with a Spanish uncial scrawl naming Don Juan de Oñate and the year 1606.

There is an abundance of suitable stone in New Mexico, yet very little of it became sculpture during Spanish times, for very good reasons: the lack of proper tools and proper training. During the construction of the present Cathedral, begun in 1869, handsome capitals and other decorations were carved in stone, but by professional stonecutters brought from elsewhere.

The making of *bultos* decreased steadily after 1850, since artists were unable to compete with the importation of more realistic sacred statues in tinted plaster of paris. By 1885 there were only a few *santeros,* and these no longer followed the strict technique of the old tradition.

Celso Gallegos, of Agua Fria, earned a considerable reputation about fifteen years ago for his fanciful carvings of birds and animals, and his simple religious figures. The Lopez

family, of Cordova, also worked in wood, and does today. Utilizing the natural beauty of white pine and red juniper, the Cordova craftsmen ornament the surfaces with delicate floral and geometric intaglio. They play upon the element of contrast, placing a white *Cristo* on a red wooden cross, and cut deeply into the wood to make the designs stand forth. The Lopez creations still bear some resemblance to the *santos*, but are fine examples of unspoiled modern sculpture, characterized by grace and direct expression.

Patrocino Barela, of Taos, whose work was sponsored by the Federal Art Project, gained national notice for his crude but powerful sculpture. His pieces have a strong resemblance to African carvings. He was influenced by old *bultos,* and by the stories of the saints which every New Mexican hears. Barela has a mystical turn of mind, and his elaborate chisellings in juniper take the form of narratives. He tells little stories, and interprets them in wood. These notes are extracted from his explanation of a large six-figured sculpture in wood:

"The heart of man is always worried and always thinking hard. But when a man finds himself in this stage of life, he does not mind, for the Woman with her right hand makes him forget everything—making him so confused that he does not know whether he has changed places with his head and feet. This figure represents the same body leading a bad life—a life of impurity—and in this way neither one is really happy. The bell represents the Woman—only once is she dragged into sin—then she keeps on and on."

Of these contemporary native sculptors, none seems to have worked in gesso, preferring to finish the details in the wood itself. They rarely use paint to heighten the effect. Because these men create highly individual pieces, straying from con-

ventional iconography and even doing non-religious themes, they should not be labeled as *santeros,* but as imaginative artists, only slightly warmed by the dying embers of the *santo* tradition.

Under the auspices of the Works Project Administration, a large number of *retablos* and *bultos* were reproduced for museum use and general public exhibition. Juan Sanchez, a young native sculptor, was employed for this purpose, imitating the technique used in older pieces. Another artist has copied a series of *santos* for the Museum of New Mexico. Perhaps more than any of the New Mexican arts, the antique *santos* have been of interest to museums and private collectors. The Pueblo missions and the more remote Spanish villages have kept much of their original religious art. Several hundred authentic *retablos* and *bultos* are thus preserved.

Secular sculpture, as we know it in the form of portraits and fanciful figures, was virtually non-existent in New Mexico. It was, in fact, seldom made in the Medieval world, except where it cropped out in the disguise of misereres beneath choir seats, and in the portraits of kings and noblemen on tombs and the columns of churches.

The native sculpture of New Mexico was religious in theme and formal in execution. Its materials were cottonwood and pine, the members carved separately, attached with pegs and glue, and modelled in detail with a coat of gesso plaster.

To increase realism, the figures were painted with tempera colors, and often dressed in cloth. In size, the statues ranged from household *bultos* no larger than one's hand, to life-size *Cristos* intended for the church. The saints were portrayed as slender and regal. The focus was upon the face, which was wide-eyed and austere, suggesting Byzantine and Gothic.

The men who made the *santos* lived in a hard and lonely land. They came of a religion which held out for eight centuries in constant jeopardy of extinction by the Moors. Their art glowed with the singleness of devotion and starved desire that is called asceticism.

CHAPTER TEN **J.M.J.**

J. M. J. THE CHILDREN write on corners of examination papers—"Jesús, María, José."

Here, as in every Catholic region, the Holy Family and the saints are earnestly implored in every crisis. Each saint has his sphere of special efficacy, and the language is rich with deference to holy persons.

From the Guadalupe Mountains to the San Agustin Plains, from the San Juan River to the Santa Rita Copper Mines, Southwestern geography is an index of popular saints. Cities and towns, too, are commemorative, usually named from the saint's day of their founding.

Devout families refer to an almanac of Church celebrations

so that children may be baptized under the guardianship of the holy personage on whose festival they are born. Lists of saints' days have been used by Christians since the beginning of the fifth century, and one of the earliest, the *Martyrologium Hieronymianum,* was compiled from the calendar of saints of the Eastern Church and the religious festivals of Italian cities. The faithful were informed as to the deaths of Christian martyrs and the disposition of their bones. The Church has usually chosen the day of the saint's death for celebration, as the day of his "birthday into heaven."

Like many present-day almanacs, patent medicine companies sponsor those in Spanish distributed to the New Mexicans. A locally popular brochure advertises the virtue of "Guadalupe Liniment," and along with the aspects of the moon and the signs of the Zodiac, one finds the name of the saint for whom each day is set aside. Not without reason is one's given name called the "Christian" name. It is still the custom to bless each Latin child with the name of the patron saint of his birthday. Those named Lorenzo, for instance, will share the celebration of St. Lawrence's Day on the tenth of August.

Sometimes the birthday coincided with an important Christian event, and accounted for such usual names as Epifanía, Asunción, Pascual (Easter), and Trinidad. W. H. Hudson has reported a South American child named Circuncisión, who would, of course, have been born on New Year's. A boy born at the celebration of a female saint might have María or Guadalupe in his signature, but his friends would call him by one of several masculine appellations he inherited from his godfathers and grandfathers.

Every Christian community of long standing develops its

own favorite stories of miraculous happenings, its own inter-
pretations of religious literature and ritual. Divine interces-
sion was described in accounts of the first explorers of New
Mexico, and it occurs over and over in the folklore that has
built up in the three and one-half centuries since Oñate
founded the first colony.

Among the early religious miracles associated with the
Southwest is the story of a Spanish nun. According to Mother
María de Jesús, Abbess of a Franciscan convent at Agreda,
Spain, she was divinely transported to New Mexico many
times between 1620 and 1631. She was carried by St. Michael
and St. Francis, and she preached to the Quivira and Humanas
Indians. On his return to Spain, Benavides quizzed the
Abbess on her experiences, and reported to his superiors that
he was convinced she, invisible, had seen him and his asso-
ciates at work in New Mexico.

Benavides attributed the conversion of Taos Pueblo to a
divine event in which an old woman who was trying to lead
her neighbors back to polygamy, was struck by lightning
from a cloudless sky. St. James, who had helped Cortez in
the conquest of Mexico, appeared in New Mexico at the
battle of Acoma. Astride his white charger, bearing his lance
and banner, the saint encouraged the Spaniards and dismayed
the Indians. Santiago, as St. James is called, is the symbol of
Spain's militant patriotism. His aid at the Battle of Clavijo,
where sixty thousand Moors were slain, dates from 939 the
Spanish war cry— *Santiago cierra España!*

The tomb of St. James in Spain was a greater attraction to
Medieval pilgrims than St. Peter's in Rome or St. John's in
Ephesus. The city of Santiago de Compostella was built to
commemorate the saint's miracles, and Pope Calistus II said,

in 1009, "he who enters Santiago sad, will go out happy." Thousands came from all of Europe to light their candles in the Cathedral of Santiago. The English journeyed to Galicia in such droves that a guide book called *The Way from the Lond of Engelond unto Sent Jamez in Galiz* was published in the sixteenth century. Pilgrims carried home scallop shells emblemic of St. James, and little images from the street of the jetcarvers. It is small wonder that Santiago found such favor in Spanish New Mexico.

In Spain, Santiago's image took on the garb of the pilgrims who flocked to his tomb—the broad brimmed hat, the flying all-weather cape, and the scallop shell symbolic of his rising from the sea. This shell, or *concha*, made in silver for pilgrim's wear, is the probable ancestor of the silver *concha* belts worn by Navajo horsemen. As a New Mexican *santo*, St. James is at home in regional dress: the black sombrero, short jacket, breeches, and boots of a Southwestern *ranchero*. A new cowboy hat is a proper gift for him, and recognizing his love of horses, he is carried into the corral to encourage the fertility of the mares.

In local art, Santiago is shown trampling the heads of the conquered Moors, and thus he appears on the 1761 stone reredos in Santa Fe. His statues wear real clothing, and have such accoutrements as a handmade metal spear, stirrups, and spurs, plus rawhide lasso, quirt, and bridle reins.

San Ysidro Labrador is at the opposite end of the social scale from Santiago, caballero, but he is equally Spanish in character and appeal. St. Isadore, laborer, worked on a farm near Madrid, late in the eleventh century. A devout man, he attended Mass each morning, which made him late for his plowing. A fellow workman complained to the *patron,*

and on looking into the matter, the employer found Ysidro praying, while an angel drove his oxen to the plow.

"You never think of Santa Barbara 'til it thunders," say the New Mexicans, and the weather is of real concern in a land where drouth parches the corn, yet the Rio Grande may rise in flood and soak away the adobe of whole villages. Farmer Ysidro would understand. He is credited with having caused a spring to gush forth at his bidding, and when his little boy fell into the well, the water miraculously rose to the top so the child could be rescued. San Ysidro's wife was Maria Torribia, a canonized saint, who is venerated as Maria de la Cabeza in Madrid, where her skull is carried in processions in time of drouth. Many rural villages in New Mexico hold fiestas for San Ysidro early in the spring. His image is borne through the fields, often in the company of Our Lady of Guadalupe.

Frank Applegate and Mitchell Wilder have noted a popular local story in which San Ysidro is accused of working on Sunday. The Lord plagued him first with grasshoppers, and then flooded his fields, but Ysidro persisted in breaking the Sabbath. When the Lord finally threatened him with a bad neighbor, Ysidro gave up his Sunday labors. Long-suffering Job is also appreciated in New Mexico, where he is portrayed seated in a little tin house.

San Ysidro is almost invariably preferred in sculpture by local *santeros,* and his broad-shouldered figure towers high above yoked oxen and a guiding angel. The animals are carved with decorative charm, convincingly bovine, and often equipped with painstaking detail in the structure of the plow and the harness. Like Santiago, this active saint and his angel companion receive little sombreros from their admirers. In-

stead of Santiago's metal lance, Ysidro carries a pointed stick
to goad the oxen.

The angel who drives Ysidro's oxen often appears without
his wings. Perhaps the pinions were an inconvenience to the
señora who fitted a little robe over his shoulders to wear with
a new hat. Occasionally, as a mark of his celestial origin, the
village metalsmith gave the angel a small tin crown. San
Ysidro, in New Mexican sculpture, customarily was carved
wearing a long military jacket decorated with gold frog braid-
ing, painted in yellow, since gilt was not available. He sported
knee breeches, with side buttons, and colored leggings. Fond
admirers were impelled to make St. Isidore a fine pair of
boots, like those Santiago swung in his stirrups.

The saints who love animals are held in high regard by
New Mexicans. "There must be dogs in heaven," the vil-
lagers declare, "for a dog licked the wounds of San Lazaro."
St. Lazarus, who is confused locally with St. Roch, is also
appealed to for the cure of infectious diseases. St. John the
Baptist, who cradles in his arms the symbol of "the Lamb of
God which taketh away the sins of the world," is the favorite
of sheep herders. European legend has it that a starving horse
knelt to the Blessed Sacrament before eating hay offered by
St. Anthony. On the feast day of San Antonio, in the South-
west, as in Mexico, burros and cows are paraded past the
Church for special blessing. San Antonio also helps to find
lost things, but Santa Inez del Campo is assigned the task of
finding strayed livestock. It is Santo Niño de Atocha who
locates missing persons.

A shrine of Santo Niño de Atocha is in the little weavers'
village of Chimayo, at the foot of the Truchas Peaks. "El
Santuario," in New Mexico, always refers to the chapel built

in Chimayo to commemorate the marvelous discovery of a statue of Santo Niño, the Christ Child. For six generations New Mexicans have made pilgrimages to this sanctuary, seeking the miraculous curative abilities of the Holy Child. The little church is also a shrine for lovers of native New Mexican art, for it embodies the best traditions of adobe architecture, and the gesso panels which decorate the interior are among the finest examples of native painting.

Pilgrims take home bits of healing mud from a hole in the earthen floor of a little room next to the main altar of the Santuario. This hole, which is said never to change in size no matter how much earth is taken, marks the place where the image of the Holy Child was unearthed about one hundred fifty years ago. The people of Chimayo tell the story of a man driving his oxen to plow his field, accompanied by his little daughter. The little girl hears a church bell beneath the ground, and begs her father to dig. He uncovers a sanctus bell. She urges him to continue digging, and he finds a wooden statue of Santo Niño de Atocha. Many miracles took place in the presence of this statue and a chapel was erected by grateful villagers.

The doings of Santo Niño are favorite tales of the villagers, who bring him little shoes as gifts. He wears them out tramping around New Mexico on errands of mercy, often in the company of his good friend San Ysidro, who knows the short-cuts through the fields. Near Española, an old man found the wheels of his wagon stuck in a creek. Soon a little boy appeared: "How do you do? May I help?" The man regarded him kindly. "My dear boy, you're too small." But the boy pushed the wagon out of the mud, and the old man knew that the Holy Child had come to his assistance.

For the annual fiesta of Santo Niño at Carnuel, in Tijeras
Canyon, the villagers set up small pines on the barren rock
before the chapel, decorating them with ribbons and crepe
paper in the manner of Christmas trees.

Much as his compatriot Santiago dresses in Spain, Santo
Niño de Atocha wears a pilgrim's plumed hat and cloak, and
the Santiago scallop shell. Over his shoulder is a strap with a
little purse attached. Admirers tuck money and religious
medals in this purse, and it is said that if you leave a letter,
the saint will write an answer. This bandoleer and pouch,
often ornamented with a silver shell, was another identifica-
tion of the Medieval religious pilgrim. In New Mexico it is
made of ribbon and velvet, frequently in ignorance of the
original function, as a proper accessory for male *santos,* St.
Isidore and St. Joseph in particular. For a performance of
the miracle play, *Los Pastores,* the Shepherds wear pouches
made like little silk pillows, each emblazoned with the name
of the character, and suspended from the shoulder by col-
ored ribbons. Shortly after World War II, native actors car-
ried Army musette bags in the play. The shoulder bag or
pouch has remained in New Mexico as the badge of a travel-
ler, bearing the same connotation as a bandanna bundle tied
on a stick.

Santo Niño is usually depicted as seated in a chair, and has
in one hand a staff with a gourd water bottle, and in the other
a basket of bread. In local statues the basket is likely to be
filled with paper flowers. According to Spanish legend, the
Christ Child visited the prisons where Christians were held
by the Moors, bringing them water in a bottle that was never
empty and bread in a basket that was always full. Besides
his aid to those unjustly in jail, the Atochan is appealed to

for protection against crimes of violence, a reputation which he has gained for his good deeds at Plateras, Mexico.

The Child of Atocha is known as the special intercessor for the imprisoned and politically oppressed. Many members of the New Mexico 200th Regiment, captured by the Japanese during World War II, vowed a pilgrimage to El Santuario if their lives were spared. Since V-J Day, many ex-soldiers have come to Chimayo to thank Santo Niño for his favors. Plaster images of the Child of Atocha are among the most commonly seen in present day New Mexican homes, as well as nineteenth century prints in tin frames.

Many of the pictures to be found in New Mexican tin frames were lithographed by Currier & Ives, who sold quantities of religious prints to the Catholic trade. Colored pictures manufactured in Germany, with the saint's name printed in several languages, also had wide distribution in the Americas. Small black-and-white wood engravings, sometimes tinted by hand, preceded the lithographs, but the first prints known in New Mexico were the illustrated pages of religious books, which had a discernable effect upon native painting. Engraving and lithography were not done in New Mexico until after American occupation, although in 1834 a small press issued *El Crepúsculo de la Libertad,* the first newspaper. *Crepúsculo* may be translated as "dawn," or "dusk," and what began as the *Dawn of Liberty* soon turned to twilight. The journal was discontinued for want of customers who could read, and the first book printed in New Mexico, a speller, was released by Padre Martinez, of Taos. An American wit noted that there could be no freedom of the press where there was no press.

Many Southwesterners make pilgrimages to another shrine famous for healing located at Zuñi Pueblo. There a statue called "Santo Niña," and referred to as "she" by the Zuñis, is kept in a private house which the devout approach peni-

tently on their knees. Despite the feminine designation, a frequent lingual confusion, the symbolism associated with this statue would identify it as the Christ Child, and some of the legends concerning it are similar to those told of the Child

of Atocha. The Zuñis hold an annual celebration called the "Doll Dance," in which the Santo is carried in procession, and a ritual dance is performed by virgins of the Pueblo. In the words of an informant at Zuñi, we learn the origin of the Santo Niña:

"The people tell of how long ago a ray of sunlight shone down from the roof, you know how the houses used to have a hole in the top for the entrance of a ladder, and this woman was with child and she went down to Hawikuh and had it there. There were so many people that wanted to get this child away from Zuñi that it turned to stone, so that they were able to keep it there. You know that it sweats, that the perspiration forms on its face when it is going to rain. All the people believe that."

This immaculate conception story resembles that told by the Pimas to General Kearny when he inquired about the great adobe ruin of Casa Grande in Arizona:

"It was built by the son of the most beautiful woman who once dwelt on yon mountain; she was fair, and all the handsome men came to court her, but in vain; when they came, they all paid tribute, and out of this small store, she fed all people in times of famine, and it did not diminish; at last, as she lay asleep, a drop of rain fell upon her navel, and she became pregnant, and brought forth a boy, who was the builder of all these houses."

Christian legends tend to follow the same plot threads. Many religious pieces in Spain were buried to hide them from the Moors, forgotten for many centuries, and then rediscovered, supposedly with divine assistance. The tomb of St. James and the statue of the Virgin of Rábida are examples. In New Mexico one hears of statues and bells with remark-

able religious efficacy being dug up at Laguna, Zuñi, and Is-
leta, buried long ago to escape destruction during the Pueblo
Rebellion. The story of El Santuario is not unlike the follow-
ing legend of the discovery of a miraculous statue of Our Lady
of Guadalupe, in Spain:

The year was 1329. A Spanish peasant lost his cow, and
trudged weary miles looking for her in the beautiful Estre-
madura hills above the River Guadalupe. He found the cow,
dead, and when he started to salvage the hide, the Virgin
Mary appeared to him, restored the beast to life, and com-
manded him to dig on the spot. He returned home for a
spade, found his child dying, and entreated the Virgin to
restore its health, which she did. Digging at the place indi-
cated in his vision, the cowherd uncovered a chest which con-
tained a long-lost statue of the Virgin, seated on a throne and
bearing the Christ Child in her left hand. Wonderful things
came to those who prayed to the Virgin of Guadalupe, includ-
ing the victory of a handful of Christians over thousands of
Moors at the battle of Algeciras. A great monastery was built
at Guadalupe, which came in time to be decorated with the
finest paintings of Zurbarán. The monastery was host to
countless pilgrims, including such distinguished guests as Don
Juan, Columbus, and Cervantes.

When Columbus sailed into the Lesser Antilles on Novem-
ber 4, 1493, he named an island Guadalupe in honor of the
Virgin. It was not until 1531 that a miraculous painting of
the Virgin appeared on the poor *tilma* of Juan Diego in Mex-
ico City. The latter miracle was named for the already famous
Guadalupe of Spain. Just as the tomb of St. James had re-
placed a famous Roman temple of Janus, the shrine of the
Mexican Guadalupe superseded the temple of a Mexican god-

dess, Guautlalapan, which readily translated to Guadalupe.

Our Lady of Guadalupe of Mexico has become the best known religious manifestation of all Latin American countries, and in popularity has surpassed the sister miracle in Spain. Her image is more frequently reproduced than any other in New Mexican *retablos* and *bultos*. Although the original design is a painting, it is readily adapted to sculpture.

The original statue of the Spanish Guadalupe and the original painting of the Mexican Guadalupe are similar in many respects. Each is based on a type known in art as "the Immaculate Conception," which is described in the twelfth chapter of Revelation: "A woman clothed in the sun, with the moon under her feet, and on her head a crown of twelve stars." An angel holds the upturned crescent moon on which the Virgin stands. The crescent was also a symbol to the Moors.

Devotion to the Immaculate Conception increased steadily from the fifteenth century onward, and was, in consequence, much portrayed in art, becoming widely known through the works of Raphael and Murillo. The doctrine of the Immaculate Conception frequently is misunderstood by both Catholics and Protestants. It refers *not* to the birth of Christ, but to the birth of his mother, the Virgin Mary: from her birth the stain of Original Sin was excluded. It was not until 1854 that the doctrine was confirmed by the Papal Bull, *Ineffabilis Deus*.

The Spanish Guadalupe bears about her head an *esplendor,* or rayed nimbus of flamelike gold prongs terminating in stars. In the Mexican painting of Guadalupe, the *esplendor,* representing the sun, surrounds the entire body, the twelve rays increased to one hundred. The Spanish statue is hidden beneath a robe heavy with pearls and precious stones. The

Mexican painting shows Our Lady wearing a magnificently embroidered cloak. The Spanish Lady of Guadalupe is accompanied by the Christ Child, while the Mexican manifestation is not. In New Mexico the Immaculate Conception theme also appears as Our Lady of Light, but whenever the Guadalupe is designated it is always in imitation of the Mexican version.

New Mexican iconography is filled with the tenderness of the Virgin and the Holy Child, but like the character of the Spanish people, it has a somber side, aware of the sorrows of Mary and the passion of Christ.

Remembering the bitterness of Christ's crucifixion and the anguish of His Mother, the New Mexican felt better able to bear the privations of his own life. *Santeros* made images of *El Cristo* which dwelt upon His agony. Gesso and paint became streams of blood, gushing from the holy wounds and pouring down the stark body. "I have the soul of my people," wrote Miguel de Unamuno, "I like these livid Christs, emaciated, purple, bloodly."

One of the achievements of the New Mexico Federal Art Project was a portfolio of hand colored plates illustrating Spanish Colonial art. A sensitive young woman was assigned the task of applying color to a series of plates depicting typical native crucifixes. "I'm so sick," she remarked. "I've painted eighteen hundred drops of blood this week."

New Mexican *Cristos,* more than other sculpture, betray the stern emotions of Medieval concept. The Man of Sorrows is sad-eyed and tragic. Yet rather than the miserable discomfort achieved by untutored painters, or the slick benignity of the sentimental poster school, the New Mexican artist filled the face of the Crucified Christ with dignified virility and a

genuine sympathy for those who "know not what they do."
Like Gothic sculptors, the native carved the ribs and muscles
into an angular rhythmic pattern. The streams of blood were
neatly arranged for artistic effect, and the hands and feet were
realized with the greatest sensitivity. In many European cru-
cifixes the feet were nailed to the cross separately, until an
edict of Rome fixed upon the convention of a single nail
through the crossed feet. In New Mexico, Christ is fastened
to the cross sometimes with three nails, sometimes with four.

Most closely associated with portrayals of the Crucifixion
are *Los Hermanos Penitentes,* the Penitent Brothers, who
create a phase of New Mexican religious life much misun-
derstood. The *Penitentes* are derived from a lay order of
St. Francis of Assisi, and are noted for their mortification of
the flesh during Holy Week. They dramatize, with startling
reality, the story of the passion of Christ. The members flag-
ellate themselves with whips of cactus or yucca, carry heavy
crosses, and otherwise imitate the grueling pain of Christ's
last hours. Little girls called "Veronicas" wipe the brows of
the participants with handkerchiefs. In former times one
member of the organization was nailed or tied to the cross,
but now a large sculptured representation of Jesus is used.

There is a large body of literature on New Mexico's
Penitentes, some of which is hysterical and written without
proper cognizance of the historical background of the Order,
which had enormous popularity in Europe during the fif-
teenth and sixteenth centuries. The intensity of the move-
ment has died out in the more sophisticated parts of the
world, but has remained in New Mexico as an example of the
religious fervor and sincerity to be found in any isolated area
of Christianity.

This re-enactment of Christ's road to the Cross has been described as strange and horrible by persons whose religious education has not placed great emphasis upon the physical sufferings of Christ. *Penitente* chants and the music of the flageolet have been called "eerie" by persons unfamiliar with Gregorian music and the characteristic wailing timbre of Spanish rural singing. Members of a civilization which has invented the most cruel and impersonal of life destroying instruments have called "barbarous" these people who believe strongly enough to shed blood in proof of their religious tenets.

The particular requirements of *Penitente* ritual have left their mark on certain *santos*. Several figures of Christ are life-size, and have been adapted for dramatic use with movable legs and arms. Thus they can portray more realistically different parts of the ceremony—Christ Crucified, with His arms outstretched, and afterwards Christ in the Tomb, in death's repose. A sharp realism is employed in carving and painting the figure, and human hair and eyes of mica are added. The wounded side is sometimes equipped with a sponge and wick so as to drip red liquid, and associated with this is a little carved angel, hovering by the wound and bearing a cup to catch the Precious Blood, a Communion symbolism.

The personified presence of Death is recognized in *Penitente* ritual with the Cart of Death, a miniature ox-cart bearing a skeleton with bow and arrow. The Cart is pulled by a strip of rawhide which cuts cruelly into the flesh of the man dragging it. This is a survival of the European Cult of Death which developed in the presence of the great plagues which spread rapidly because of slum conditions in Medieval cities.

Present-day surrealism is matched by Medieval paintings and sculpture showing the souls of the damned tortured in hell, the ghastly bodies of the dead rising on Judgment Day. The living, too, wishing to mortify their vanity, had themselves sculped as cadavers with worms and rats gnawing at the decaying flesh. Skeletons and mummies of the saints were exhibited as holy relics in the churches of Europe, a practice still followed. The Cult of Death, as it is demonstrated by the *Penitente* Death Cart, is an isolated vestige of a philosophy once widely followed.

Those whose principal community experiences are in the impersonal atmosphere of the bus, the cinema, and the department store, may find it difficult to understand the participation of whole villages in simple ceremonies which demonstrate a fervent belief in religion. True tragedy and strong emotion are sternly repressed by modern man, and strengths are not of the muscles but the nerves. He lives amid the fantasies of the movies and the insidious Pollyanna world of breakfast foods and vitamins. It might be well to examine with tolerance the *Penitente* recognition of personal tragedy and the inevitability of death.

The transfer of Continental art forms and religious customs may be noted also in the design of the coffin of carved wood in which the *Cristo* reposes at Santa Cruz Church,

north of Santa Fe. The architecture of the casket is modelled on the church-shaped feretories of gold and jewels which hold saints' relics in European churches. Known locally as *Santo Entierro,* or the Holy Burial, the piece is equipped with handles so that it may be carried about the village in procession. On the morning of Good Friday, the statue in its bier is placed on a truck and driven slowly about the community. The entire population follows on foot, carrying banners of religious societies and chanting dirges.

The miracle plays performed in New Mexico at Christmas and Easter demonstrate further the retention of the religious practices of centuries ago. Actors dress like pictures in the Church, and perform such favorite stories as the Nativity

and the Flight into Egypt. The Christmas play, *Los Pastores,* dramatizes the tribulations of the Shepherds following the Star to the manger, where each presents a gift to the newborn Christ. The peak of excitement is a swordfight between Good and Evil personified by the Archangel Michael and Satan. A youth dressed in white and tinsel is Michael, and Satan is portrayed in a tight black suit, with red horns and tail. At the conclusion of the fight, the Archangel assumes the victorious pose in which he is shown in New Mexican *santos* —one foot upon the prone but waggish Devil. It is Satan who is the comedian, teasing the performers and disturbing their ritual until exorcised by the Cross.

The details of costumes and paraphernalia in native miracle plays exhibit striking ingenuity. Isolated from current conventions of the theatrical world, the village women who costume the players, and the men who make the "props," show a fine sensitivity in the effective employment of ordinary materials. While elementary symbolism is followed sufficiently to make a character recognizable to the audience, the greatest variety occurs in the costuming of individuals. Wives and sweethearts of the performers vie with each other to create distinctive dress for the performers.

The Shepherd's staves in *Los Pastores* have lost all reference to function except that of being sticks. Instead, these have become aids to the spectacle of a stately dance, being hung with bells and streamers, and struck against the ground in cadence. At the top of each tall staff is fastened a cage-like globe of bent willows or wires, inside which are little bells. The staff and cage are striped with colored papers, tipped with a star, and garnished brilliantly with paper flowers, tinsel, and flying ribbons. The finished wand resembles nothing

so much as an ethereal wedding cake on a giant peppermint stick. The bell on a stick may well be of European origin, while the visual structure probably is derived from South American Indian dance wands, elaborated with plumes.

In Old Mexico, the love of paper decoration is highly developed in the *piñata,* a clay bowl filled with goodies, amusingly disguised, perhaps as a melon or an airplane. The *piñata* is suspended out of reach, and blindfolded children strike it with sticks to break the bowl and discharge its presents. Although this Christmas custom is rather rare in New Mexico, the same impulse for florid, but not unpleasing detail, is exercised in decorating the creche and the evergreens which serve as backgrounds for religious plays. Indeed, this nimble-fingered handling of cloth and paper extends to the church at fiesta time, and expresses itself in colored streamers about the sanctuary and garlands for the holy statues.

Once every devout New Mexican recited to his children stories of the *santo,* dark with age, who guarded the house from a carved wooden niche. *Santeros* made regular rounds of the villages to repair the fragile gesso of the *santos* and offer new ones for sale. The *santos* could be punished as well as invoked. They were cajoled with gifts of candles and new dresses, but if they failed in the desired favor they might be turned to the wall or locked in a chest. Sometimes even sterner measures were in order, and St. Joseph, for example, might be deprived of the tiny sculptured Christ Child who rested on his arm. Slivers from a *santo* were thrown outdoors to quell a storm, and the bases of statues were burned to provide charcoal to mark crosses on the forehead for Ash Wednesday. These practices, plus years of weathering, have disfigured many native portraits of the saints.

Santeros have gone the way of the buggywhip maker and the itinerant weaver. Nowadays the adobe houses of New Mexico have storebought saints in the tradition of Raphael's pictorial sentiment. Red glass vigil cups and wax flowers from the dimestore adorn the family shrine. The old handmade *santos* have come into the possession of antique dealers, collectors, and museums. A few of the rural churches—Santa Cruz, Chimayo, Truchas, and some of the Pueblo missions— retain their original art where it may be seen in relation to its proper setting.

The long isolation of New Mexico preserved in art the iconographic tradition of the fifteenth-and sixteenth-century Spanish church. There were echoes of Gothic austerity, and a strong suggestion of the Byzantine in the staring eyes, rigid posture, and stiff drapery of the *santos*. Portraits of popular saints were copied from books and paintings, and then from each other, adapted to local materials and local ideas. New Mexico was not under the everyday surveillance of the church, and many pieces show outmoded portrayals, no longer sanctioned by Rome. Stories of the saints were retold, embellished with legend, and colored by common experiences. Over the centuries there developed a New Mexican branch of Christian lore, made real by repetition and daily use in the lives of the people.

The saints were human beings, living in the crises of their own times, and they contributed to man's long story of frailty and courage. Fashions of portraying them in art change, but the saints still exert influence on the lives of those who remember them. Their names are pronounced every day, in and out of the church, and their deeds are cited as examples of piety and wisdom.

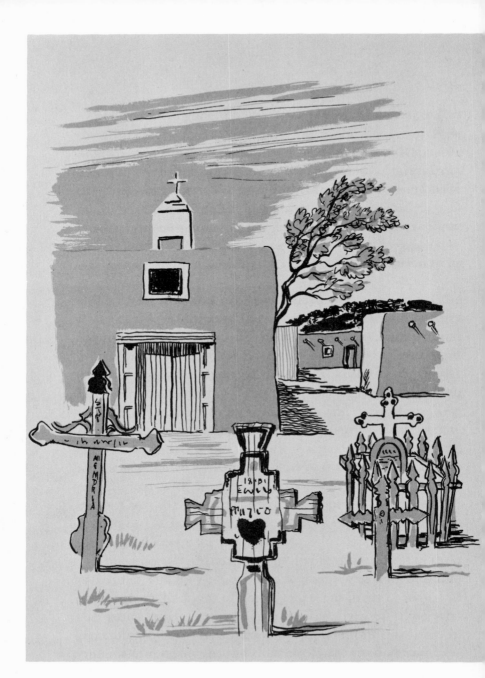

V. Baptism to BURIAL

CHAPTER ELEVEN THE HUB

THE IMPACT OF HISTORY upon a village is recorded in the architecture of its church. Like a barometric graph, the building registers the rise and decline of faith, the prosperous and the lean years, population changes, the encroachment of foreign ideas, and the status of neighborly coöperation.

The time is late in the eighteenth century. A few families separate from the principal village of a large ranch and move further up a little valley to exploit a fertile spot of ground. The stream will supply water for the houses and the fields. There is pasture land for the animals. Only a few souls inhabit the place, and the priest comes rarely. Once or twice a year he rides to the settlement to solemnize a marriage, to baptize new babies. A table in the largest room is laid with the instruments of the Mass.

If the village prospers, the young men stay to farm, and they marry girls from the towns nearby. Other families come to join them. A bit of land is set aside as holy ground. In mid-

189

summer, while the crops are ripening, the men begin to make adobe bricks for the future church. An expedition is sent into the altitudes of the mountain forest to cut tall pines for *vigas*. Thirty long, stout logs will be needed, a dozen more to saw into supporting timbers, and a great quantity of lighter wood for roofing, lintels, and scaffolds. The builders will have the advice of the priest; for models there are churches in the larger towns, and older Indian missions in a local style which matured during the seventeenth century. Village men will construct the church in much the same way as they build their houses, but on a larger scale.

A hillock is chosen as the site, for physically as well as spiritually the church will dominate the houses of its congregation. The building must be safe from the flood tide of the stream, and it will need no irrigation ditch, for no trees will surround it, no green lawn will carpet its yard, and the dead must lie in dry ground. The men scratch on the site a tentative plan. Here is the altar. Here is the church door. The orientation? East, roughly, or south. There is no compass for exactness, and no one stays at night to trace the line of the pole star, or tries to determine the moment the sunrise at solstice will strike the altar with its rays.

With oxen hitched to wooden plows, the earth is scored, and men with shovels and hoes level a plot to accommodate the foundation. They trace an outline of the interior. The length is stepped off: twenty-five yards should allow enough room for the people of the village and their visitors on fiesta days. The width is easier to decide, for men know the height of trees on the nearest mountain. Twenty-five feet, thirty at most, is the widest space the *vigas* will span. A wide, shallow trench is dug, and the men pack it with boulders and mud as

a base for the wall. The shape of the nave appears to be a long rectangle, yet the space between the walls gradually widens until it reaches the sanctuary. At this point the walls taper sharply inward until they meet at oblique angles the wall against which the altar will rest. When the church is finished, it will have the shape of a gigantic old-fashioned coffin. A large parish, with greater resources of labor, might prefer the more ambitious cruciform plan, but the small village wisely bends its efforts toward a simple church without a transept.

Adobe bricks, hundreds of them, are piled in readiness. They may be made from the dedicated earth, but every family is proud to have a bit of its land go into the body of the church. Gangs of men work in teams at erecting the earthen walls. The side walls are about four feet thick at the base. The walls around the front door and the sanctuary are much heavier, six, or even ten, feet in thickness at the foundation, because at these points elaboration of the structure subjects it to strain. Certain men carry the bricks, others mix mud mortar. The most skilled workers lay the adobes in place, carefully troweling the interstices with mud. When the work is well in progress, the heavy frame of the front door and its huge log lintel are set in position. A small door is made to the left of the sanctuary for the priest's use. As the wall rises upward, the workmen taper it slightly, especially on the outer side, so that it will hold by its own weight. At intervals, long timbers are laid horizontally within the wall to lessen the vertical cracks which occur between bricks as the wall settles. When the height reaches twelve or fourteen feet, logs are laid in place for the window sills. Stout timbers are set into the wall across the top of each window to support the adobe above. Probably only three windows, each about a yard

square, are planned. One window is inserted just above the front door, and one on each side of the nave, about two-thirds of the distance from the door to the altar. Since few communicants can read, and printed prayer books are at a premium, a stronger light in the nave would only distract attention from the ceremony at the altar.

The bricks high in the structure are pulled to the top one at a time, caught in the loop of a lasso. When the wall is nearly thirty feet above the floor level, it is made ready to receive the roof. Short, square timbers are hoisted into transverse notches, opposing each other on the side walls at intervals of a yard. These timbers are corbels, the purpose of which is to help distribute the weight of the roof to the walls. The corbels are about five feet long, and have been adzed to a square shape. Aside from their function of strength, they will form the chief ornaments of the ceiling, and the ends are cut into decorative brackets. The pattern is so old as to be called classical, for it is found all the way from China, through Africa, to Spain and Italy. The corbel is flat on top, and the underside has the profile of an elongated scroll stretching out like a curling tongue. Details of the pattern vary among the villages, from the shallowest pretension of a curve to complex inverted stair-steps and balls, enriched with hollow-chisel carvings. The flat sides of the corbel were a favorite spot for ornament by the Moors, and some of the earliest Mudejar carving is found on corbels in ancient Spanish churches.

Once the corbels are cemented firmly into place, the beams can be installed. Two timbers are leaned against one end of the church. Men on top of the wall, using rawhide lariats as windlasses, pull the round *viga* logs up the inclined timbers. Teams of men, walking on each sidewall, carry the *viga* to

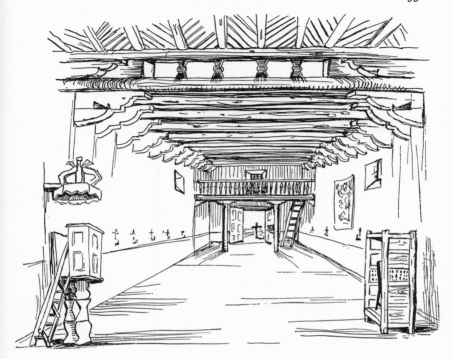

its correct position spanning the nave. If the span is especially wide or vital, as at the meeting of the nave and sanctuary, two corbels, one above the other, will support each end of a single *viga*. The masons now build the walls even with the top level of the *vigas*, taking care to pack tightly with mud the spaces around the timbers, because water erosion here might cause a beam to slip and weaken the roof.

The *vigas*, though functional, bring color and texture to the ceiling of the church. Shorn of their branches and stripped of their bark, these logs are marked with sinuous irregularities from the seasons of stress in the mountain for-

est. They are pocked by knots and flaws, and the workmen have made little attempt to make them smooth and regular in diameter. As the years pass, the *vigas* will sag and split, and their dazzling clean yellow turn to brownish gray and be stained by seeping rainwater. Their placement in parallel intervals across the ceiling of the nave provides a pattern of highlights and black shadows, changing with the time of day and thrown into sharp relief in the flickering blaze of torches.

The sanctuary is given special attention. In churches equipped with a clearstory window, which functions as a horizontal skylight, the sanctuary walls are constructed a little higher than those of the nave. After this is done the first *viga* of the sanctuary is laid directly above the innermost *viga* of the nave. The narrow space between these two beams is fitted with a wide, horizontal window, at right angles to the nave, and out of sight of the congregation. It provides effective natural light for the entire altar area. An altar table of wood or adobe is built against the sanctuary wall, and a railing set up to mark the boundary of the sacred precinct.

The men of the village apply the technique of domestic roofing to the church. Split logs are laid across the *vigas* as a ceiling, then covered with brush and mud plaster. Tons of earth are lifted to the roof in baskets and leather buckets, and spread in a thick insulating layer. Long wooden drainspouts are inserted at the roofline to prevent rainwater from cutting the earthen walls beneath. As on houses, it is necessary to raise the walls into a parapet above the roof level to provide adequate weather protection for the juncture of the ceiling and the walls.

The bell must have a proper place. Towers can be con-

structed, but these require great quantities of adobe with small functional use. The little village ornaments its church with a plain flat façade raised upward in a triangular false front. The bell is hung in a hole in this wall, or suspended by a rope beside the front door. If the community is fortunate, it inherits a sweet-toned bronze bell from Spain, cast with the date of manufacture and the name of a saint.

Bells always have a romantic history. When the Spaniards conquered a Moorish town, they melted down the Mohammedan temple metals and cast them into Christian bells. When the Moors sacked a Spanish town, they converted the church bells into lamps for the mosque. The bells of Santiago, it is said, were made into eight thousand lamps. During the nineteenth century, iron bells came to the Southwest by wagon train from the United States, and in recent years village churches have put locomotive and school bells to holier uses. Lacking a bell, the sacristan sounded an Indian drum, a needless announcement in a rural community which noted the infrequent visits of the priest with eager interest. In the sadness of Holy week, the ringing of bells was forbidden, and a large wooden clacker called a *matraca* was substituted.

The rough work of construction finished, it is now the women's turn. Their task is to hide the rugged mathematics of adobe bricks beneath a thick protective plaster. The walls begin to lose their uncouth appearance, and to take on the plastic texture of a smooth blanket of mud. The church becomes clean and sleek and unified. The interior receives the same treatment, plus a cosmetic of gypsum whitewash. Water is sprinkled on the dust of the floor, and the accumulation of loose adobe from the building process is tamped into a

hard surface on which to kneel and pray. The floor is graded upward toward the sanctuary, which stands two or three feet above the nave.

An artist is commissioned to make a large crucifix and a statue of the patron saint, and on the saint's special day the priest comes to sanctify the church, the village celebrating the event with three days of fiesta. The priest brings sheets of fine rag paper in a rawhide envelope for the church records. In fancy calligraphy he dedicates the book: *En el Nombre de la SSma. Trinidad, Padre, Hijo, y Espiritu Santo, y de la Reyna de los Angeles Maria Señora Nuestra* . . . The page is finished with crosses and flowers. With sheets marked for marriages, baptisms, deaths, began the written story of mortal events in the village.

As the years progressed, the villagers added steadily to the church. A little room was built outside the sanctuary to serve as a sacristy, with a *trastero* for vestments and altar equipment. A confessional and a pulpit were made of wood, intricately carved. Large, formal chairs in native baroque were placed near the altar as seats of honor for the dignitaries who came to conduct Mass.

Weaknesses in the structure of the wall came to light, and enormous conical buttresses of adobe were molded at the corners and along the sides to resist the outward lean. The walls of the sanctuary acquired earthen reinforcement many feet in thickness. The façade was made more impressive with a pair of small bell towers, constructed of solid adobe masonry laid in a square at the front corners of the church. Simple arches, the mud strengthened by logs, graced the top of each tower.

The congregation might feel the need for a choir loft to

make church music more dramatic. Neighborhood carpenters installed a shelf-like structure at the rear of the church, just above the front door. This choir loft spanned the nave,

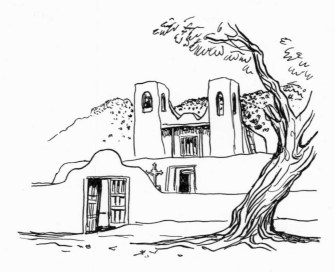

and rested on heavy beams and corbels thrust into the walls. Posts set under the main beam added strength, and wooden capitals served to distribute the weight from the beam to the posts. These capitals were of a single piece of timber, three or four feet long, each side cut in the profile of the corbels of the church. Since the choir loft was an important ornament of the church, it was floored with peeled poles in herringbone pattern, and framed with a carved and painted railing. Access to the little gallery was by ladder or stairs inside the church. Sometimes, however, entrance was through a door cut in the church wall, and the musicians mounted an exterior ladder. Emory, attending Mass in Santa Fe, noted that "The band, the identical one used at the fandango, and strumming the

same tunes, played without intermission. When a favorite air was struck up, the young women, whom we recognized as having figured in the fandango, counted their beads, tossed their heads, and crossed themselves to the time of the music." It is not likely that church behavior in the rural towns was so frivolous, but it was the custom to bring an orchestra into the church on special occasions. Small manual organs, often interestingly antique, are used in the churches today.

The Moors liked to concentrate brilliant color about the altar of their mosques, and the elaborate altarback developed as a typical embellishment of Spanish churches. The principal altars of cathedrals in Spain have such a profusion of carving and maze of color as to be overwhelming if not subdued by distance and dim light. The reredos, or tall altarback, was introduced in the Indian missions and the large churches of New Mexico. It was natural for the villagers to desire a similar work of art for their own chapel, and they commissioned a *santero* to design an altarpiece.

The artist planned the piece to cover the entire wall above and behind the altar, a space perhaps eighteen feet tall and twenty feet wide. Large religious paintings were a vehicle of instructive decoration and these were fastened, three abreast, in a heavy wooden frame. Saints appropriate to the village were chosen, and their portraits were painted in tempera colors on gesso boards. The symbolism was bold and simple, so it could be seen and recognized from any part of the church. The painter drew the attitudes of holy persons in a sharp contrast of color against the background. If the *Penitente* brotherhood were strong in the community a suitable central motif was the symbol of St. Francis: the naked arm of Christ crossing the sleeved arm of Francis, each with the hand nailed

to the Cross. Our Lady of Sorrows, St. Joseph, and St. Rita
were welcomed, as were the archangels, Michael and
Raphael. The altar frame was carved, then coated with gesso
and color. The top was terminated with a broad lunette on
which the Holy Dove descended. Some of the most exotic
designs in native art were applied to reredos frames. Although
the general plan was static, no two examples of the New
Mexican reredos were identical. The portrait panels varied
from three to twelve, and the treatment of the frame was
highly individual. Cruciform churches had altarpieces in
each arm of the transept, and in recognition of this style,
smaller churches, lacking a transept, placed altarpieces on
each side of the nave.

The intimate effect of the church increased steadily in the
village as families identified themselves with its ceremonies.
The young people were married there. Their children were
touched with holy water and baptized with the name of a
guardian saint. Wooden crosses rose in the churchyard as the
old, the sick, and the suddenly stricken came to be buried in
the comforting shadow of the church. Public joy and private
sorrow found expression in the church. Families brought fav-
orite *santos* to the chapel, where all might enjoy their in-
fluence. The healed and the helped expressed their gratitude
by having paintings and statues made to add to the already
large company of saints. Tables were built to hold the rigid
array of sacred statues, and the walls were warmed by a multi-
tude of wooden panels and religious prints encased in tin
frames. Statues were hung by leather thongs on pegs in the
walls. The interior became rich, even crowded, with tangible
evidences of piety, a veritable gallery of native art.

The ladies of the district embroidered woolen cloths for

the frontal, and kept the altar table fresh with lacy covers in drawnwork and crochet. Evergreen branches and dried plants were set in pottery bowls. Flowers of wool and silk and feathers were laid upon the brows of the saints. Ingenious decorations for fiesta and Christmas were added to year after year; only when quite shabby, could they be thrown away without offense to the pious communicant who fashioned them. Late in the nineteenth century there appeared red and green tissue paper bells, manufactured in the Orient. Nowadays colored crepe paper, cut and twisted in Dennison's formulas for flowers and streamers, are tacked about the sanctuary. Paper and wax flowers sit in fruit jars and vases of every description, accompanied by candlesticks of tin, wood, pottery, and glass.

Political disturbances in the newly-formed Mexican Republic diminished the number of trained clergymen available to New Mexico toward the middle of the nineteenth century. Local congregations, lacking the stimulus of energetic pastors, ceased to attach the former importance to the church. Because Mass was held there perhaps only once a year, the building fell into bad repair. Men of the village could not be persuaded to keep up a structure which had lost its place in daily life. Seasonal rains eroded adobe walls in need of plastering, and rotting timbers collapsed under leaky roofs.

History took another sharp turn. The Americans came, seizing New Mexico in the first skirmishes of the Mexican War. The newcomers brought with them a vast interest in material things, the doctrines of progress, and the Yankee instincts for the upkeep of property and the increase of comfort. Most of the Americans who came to New Mexico were Protestants, and the Government encouraged the activity of

Baptist and Presbyterian missionaries among the Indians.
To the surprise of the native population, who had been
advised that all Protestants were devils, General Kearney pro-
claimed and demonstrated the American policy of religious
tolerance.

By a curious sequence of events, the American occupation
resulted in a rejuvenation of the Catholic Faith in New Mex-
ico. The Bishop of Durango, far away and preoccupied with
problems closer at hand, seemingly took little interest in his
subjects of the upper Rio Grande. American Catholics, more
active than their complacent European confreres, lived in
what they referred to as "a hot-bed of heresy," and were most
zealous. With New Mexico now a territory of the United
States, Santa Fe fell under the jurisdiction of American Cath-
olics, and the Holy See designated it as the seat of a new dio-
cese. Jean Baptiste Lamy, a Frenchman who had worked
energetically with the Church in Ohio, was chosen as the first
Bishop, and later promoted to Archbishop. A man of force-
ful character, Lamy set about to resuscitate Catholic faith in
New Mexico. Eminently a practical man, he encouraged the
rebuilding and repair of the decaying churches, and made
it his business to obtain qualified clergy for the celebration of
the Mass. The new priests were mostly of north European or
American training, and had therefore, small understanding
of the New Mexican tradition in arts and architecture.

The little village church, which we left perishing in the
arms of disinterest and neglect, suddenly found itself minis-
tered by a circuit-riding young priest who revived the fears
of hellfire and damnation and pointed out afresh the proper
road to heaven. The church was set in order, but it was a new
order, prescribed by the new ways of life which came with

American civilization. Above all, Archbishop Lamy and his assistants wanted religious buildings to be clean and neat. The patina of age and the harmonies of tradition held little charm for their eyes. It was important, the Archbishop emphasized, to save the existing structures from further destruc-

tion by the weather. The flat roof, which it must be admitted *did* leak, was the principal offender, in the opinion of the progressive Americans. Therefore, to preserve the walls and the interior, a gable roof of sheet iron was erected over the older structure. It has taken almost a century to learn that these new roofs, foreign to the architecture, were not necessarily the best solution. Not only did they impose additional weight and pressure on walls not designed for lateral stress; all too frequently they poured water down the lower part of the walls, weakening the foundation and demanding additional buttressing.

Architecturally, the gable roofs were a grave mistake. They spoiled forever the magnificent lines and impression of solidity and plastic individuality which characterized pre-American adobe churches. The roofs shut off natural light and destroyed the drama of the clearstory window. To make up

for this loss of illumination, the side walls of the church were pierced with a multitude of glass windows in standard frames. These windows had many disadvantages. They weakened the mass of the wall, and subjected it to erosion around the window frames. While admitting sunlight, they admitted summer heat and winter cold. They disturbed the excellent acoustics of the church. From the standpoint of ritual, the diffused light took away the sharp focus on the altar and dimmed the excitement of the candles. Accustomed to the Gothic theme which was so successful in northern climates, Victorian churchmen destroyed the fundamental values which had fostered the Romanesque in sunny lands and reached a highly functional status in New Mexico.

In the rush to make God's house the most modern and progressive in the village, native esthetic judgment was shaken. The honest strength of old log *vigas* and the rhythmic carvings of corbels were hidden under sheets of pressed tin, another factor affecting the acoustical resonance of the building. The old reredos, its paintings the finest work of an artist of long ago, was torn out. In its place native carpenters, equipped with sharp American tools, built American Gothic structures of complex moldings, painted white and gold. The walls of the nave were dressed, straightened with a plumbline, and slickly coated with hard lime plaster. Buff calcimine and colored stencils completed the décor. Only the thickness of the window reveals hinted that the walls were adobe. The earthen floor, soft and resilient to the step, was replaced by a more sanitary covering of planks, which registered the sound of every scuffing foot. Potbellied stoves were set up in the central aisles, with long, black pipes elbowing their way to the outdoors. Heating units were a comfort to the congre-

gation, for certainly the church was cold before, but the cast-iron shapes stood between the communicant and the altar, and broke up the long dramatic sweep of the nave. The village church, once planned as an effective receptacle of color, sound, and ceremony, had succumbed to two American characteristics: standardization and lack of sensitivity to visual and auditory distraction.

Discouraging as this picture seems, the village churches were not beyond rescue by the inherent taste of Spanish communities. Though they lacked training in the purity of art, and were indeed helpless against the pressure of progress, the people over a period of years re-asserted their desire for harmonious architecture and the expression of native genius.

The craftsmen applied new tools and materials to old patterns and techniques. The altarpiece, now English Gothic in derivation, took on a fresh simplicity which lacked the tortured ornament of Victorian America. Designs were cut in the woodwork, spaced mathematically, executed with technical perfection, but still remained native in origin. The old Iberian theme of concentrated ornament emerged in the altar and the portal. The very placement of materials smacked of the Spanish sense of balance—a multitude of objects paired bisymmetrically on either side of the common center. In the sanctuary, where once a host of hand-made *bultos* expressed elemental emotions, there appeared the same crowd of celestial characters, in smooth imported plaster now, clothed in the anemic blues and pinks of religious calendars, their faces saccharine, their gestures refined and elegant. The ecclesiastical supply houses had some difficulty filling the orders of New Mexican churches. St. James, minus his horse, came masquerading as St. Isidore. And the local church committee,

knowing that the congregation would not recognize St. Isidore as a farmer in these Sunday clothes, added a pair of crude plaster oxen and borrowed an angel from the Annunciation to complete the symbolism.

With scrollsaw, molding plane, and milled lumber, local carpenters fashioned new doors for the church. For simplicity of proportion and fertility of design, these doors have rarely been surpassed. Perhaps the best known is the pseudo-Gothic doorway on the church of Ranchos de Taos, which is much photographed. The portal of the church in Bernalillo is likewise effective. Cut-out Maltese crosses distinguish the large wooden doors at Santa Cruz church. Influenced by American models, many localities added wooden belfries to their churches. Like the altarpiece and the portal, the imported belfry style soon acquired a local character. A little cage, fretsawed like a valentine in wood, was perched atop the church to hold the bell. Among the most ornate are the paired bell turrets at San Felipe de Neri, in Albuquerque, and on the mission church of Isleta Pueblo. Both these belfries were built prior to 1880. In the lesser villages, the form is often no more than four posts and a peaked tin roof with a cross, set immediately above the church façade.

While New Mexican churches were losing their ancient adobe character, another feature of local architecture was passing into oblivion. The large houses of Spanish haciendas were being abandoned or subdivided as separate residences because of changes brought about by American economic domination. Many of the wealthy families who owned great ranches and controlled a large number of peons were unable to maintain their importance in the face of the American competitive system. Some of them were slow to recognize

the shrewd business methods and increased efficiency of
American ranchers. Accustomed to dealing in real goods and
labor, rather than money, others of the elite sold their prop-
erties at ridiculously low prices and moved into the towns.
Because the hacienda tradition seems glamorous and roman-
tic, it has received, perhaps, undue emphasis in the cultural
history of New Mexico. There were scarcely a dozen really
large houses between Taos and El Paso, and the elegant liv-
ing attributed to *rancheros* has been exaggerated. Many of
these residences were quite modest until the nineteenth cen-
tury, when they were enlarged because the owners, who were
also merchants, profited through participation in the Santa
Fe Trail trade.

Except in the number of rooms, the home of the wealthy
New Mexican differed little from the conventional village
house. The usual plan included a wide hall, or *sala,* with a
row of rooms on either side. The *sala* was intended for parties
and dances. Some houses, especially in the towns, were built
about a central patio, but more commonly the patio was at
the rear, surrounded by the kitchen, storehouses, and servants'
quarters, with a stable at the end. The house was likely to
have higher and thicker walls than the laborer's hut, for the
dwelling of the patron might serve also as a fort during Indian
raids. Though the furnishings of the big house were more
elaborate, and even imported, there were few architectural
commodities except mass labor, which were not equally avail-
able to the poorest peon. After 1846, the leading Spanish
families of New Mexico refurbished and elaborated their
homes in the Territorial style, creating some of the best
examples of recent native architecture.

The little village churches stand as strongholds of faith

and integrity in rural communities where modernization increases daily with the arrival of merchants' delivery trucks, and government agents. Standardized schooling, military service, magazines, radio programs, and motion pictures are likewise leveling factors. Despite these changes, there is truth yet in words written by George F. Ruxton one hundred years ago:

"The churches in villages of New Mexico are quaint little buildings, looking, with their adobe walls, like turf-stacks. . . . They are really the most extraordinary and primitive specimens of architecture I ever met with, and the decorations of the interior are equal to the promises held by the imposing outside."

CHAPTER TWELVE **FINE, SILENT PLACE**

''ON THE ROAD WE SAW many wooden crosses held firmly in an upright position by heaps of stones piled around their bases. These sacred symbols were not erected by the road side to mark the place of graves or bloody deeds, but to remind the traveller to pray for the soul of the person by whose friends these symbols were erected. The road sides, throughout the province of New Mexico, are, in many places, lined with these crosses. Near St. Phillipe, we saw one with a

piece of board nailed near the top, on which was the following inscription: 'Passer-by, pray for the soul of Dona Maria.' "

The custom of roadside memorials, which J. W. Abert observed a hundred years ago, prevails today. Near rural villages, the traveler is likely to encounter a little grove of crosses at the top of a hill or not far from a cemetery. Here the pallbearers of many funerals have paused to rest, and the mourners have set up little crosses of wood, or scratched the sign of the cross in a boulder or the face of a sandstone cliff. The faithful who pass that way are reminded to cross themselves and pronounce the names of the Trinity for the sake of the dead.

During the seventeenth and eighteenth centuries, the dead were buried beneath the earthen floor of the church. The excavation of the mission church at Quarai revealed forty-one skeletons in the nave. So many burials were made in the old adobe Parroquia in Santa Fe that when the present Cathedral was built on the site, its walls settled unevenly and cracked the arches. Over a period of years the space for interment inside many churches, as at Ranchos de Taos, was used up, and early in the last century the priests found it necessary to consecrate new ground. The churchyard now served as the *campo santo,* or holy field. For several generations, the only bodies buried in the church have been those of the prelates of Santa Fe, who are laid in a vault beneath the floor before the main altar of the Cathedral. The entombment of church notables in the sanctuary began in the early years of Christianity with the celebration of Mass over the bones of the martyrs who died in the cause of their faith.

The church itself was sufficient monument when burial was within its walls, but the establishment of exterior ceme-

teries brought forth an elaborate mortuary art to protect
the graves with the sign of the cross. Since most of the markers
were of wood, the earliest examples have weathered away,
and those which remain show the influence of American
grave customs. In many communities, the churchyard proved
too small, and a new *campo santo* was founded on high, dry
ground at a distance from the village. Despite the strict con-
ventions of funeral art, which dictated the symbolism, the size
and placement of grave fences and stones, the native artisan
again asserted his creative ability in designing memorial
pieces for the graves of his loved ones.

Native cemeteries in New Mexico are barren and beauti-
ful. A little company of crosses on a hill speaks the last de-
fiance against barren earth and limitless sky. A barbed wire
fence and a cross-topped wooden gate forbid the entrance of
animals, who are little tempted, for here is no green lawn, no
flowers, no trees. The soil is sandy, and there is little evidence
of life but the works that signalize the resting places of those
who await the blast of Judgment. The memorials concern us,
for it is through these that men have spoken in the language
of art their love for the dead and their belief in immortality.
The impulse to defy death and time, to perpetuate grief, is
as old as the pyramids, as intricate as the Taj Mahal, as poetic
as the Oriental prince who incorporated musk in the mortar
of stone towers. In the dry hills of New Mexico, men felt the
same urgent need for mortuary art and expressed it in the
humble materials at hand.

The visitor is struck at once by the intricacy and charm
of wooden picket fences which surround many of the graves.
These fences, which originated in the need to guard the
grave from wild beasts, form a hedge of pointed staves, with

a large and elaborate cross at the head, and sometimes a gate at the foot. It is in the shape and arrangement of the staves that artistry enters. When Victorian fretsaw work was popular, the carpenter drew his patterns from spears, classic vases, lozenges, cutout crosses, opposing curves, and any geometric form that stirred his fancy. If he possessed a lathe, he created a composition of slender knobs and turnings, rhythmically arranged as pickets of the fence, with larger columns at the corners and a delicate spool-turned cross at the head.

About 1915, many communities abandoned the grave fence in favor of a single cross at the head of the grave. The shape of these crosses ranges from severest Roman to the fanciest Maltese; variants are limited only by imagination. The cross arms are notched, knobbed, or branched with smaller crosses. Cutout circles and diamonds are added in symmetrical groups, and various moldings trim the edges. Centers are sunbursts or carvings of the Sacred Heart. Religious medals and manufactured crucifixes blazon the junction of the arms. On some crosses inscriptions or decorations are burned in the wood. On others, crudely painted letters give the name, date, and age at death. The words may be incorrectly spaced, giving the impression of meaningless copying by a craftsman who never learned to write. Perhaps the most ornate of all these wooden mortuary crosses is that made by the sculptor Jose Lopez for his own grave before the church door at Cordova. The woodcarver fashioned a large cross with stairstep diamond ends. He covered it with colored woods and painted designs in a mosaic of checkers and little stars. This piece, into which the artist put so much labor before his death, has been stolen from its place.

Itinerant stonecutters, reputedly Italian, around 1880

came to New Mexico from "the States" and took orders for monuments in marble, granite, and other hard stones. The wealthy families availed themselves of this service, and at Valencia, Los Lunas, Bernalillo, and many other towns of the Rio Grande there are examples of this sentimental, but often excellent sculpture. At Belen, Don Felipe Chavez, a rich merchant, brought sculptors from Italy to build a colored stone mausoleum for himself. Next to the exterior decorations of the Cathedral in Santa Fe, perhaps the best nineteenth-century stone carving in New Mexico is to be found in the architrave and angel cornices of the Chavez Memorial. The structure stood originally before the church door, but recently has been moved to the north side.

Stimulated by professional memorials in stone, the poorer villagers imitated the vogue with local red and yellow sandstone. Though technically immature work, it demonstrated the craftsman's ability to adapt native designs to any medium for which he had suitable tools. Stocky stone crosses and tablets topped with a cross were the conventional shapes, but in the carved decorations regional inventiveness came to light. Designers favored the Sacred Heart and the Cross in many forms. Geometric motifs abounded, most often a version of the six-pointed daisy so well known as a Pennsylvania Dutch hex-sign. On a stone in the Padillas cemetery, this element forms the rowel of a spur. In general, the village sculptor avoided realistic themes, but he did carve approximations of the Victorian funeral sentiments: ribbons, roses, and the Paschal Lamb. Saints were portrayed now and then, with a preference for Santo Niño de Atocha.

Concrete markers have been introduced in recent years, usually an erect cross based in a slab covering the grave. The

pieces are decorated with pebbles thrust in the wet cement to form designs. Divine protection is invoked by the presence of a plaster statue—the Christ Child or Our Lady of Guadalupe —cemented in a niche in the concrete and covered with glass.

A little garland of paper roses gives color, and a memento of the dead, a photograph nowadays, personalizes the marker. One bereaved family at Padillas made a mortuary niche with an empty clockcase of wood and glass. Possessions of deceased may be left on the grave; in one instance a large metal toy street car was laid on the headstone of its child owner. Flowers of paper or foil are twined about the cross and renewed annually.

There are many societies among the Spanish people of New Mexico which have the dual social and religious purpose of aiding in the expense and ritual of funerals. In some cases these correspond to the "burial societies" so well known in the South, and the members make regular contributions to pay for the funerals of individuals, since the expense of a

funeral is a calamity to a family whose annual cash income may be less than five hundred dollars. These societies own richly embroidered banners, always bearing the portrait of the Virgin or one of the saints, which are carried in religious processions and at funerals. One of the largest groups is dedicated to Our Lady of Mount Carmel. The headquarters is at Santa Cruz, and in 1881, Bourke credited the confraternity with five thousand members. Local belief holds that a "Carmelite" may not die until he has felt earth, and it is the practice to bring in an adobe brick so that a sufferer may touch it and be relieved of his last agonies.

Funerals for the wealthy were prolonged and expensive affairs, involving much church ceremony, carriages, and special dress. Davis has recorded expenses of the funeral in 1851 for Doña Gertrudes Barcelo, a famous female professional gambler in Santa Fe. The cost was about $1600, which included $1000 for rites by the Bishop, and $50 for each pause on the way to the burial. Services for the poor were simpler, but Davis itemized an instance where the offices of the Church totalled $141, including $10 for tolling the bells, and $3 for the resting places, on which occasion prayers would be said while a cross was erected by the roadside.

Death was an ever-present threat in the New Mexico village, as it was everywhere until Koch's and Pasteur's knowledge of bacteria was known and understood. Smallpox, dysentery, and typhoid fever spread rapidly where many persons slept in the same room, the most primitive sanitary facilities were lacking, and the water supply was open to contamination. Most families obtained their water from streams and irrigation ditches; within the memory of living men, the water for Old Albuquerque was brought in barrels from

the Rio Grande. Even today, with metal pitcher pumps, wells are often too shallow for safety.

In the old days, the villagers depended upon local healers, *curanderas* they were called, for the treatment of physical ailments, grudges, and affairs of the heart. These women had a knowledge of herbs, some of it learned from the Indians, but charms, incantations, and psychosomatic healing were their stock in trade. Even currently when counties as large as some New England states are served by a single physician, the *curandera* continues to ply her trade with a dash of romanticism not found in the directions on the medicine bottle. She has modernized some of her formulas, and old villagers with blue tobacco stamps pasted on the forehead to draw off a headache are not an uncommon sight in rural New Mexico.

Religion offers solace in moments of crisis, and the little children who die are spoken of by the devout as *angelitos*. The bereaved are asked to rejoice that these new souls have been spared the sin and travail of this world, and gone quickly to the delights of heaven. It was the apparent levity of a funeral procession for a little child which shocked Abert in the streets of Santa Fe in 1846:

"I was much surprised with the manners of the Mexicans at a funeral. They marched with great rapidity through the streets near the church, with a band of music. The instruments were principally violins, and these were played furiously, sending forth wild raging music. The corpse, that of a child, was exposed to view, decked with rosettes, and flaunting ribands of various brilliant hues, and the mourners talked and laughed gaily, which seemed to me most strange. I was told, too, that the tunes played were the same as those which sounded at the fandangoes."

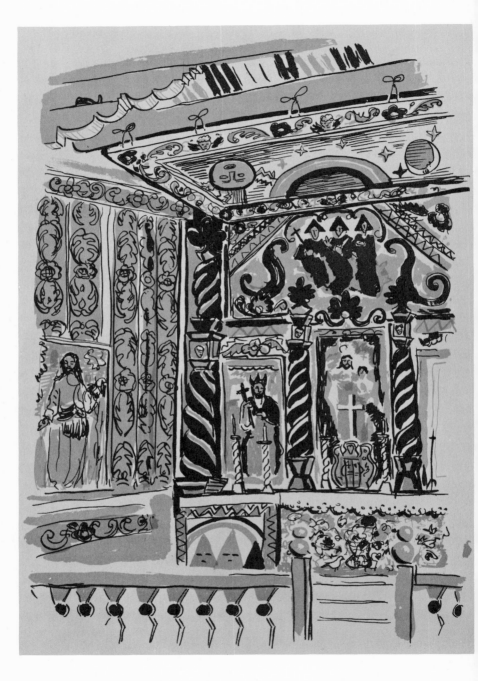

VI. Christian INDIANS

FRAN-
CIS & THE BIRDS

INSPIRED BY RELIGION, and consumed with loneliness for European skylines pierced by a host of church spires, the Spanish missionaries channeled Indian energy into the construction of fine houses for Christ. The Pueblos hid their ceremonial kivas underground, but the white man's religion asked heaven-reaching architecture. And so, as cathedrals towered above Medieval towns, church walls rose high above Indian towns that hugged New Mexican earth.

The seventeenth-century Franciscans wisely relied on the inherent taste of Pueblo builders, who held in their fingers a magic touch for adobe and pine. Nor were these materials new to the Spanish fathers. They had seen the sun-soaked mud walls of North Africa. Their churches in Spain bore ceilings of pine beams, carved and fitted with the exquisite craftsmanship of the Moors. But the basic earth and wood took fresh impulse under Indian hands.

217

The mission churches varied greatly in size and architectural detail. Some were small and modest, the most elementary answers to the request for a house of worship. Others were remarkably large and elaborate achievements in earth, wood, and field stone. The refinement of true keystone adobe arches and carved pine corbels to support roof timbers distinguished a few. Residence missions boasted tall adobe belltowers, wide balconies, and colonnades. Simple cloisters sheltered a labyrinth of monastery rooms and church offices.

An elemental grace characterized the mission church. It had size, strength, and ponderous unity. The hollow block of tons of clay appeared to have been formed in a single gigantic mold. Massive walls, unmarred by detail, tapered upward like sandstone cliffs to the rounded edge of a broad, flat roof. Conical buttresses pushed at the points of stress. Square towers flanked the façade. The church at Pecos, of cruciform plan, had six adobe towers. The simpler structures lifted their flat fronts in a blunt triangle above the roof line. High apertures held Spanish bells lashed to poles with rawhide thongs. A low, undulating wall embraced the churchyard, entered through a mud and timber gateway, topped with a cross. Crosses marked the height of the church, and a tall log cross stood in the yard, between the gateway and the main door.

A cavernous porch shaded the double doors of the portal, and just inside was a tiny choir loft, spanning the nave above the doors. The long narrow nave, dimly illuminated and bearing on its walls the Stations of the Cross, focused the attention of communicants upon the central altar. To throw brilliant light upon the altar from a source concealed from the congregation, windows were set into the space made by

building the roof of the sanctuary somewhat higher than the roof of the nave. This "transverse clearstory window," according to George Kubler, was probably a unique feature of New Mexico churches. The adaptation of tin roofs for adobe churches in recent years has blocked off this ingenious and effective method of illuminating the sanctuary. A rhomboid apse served as the stage in which to present the drama of Christ's life, enacted long ago in the catacombs with a sarcophagus for an altar table.

Not only new sights, but new sounds, greeted the Indians who came to the mission churches. Bells, trumpets, and bassoons brought European melodies to Pueblo ears, heretofore accustomed to the pentatonic scale and the rhythmic noises of drums, rasps, gourd rattles, and the untuned bone flute. Along with reading and writing, the padres taught Indian youths to make and to play musical instruments. In 1626, Benavides listed among his New Mexico supplies "Five antiphonal books composed by Fray Geronimo Ciruelo of the Franciscan order," for use in responsive singing between the priest and the congregation. At Taos, said Benavides, "is the wonderful choir of boy musicians, whose voices the friar chose from among more than a thousand who attended the schools of Christian teaching." At Zuñi and San Felipe, the boys learned organ chant, and "good organs" were noted at Pecos and Jemez in 1641.

In competition with Indian religion, the padres gave the interior of their churches whatever magnificence they could command. An ornate reredos of carved and painted pine was erected to house oil paintings carted from Mexico. The walls were whitened with gypsum plaster, and mica-rich *tierra amarilla* clay made a painted wainscot of reddish gold. Carved

geometric and animal designs decorated the ceiling beams at Pecos and Humanas. The effect was completed by the panoply of sights and smells and sounds which accompany the Church throughout the world—candles, incense, solemn music.

A suggestion of the interior appearance of seventeenth-century mission churches is echoed in the present-day church at Laguna Pueblo. This church was built in 1699, a few years after the reconquest of New Mexico by de Vargas. Its interior is the most ornate of all the Indian churches now standing.

The Laguna altarpiece, with its twisted columns of carved wood topped with baroque swirls and palmettos, imitates in miniature the structure of the main altar of La Caridad in Seville. The upper half of this New Mexican reredos portrays the Trinity as three red-robed beings in human form. This anthropomorphic concept is a survival of a style long out-moded in Europe, but not uncommon in New Mexico. God the Father sits in the center, His fingers raised in benediction, a scepter in His left hand. At the right hand of the Father sits the Son, bearing the Cross, and at the left is the Holy Ghost identified by the dove, a convention derived from ancient Egypt, where a bird symbolized the human spirit. Each figure wears a triangular halo.

The four sculptured columns of the reredos support three large paintings in tempera on wood coated with gesso. The church is dedicated to St. Joseph, and his portrait occupies the central panel. The saint carries the Christ Child in his left hand, and in his right the traditional blossoming rod by which he was selected as the husband of Mary. On the left panel is painted St. John of Nepomuk, wearing his triple crown of martyrdom; beside him is drawn the bridge beneath which he was drowned. *Laguna* means "lake," and in New

Mexico, John of Nepomuk is the patron of irrigation. The third picture is of St. Barbara carrying the monstrance. Behind her is the donjon keep, symbolic of her imprisonment. St. Barbara is believed to save the devout from being struck by lightning, a fate much feared in New Mexico.

Across the front of the altar table is a tapestry-like painting on leather depicting potted plants in bright colors, with tiny birds and butterflies. Beside this, typical Indian designs of mountains and the rainbow have been painted on the adobe supports to the altar table.

A large painting on animal hides covers the ceiling above the altar. The border is of baroque floral design, interspersed with the faces of angels, but the subject is pagan in aspect, revealing the rainbow flanked by the sun and the crescent moon, with four-pointed stars. Benavides, in his Memorial of 1630, describes a somewhat similar painting on skin presented by the Gila Apaches—"in the middle of it was a sun of green color, with a cross on top; and below the sun was painted the moon in grey color with another cross on top." It has been suggested that what Benavides took for crosses were really stars, and the Laguna hide painting is interpreted as having white morning stars and yellow evening stars. These pieces illustrate the typical intermingling of symbols from Christian and Indian sources which began with the first conversions and continues today.

The full length of the nave at Laguna is dominated by wide bands of painted Indian design. The motifs appear to be those of Pueblo pottery, yet they are given Christian meaning. Rainbow-like curves are described as tombs, and turtle-doves as the souls of the dead. The birds are done realistically, and each holds an accurately drawn local flower, but the

remainder of the painting is severely stylized. In marked contrast to these native murals hang Stations of the Cross, not of Indian make. Beneath each is a candlestick of Laguna pottery. Abstract religious ideas, such as soul and death, translate readily into Indian art, but concrete happenings, like Christ carrying His cross, remain European pictorial concepts.

The construction technique revealed in ruins of certain long-deserted missions illustrates the architectural peak reached in New Mexico during the seventeenth century. Most of the churches in living Pueblos are of adobe, but three hundred years ago rough stone was also a favorite building material.

That strange group of Indian towns called the Saline Pueblos took character from the wooded borderland between the Manzano Mountains southeast of Albuquerque and the Great Plains of eastern New Mexico. Down the center of a broad valley are a series of weird transient lakes—the Lake of the Dog, and others—which rise and sink with moisture and drouth, and form at times an impassable barrier to the plains beyond. The shores of the lakes glisten with salt, which Indians traded for untold generations, and the Spaniards scooped up and sent back to Mexico with the supply trains.

In this dramatic valley are the ruins of the Saline Pueblos, deserted before 1675. The Indian houses, pyramidal in appearance, were of flat stones cemented with mud mortar. They had some of the fortress character and precise masonry of the long-dead towns of Chaco Canyon in northwestern New Mexico. In these Saline villages, Franciscans fostered the building of great mission churches at Quarai, Abo, and Humanas.

The church walls were laid of crude rock slabs, mortared with adobe mud. Six feet thick or more at the base, the walls tapered upward to heights above thirty feet. Heavy timbers of Douglas fir, the royal pine of the Spaniards, were squared to form ceiling beams. These were lightly carved in the Moorish fashion, and enriched with earth colors. Each of the churches has an approximate floor area of 5,000 square feet, with interior dimensions roughly fifty feet wide and one hundred feet from door to altar—a considerable engineering feat for people of limited tools and no previous experience with large buildings. The floors were finished with flagstones, and the interior walls received thick coats of white gypsum plaster. The tall windows had wide, sloping sills.

Though basically European in design, following the pattern of old basilicas, the padres encouraged the ingenuity of the Indians, and the result was a powerful and extraordinary architecture to be seen nowhere else in the world.

Before the seventeenth century reached its bloody climax, the Indians who built the Saline Missions had fled their villages. Various reasons have been suggested: raids by Comanche and Apache, consolidation at the order of the Spaniards, consolidation for defense against the Spaniards, drouth and crop failure, and pestilence. Here, as a hundred

places in New Mexico, ruins trace the passing of peoples who, for reasons of their own, felt it wise to desert their homes and settle elsewhere. Of more than seventy pueblos counted by Coronado, twenty live today. Not all these disasters can be laid at the white man's door. A similar shift and dying of populations was in sweeping operation for centuries before the Spaniards came.

In the seventeenth century, a mission supply train from Mexico came to New Mexico every third year, a wagon being allotted each two friars in the province. The round trip, including a pause in Santa Fe for rest and refurbishing, took a year and a half. Salt, hides, and Spanish and Indian textiles were loaded for the return trip.

This supply train was the mail-order lifeline of New Mexico's missions. For the church building it carried tools—axes, adzes, Mexican hoes, augers, chisels, carpenter's planes, and two sizes of saws. Hardware included hinges and hook-and-eye latches for windows, door locks, tin-coated nails, and

"spikes a span long." Franciscan missals; statues and paint-
ings; silver chalices and patens, plated with gold; Turkish
carpets; Rouen linen and Canton damask—these equipped
the altar. For the comfort of the missionaries the wagons
brought Mexican blankets, clothing and sandals with needles
and thread to repair them, sack cloth (one hundred yards per
priest), and a razor for each two friars. Refectory pleasures
were assured by wine and olive oil, cheese, shrimp and dog-
fish, sugar, pepper, and cinnamon, dried peaches and raisins,
Castile rice, Campeche honey, and Condado almonds.

For the Indians these seventeenth-century caravans
brought the inevitable trinkets—little bells, macaw feathers,
glass beads.

The zeal and magnificence of the first missions were not
destined to last. Under the impetus of moral and financial
support from the Crown of Spain, the churches in New Mex-
ico reached a peak of architectural excellence and Indian
coöperation. But the wrongs inherent in Spain's administra-
tion of her colonies became increasingly irritating. In 1680
the Pueblo Indians rebelled and drove out their conquerors.

The churches in New Mexico changed with the demands of
fashion. Time, flood, fire, and the rise and fall of community
faith and economic status left their marks on individual mis-
sions. The tag-ends of history show in the crude adzed timbers
of the seventeenth century, baroque decoration from the
eighteenth, American tin roofs and glass windows of the last
century, electric lights and coal stoves of recent years. Except
for foundation walls, many present-day mission buildings
must date their actual construction from the eighteenth cen-
tury or later, since most New Mexican churches were de-
stroyed in the Pueblo Rebellion.

Spaniards entering New Mexico, like Americans three hundred years later, labored under the mistaken impression that the Pueblo Indians were a primitive, that is, a "simple" people. Acts of violence against the Indian were instigated by a sadistic minority who thought of men with darker skins as "inferior" and therefore having neither rights nor sensitivity. Through four distressing centuries the Indians have had many friends and champions. Their relations with the white man, even today, are a story of changing and conflicting policies.

The Indian lacked some of the conveniences of European life—beasts of burden, iron, gunpowder, and formal writing. But the Pueblos had an advanced civilization: a complex social structure, a philosophic religion, irrigated agriculture, substantial architecture, and mature arts and crafts. With allowances for drouth and marauding neighbors, they had worked out efficient, satisfying, and peaceful lives—more than could be said of the restless Europeans.

Indians reacted unfavorably to fierce-visaged young Spaniards who rode into their villages brandishing steel weapons, requisitioning supplies in a land where the hard work of irrigation made food precious.

Oñate the colonist, in his relations with the Pueblos, repeated the same gory precedent that the Spanish military had set in Mexico, Peru, and the Philippines. As lodging for himself and his followers, Oñate took over an entire village, forcing the Indian inhabitants to build new houses nearby. For the five years after 1598, New Mexico's first Spanish settlement depended upon the Indian for labor and food. Those Pueblos, like Acoma, which were so rash as to protest, met reprisals of slaughter and unbelievable cruelty.

Homesick and impoverished, the Spaniards were soon disgruntled with New Mexico. The Indians, taxed and tortured, quickly regretted having pledged peace. Only the Franciscan fathers had uncovered a bottomless mine of spiritual rewards.

The sovereigns of Spain, holding title to New World lands by Papal proclamation, were obligated to sponsor a harvest of Christianized souls among the Indians. Willing instruments for this task were the Franciscans.

Missionaries faced a difficult assignment in New Mexico. Eight friars who accompanied Oñate were apportioned among some sixty Indian villages, representing almost as many dialects of at least eight major Pueblo languages. Lacking the leveling factor of writing, Indian language families differed from each other more than English does from Russian.

Language barriers, distance, and short supplies were problems that could be met in a practical manner. But the missionaries had a psychological competitor—Indian religion. It had all the spiritual stimuli and material trappings that a mature religion could offer. And Christianity had few ideas that were really new and startling to the Pueblo Indian.

Pueblo religion is indigenous to the land and the lives of the people. It is embodied in ritual and bolstered by kinship and common experience. Dramatic ceremonies signal events important in Pueblo life—the changing of the seasons, planting and harvests, war, pestilence, and drouth. Music is highly complex, and a long unwritten store of liturgical chants and sagas is based on the emotional and historical experiences of each Pueblo. The dances require rigorous training and rehearsal, and are enhanced by magnificent traditional costumes.

The center of religious activity is the kiva, an underground chamber, usually circular, equipped with an altar, and decorated with mural paintings. It is made impressive by darkness and fire, which have been conducive to a religious mood since the beginning of cabala. An Indian witness said that the destruction of all kivas by the Spaniards directly incited the Pueblo Rebellion.

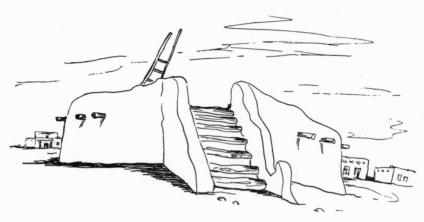

The religion of the Pueblo Indians might be described as formal animism, in that it assigns spiritual qualities to objects and forces in nature. There is, in addition, a pantheon of personalized gods, who perform supernatural duties with reference to the Indian and his environment. Since ancient times, each Pueblo has practiced its own set of beliefs and accompanying ritual. Though these conform to a common pattern, the religion does not serve to unite the Indians in the way that Christians are of one body.

The Indian had knowledge of scores of herbs, and conducted ceremonies which accomplished psychosomatic healing. The Pueblo shaman was skilled in magical performances.

But the friars were not without their triumphs. Miracles were attributed to them. Trained in the medicine of their day, the Franciscans equipped their hospitals at Santa Fe and San Felipe with drugs and surgical instruments.

The mission churches of the seventeenth century were founded by friars living almost alone among large Indian populations. Their great success as missionaries is evident in churches still in use and in the remarkable ruins of abandoned missions. The real secret of Franciscan success lay in that cornerstone of Christian faith—the love of humanity. Sincerity and an understanding heart overcame lingual and cultural differences. The statistics on record, while probably over-enthusiastic, are impressive.

By 1617 eleven churches had been built. Fourteen thousand Indians were baptized. In the next ten years thirty-two more churches were erected, and the number of the faithful increased to 34,000. By 1630 the converts numbered 86,000, and fifty Franciscans ministered to the Christian welfare of the Pueblos. Sixty-six missionaries at Crown expense was the quota fixed, but rarely filled, for New Mexico through most of the mission era. The ordeal was so great that many deserted, or refused their assignments on the basis of tales of hardship. At the peak in 1640, about forty mission churches were active in New Mexico.

Spanish *politicos* were appointed by the Viceroy of Mexico to the governorship of New Mexico, and frequently shifted from the post at the request of the priests and the residents. These governors' terms averaged three years, a new one coming with almost every supply caravan. Therefore they had little understanding of the true state of affairs in the province. Trying to recoup the small fortunes they spent in getting and

holding the job, the governors bartered with the Indians, sometimes at the point of a gun, and the resulting discontent reflected on the efforts of the missionaries.

Under cruel, greedy, misinformed, and harrassed administrators, Spaniard and Indian alike suffered and were exploited. One governor ordered wholesale beheadings of Spanish officers. Others expected the priests to act as their agents in unfair trade with the Pueblos. Demands that Indians labor on feast days of the Church increased the friction. The notorious Governor Rosas beat one of the missionaries severely with a cane as the friar knelt in the street before San Miguel Church in Santa Fe.

In retaliation, the Franciscans used their ecclesiastical powers, often despotically, of excommunication, penance, and interdict, backed by the threat of the feared Inquisition. The official representative of the Inquisition in New Mexico —Benavides was the first—often protected the converted Indian from abuse by secular authorities.

The Pueblo Indian, like so many dark-skinned converts to Christianity, shrewdly observed that white men bore arms and stole and coveted and committed adultery. When they could no longer bear Spanish authority—indignities and taxation and bloody penalties on accusation of witchcraft—the Indians plotted among themselves, and united to drive the white man from their once-peaceful land.

The Pueblo Rebellion of August 1680, came as a surprise attack, despite rumblings long in advance. Mission outposts and lonely ranches were wiped out. More than four hundred Spanish colonists were killed. Friar Maldonado was said to have been thrown from the great cliff of Acoma: twenty-one other Franciscans were murdered with equal ferocity.

Churches were burned, and books and vestments despoiled.

But the Indians did not unite effectively enough to prevent the re-entry of the Spaniards under the able leadership of Don Diego de Vargas, who came up the Rio Grande from El Paso in August, 1692, taking the southern Pueblos without loss of blood. The Reconquest was less easy when De Vargas began to move the colonists back on the lands Indians had occupied for thirteen years, including the town of Santa Fe itself. It took nine months to subdue the tribes who held the Black Mesa above San Ildefonso.

To make room for the new Spanish settlement at La Cañada, Galisteo Indians who had settled in the fertile Santa Cruz Valley after the Rebellion were requested to move eastward to Chimayo. This touched off a second conflict in 1696. Many of the northern Pueblos combined, and some twenty Spaniards and five Franciscans were killed. But the diplomacy of De Vargas and his military strength brought order into the province and launched the eighteenth century for New Mexico in comparative peace.

The Apache and Navajo troubles, which were to arise again and again, began with the Spanish practice of seizing these once-tranquil tribes as slaves, since they were "unconverted" Indians and had no one to defend them. These tribes, considering the Pueblos as allies of the Spaniard, raided villages in retaliation.

Americans did not acquit themselves much better in 1863 when they "scorched the earth" of the Navajo country, killing sheep and trampling cornfields, finally to corral the Navajos in the tiny reservation of Bosque Redondo (Ft. Sumner) two hundred miles from their homeland. Starvation and smallpox subdued them.

Financial support withdrew from the mission churches in 1834, when they passed from Franciscan control and became parishes, that is, self-supporting, under orders from the Mexican government. For three centuries some seven hundred Franciscans had bombarded the Pueblo Indians with Christian doctrines and Old World culture. Forty-two friars had met violent death in the first century and a half of missionizing.

The Indian accepts the presence of the Church in his Pueblo, but the native religion continues to operate side by side with Christianity. At the various Rio Grande Pueblos, ancient dances are held on feast days of the patron saints. In Spain, the statues of saints are brought out of the church for dances in their honor. At the Pueblos, *santos* are carried into the plaza and placed under a bower where they may watch pagan ceremonies and receive the homage of each performer as a division of the dance is completed.

On Christmas Eve, the Isleta Indians dance in the church. On Palm Sunday, the people af San Ildefonso march about the Pueblo with evergreen boughs, and the Santa Claras carry little crosses of peeled green shoots in *piñon* bouquets to be blessed in the church at Santa Cruz. Afterwards these "palms" are stuck in the soil of the corral or the field to invite fertility of cows and corn. After touching the Santo Niña, Zuñis breathe on their hands in a typical aboriginal reverent gesture.

St. Francis of Assisi, in his Canticle of the Sun, praised God for "our mother the earth, which doth sustain us, and bringest forth divers fruits and flowers of many colors." His Sermon to the Birds in 1215 foretold the end of Byzantine art, and the beginning of a new humanism and naturalism, of which

Giotto was the first great exponent in painting. St. Francis, who loved all God's creatures, would have applauded the Indian impulse to paint their love of birds, beasts, and flowers, the sun, the stars, and the rainbow, on the walls of Franciscan mission churches.

When the American commercial artist uses Indian designs, he spoils the essential quality of freehand execution and proper setting. When the Indian artist decorates a Christian church, he makes similar unconscious errors in taste.

The Indian has an art tradition, perhaps not as old, but certainly as tenacious as that of the European. Long isolation on the American continent refined and sharpened his expression. The Spanish art tradition was superimposed, and the Pueblos kept it largely within the bounds of a single institution—the Church. The personality of each Indian Pueblo inevitably crept into the churches they built and furnished, for with Spanish art was mingled the Indian decorative spirit and rhythmic geometry.

Indian and Spaniard, in producing Christian art in the American Southwest, drew upon the same sources of Christian iconography. They were guided by the same European priests, and they used the same natural materials for building and decorating.

Nevertheless, there is a sharp distinction in spirit between these two peoples, and this essential difference penetrates the art of each. The Indian hated the Spaniard for a conqueror, and scorned to copy him. The Spaniard thought of the Indian as an infidel savage and a slave, too uncivilized to imitate. Rubbing cultures in New Mexico for centuries blurred and erased some of the dividing lines. The two peoples borrowed practical lessons from each other—ways of processing raw

materials. But in the world of thoughts and emotions they remained aloof, and their arts recorded this fact.

Most of the native statues and paintings in Indian mission churches seem to have been made by Franciscans and local Spanish artists. Rarely was the Pueblo artist trusted to portray the saints in pigment or wood. Architecture and decoration are the two fields of Christian art in which Indian work is most evident.

Contrasting the Christian art of Pueblo Indians with that done by men of Spanish descent, the compositions of the Indian show more symmetry and graceful balance. When he uses color it is more subtle, and at the same time more brilliant. Above all, his work is rhythmic, giving an almost musical harmony to the work of his hands. The Indian has a delicate sense of texture and proportion, so that even his architectural surfaces are vivid and compelling. He combines a deep understanding of nature with a profound respect for the magic qualities of art, and endows his achievements with spiritual integrity.

The Spanish artist in New Mexico sought to express the dictates of his head and his heart in conventional European symbols. His saints made histrionic gestures. He was concerned not with mortal bodies, but with certain universal emotions—the heartbroken sorrow of Mary, the ecstasy of Francis. The Spaniard achieved poetry and deep religious emotion in art, but, unlike the Indian, he did not subscribe to art for its own sake.

Under Indian hands, the Spanish art heritage in New Mexico produced powerful original architecture, and the curious incongruity of Christian asceticism interpreted with Indian sensuousness.

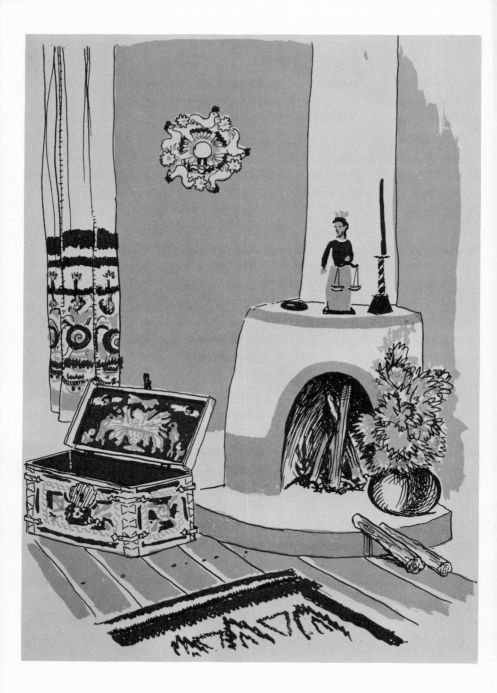

VII. RESURGENCE

CHAPTER FOURTEEN

GESTURE OF NARCISSUS

PROVERBIALLY, romance near at hand is neglected, and the significance of the New Mexican village has been eclipsed very often by the more bizarre elements of Indian culture. Toward the end of the nineteenth century, when at last the Apaches and Navajos were confined quietly on reservations of unwanted land, a few souls began to worry about the "vanishing American." For some time travelers had been picking up pottery and blankets as souvenirs, and now that the Indian himself was in no position to be heroic, he was glorified in the Hiawatha tradition. Village arts frequently were mistaken for Indian products, and the receptive frame of mind already associated with the Indian thus was transferred gently to Hispanic phases of the Southwest. Regional pride was encouraged throughout the country when the bursts of patriotism set off by foreign wars sent journalists beating the brush for

American themes. Meanwhile, the building of new highways for automobile traffic prompted the serving up of local lore as an appetizer for tourists. The creations of the "folk" and the non-industrial peoples of the world gained public attention when cosmopolitan artists, struggling to escape an overripe tradition which concerned itself with technical finesse, turned to so-called "primitive" art for fresh inspiration.

Few people indeed recognized the everyday things of their own culture as potential art, nor regretted the passing of grandfather's armchair and grandmother's butter-mold. Not until the old pattern of New Mexico village life was almost beyond recall was there serious effort to record it and to place its characteristic fruits under glass. Within the present generation it has seemed worthwhile to revive some of the village arts, and to utilize their virtues in modern homes.

The first attempt at revival of native styles was in architecture. Here again, the emphasis was on Indian tradition, and the earliest examples were called "Pueblo" buildings, although they incorporated such Spanish elements as doors, windows, corbels, and capitals. The Santa Fe Railroad took the lead, and designed its stations with pseudo-California mission exteriors, filling the interiors with furnishings made by New Mexico villagers, Southwestern Indians, and the artisans of Mexico, Spain, and Italy. Since these displays were intended to attract the attention of tourists, "curio" appeal was played up. Eventually the Fred Harvey System acquired some of the best collections of American-Spanish and Indian antiques in existence, and their agents became authorities in the field. Visitors were properly impressed, and the cult of regional architecture spread to business houses, private dwellings, and public institutions.

Santa Fe became once more a flat-roofed Pueblo. The Palace of the Governors was stripped of a Victorian façade, and "restored" to an earlier concept, yet retained its Territorial fenestration. This revival of native architectural styles was influenced more by ecclesiastical than by domestic themes. Architects attempted to blend the notable features of historic churches in a harmonious style. The towers of Acoma, the balcony at San Felipe, the carved beams of Pecos and Humanas, the doors of Santo Domingo, details from Santa Cruz and Chimayo—such elements have been resolved into various institutional buildings, including the Art Museum in Santa Fe, and the University of New Mexico in Albuquerque.

In adapting religious architecture to secular purposes, and further altering it to meet the demands of concrete, electricity, central heating, and limitless window glass, the modern versions carry only a thin suggestion of their prototypes. In many cases the symbolism is quite absurd: bell towers on a business house. All too often tremendous discrepancy occurs between interior and exterior design. Because the essential functions of religious architecture have remained unchanged from mission times until the present, several of the newer Catholic churches—El Cristo Rey in Santa Fe and St. Thomas at Abiquiu—have copied earlier models with eminent success.

Domestic houses in the Territorial style have had some effect on such buildings as the Carrie Tingley Hospital at Hot Springs, the Little Theatre in Albuquerque, the Supreme Court and the City Hall in Santa Fe. Except in architectural details—door and window trim and roof coping—the construction can hardly be distinguished from standard practices throughout America. Nevertheless these details lend an acceptable regional character.

Large adobe residences and other extensive housing, such as stores, even in ruins, are sought eagerly by Americans for conversion into modern homes. Aside from the practical advantages of thick, well-built walls, and perhaps an ancient grove of trees, historic associations are the chief appeal of these places. Like soldiers bedded down in a baronial castle, the present-day entrepreneurs seem to wish somehow to recover for themselves the supposed feudal grandeur of the former occupants. They reconstruct the architecture with elements derived in the main from native churches rather than from houses, superimposing a wealth of carved doors, hand-cut moldings, and wooden or iron grills. Meanwhile the earthen walls are channeled for electric wires, and the floors piped for air conditioning, before both are sealed with concrete. Frequently, actual pieces from abandoned churches, such as *vigas* and corbels, the age of which makes them structurally unsound, are incorporated. The architectural result has little resemblance to any *rancho* home of the Hispanic period.

In the course of thirty years, regional style has become so popular that it is now almost a cardinal sin to build otherwise in Santa Fe or Albuquerque. As interpreted, this style is by no means pure, and seldom has much relation to function. Often a flat roof and *viga*-ends (perhaps false) projecting on the outside of the house are the sole concessions to the fashion, while the interior cannot be distinguished from Dubuque or Walla Walla. The raw materials, adobe and logs, in which the architecture originated, quite often are conspicuously absent.

A few builders, fortunately, have approached the problem with genuine understanding, and their houses are a felicitous blend of historic practice and modern convenience. Blessed

with insight and restraint, they have utilized native materials to great advantage, making their dwellings pleasant with the honest colors and textures of adobe and pine, comfortable and substantial in the generosity of simple materials and unbroken space. New Mexican furniture and fabrics are appropriate in such a setting, while tinwork and *colcha* embroidery give ornamental relief to solidness and severity. There are overzealous citizens of course, who, in a passion for romantic surroundings, create domestic museums. Perhaps the worst offense of this coffee-grinder-into-lamp school is their use of honest pieces in flagrantly non-functional connotations.

After World War I there was a concerted effort to gather evidences of dying folkways. The Spanish Colonial Revival movement, which had some of the fire of the old-fashioned Methodist revival, was led by Mary Austin, Frank Applegate, and other appreciative souls who recognized the intrinsic beauty of the New Mexican tradition and sought to perpetuate it. The term "Spanish colonial arts" has come into use to identify native products, but the phrase is somewhat misleading, since it discounts the Mexican period when New Mexico was no longer an outpost province of Spain. Further, "Spanish colonial" fails to imply the strongly local character which developed in New Mexico in the absence of tropical materials and closer contact with Europe evident in the arts of colonies further south.

A common error of studies in the village arts has been the careless assignment of designs and techniques to the influence of neighboring Pueblo Indians. These misconceptions still persist, and many objects, such as the reredos in the New York Hispanic Museum, have been labeled as of probable "Indian"

manufacture, when they patently are made by New Mexico villagers. Although cultures existing side by side are prone to copy each other, there was far less artistic commerce between Pueblo and Spaniard in the Southwest than is commonly assumed. Certain writers with exaggerated notions of reputedly inherent racial traits, have concocted theories about Indian talents rising from the bloodstream and coloring the Spanish arts. Although miscegination undoubtedly occurred, the individuals leaving their parent race generally were ostracized by their own group, and normally assimilated the culture of the group they joined. Much has been made of the enslavement of Indians, particularly Navajos and Apaches, by the Spaniards. Here again, the influence upon the arts was small, for these slaves generally performed menial tasks, such as housework and spinning, and in most cases European techniques were imposed upon them. Even in the field of design there was very little interaction. Many of the figures pointed out in the village arts as "Indian" are merely parallelisms, and stem, especially in textiles, from Oriental origins. These factors of separation apply equally to Indians and Spaniards, and most especially to the traditional religious arts of each group. Not Pueblo, but Old Mexico Indians seem to have implanted certain alien derivations in village culture, for numbers of them increased the early Spanish settlements of the upper Rio Grande.

Adversity invites resourcefulness, and the economic depression of the nineteen-thirties turned the hands of many village craftsmen to their ancestral arts in an endeavor to make a living. The New Mexico Department of Vocational Education, the Native Market Guild in Santa Fe, the Works Projects Administration, and other agencies, sought to augment

the ready cash of skilled workers by providing markets, training, and employment. Schools, such as the San José Training School, were established to encourage cabinet making, leather work, weaving, embroidery, and other enterprises requiring small capital outlay. Regional antiques—chests, chairs, blankets—were offered as models, and modern methods applied to their reproduction. The peak of this activity was not destined to be permanent, since there were only two logical outlets for most of the materials produced: the furnishing of public buildings, including museums, and sales to persons who wished to decorate their homes in native style. Some of the arts, furniture and embroidery particularly, proved too time-consuming to warrant their continuance in times of prosperity when wages are high. Other crafts—tinwork, weaving—have survived because their price-range falls within ordinary means, and because they have appealed to tourists. Esoteric items, such as replicas of religious pieces, are of primary interest only to museums and collectors, a market quickly saturated.

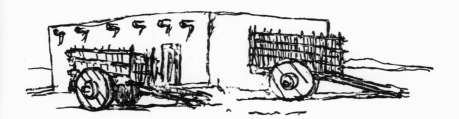

Regional styles of architecture were exploited in many public buildings erected to provide employment during the depression, and this trend has been followed widely in schools, civic institutions, hotels, and business houses constructed

within the last few years. Many communities were fortunate
in being able to have the interiors of their buildings enhanced
with authentically designed furnishings hand made by work-
men of the Federal Art Project, and the National Youth
Administration. By this means, the public made acquaintance
with excellent examples of New Mexican chairs, *trasteros*
and chests, weaving and *colcha* embroidery, and decorative
tin. No longer sponsored by Federal funds, the greater num-
ber of the native craftsmen who produced these pieces have
turned to other work, but a few have continued to make a
living at the age-old trades. The designs, especially in furni-
ture, have been taken over by commercial shops, which
employ power tools in producing the pieces demanded by
modern offices, hotels, and restaurants, often merely adding
ornament to factory items. Home workshops and the voca-
tional departments of schools and colleges are the chief expon-
ents of the original crafts at the present time.

It is inevitable that in adapting New Mexico village arts to
present-day needs, materials, and tools, the character changes
accordingly. For example, when a chest is constructed of
machine-planed pine, tailored with square and level, cut
with sharp saws and steel drills, fitted with standard dowels
and chemical glue, hinged and locked with pressed hardware,
patterned with the aid of compass and ruler, carved with a
variety of precise chisels, smoothed with graded emery papers,
and finally finished with a coat of alcohol-proof varnish, the
result is vastly different from the hand-hewn prototype. Not
only is the piece shorn of individuality, rugged texture and
intrinsic color, it has lost the indigenous qualities of struggle
and spontaneity with which the old-time craftsman, by neces-
sity, endowed it. The modern carpenter who assays to "copy"

an antique has taken on a task that is too easy, unless, of course, he attempts an exact replica, which he can achieve only by the methods of a century ago, an extravagantly foolish gesture. The handworker may learn effective methods and suggestive designs from old pieces, but if his product is to have virility, it must exhibit an intelligent and harmonious use of his tools and materials.

From the soil itself, plus rocks and trees, the New Mexican built his house. On a foundation of field stones, he laid thick walls of sun-dried mud, roofed them with logs and brush, and finished the entirety with earthen plaster. The qualities of mud gave the house a plastic unity, a warmth of color and texture, and a complete harmony with the landscape available in no other medium. The spectacular accomplishment of the turbulent seventeenth century was the construction of monolithic Pueblo churches. Under the guidance of Spanish priests, the Indians applied their ancient building techniques to the traditional plan of the Christian church, and the result

was one of the most original and effective styles of architecture on the American continent. The little village churches, modelled on the same lines, were centers of esthetic expression, and, as everywhere in the Christian world, they received the best efforts of native builders and decorators. Regional designs in domestic and public architecture are among the important and lasting contributions of New Mexican culture.

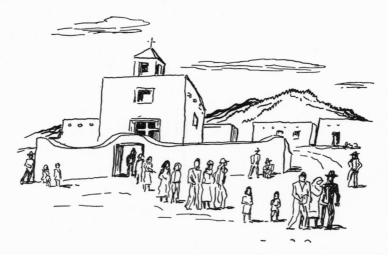

Frugal use of wood and the absence of hardwoods distinguished Southwestern settlement from the forest-frontier of the Thirteen Colonies. The tall, straight pines needed for roof timbers, door frames, and furniture, grew on the mountain slopes, often a day's journey from the village. New Mexican arts diverge from peasant arts of Europe in that wood is never used with complete familiarity, and never lavishly, even in furniture. "Whittling" was not a pastime here. Low-grade tools accounted for some of this timidity, and the structural limitations of pine and cottonwood were further inhibiting

factors; even sculptors did not realize the full artistic pos-
sibilities inherent in wood. Fettered by an unfortunate Con-
tinental fashion, the local sculptor hid honest wood under
coats of gypsum plaster, completed his carving in this anemic
medium, and then painted the piece realistically. By contrast,
when the Pueblo Indian painted ceremonial dolls, he did not
destroy the virility of the wood, nor fail to relate his painted
designs to the fundamental form at hand. Because they were
functional, and not tainted by formal concepts of art, the vil-

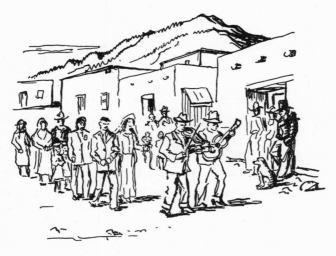

lager's wooden tools and utensils were among his most pleas-
ant accomplishments, although he rarely decorated them in
any way. In architecture, wood was used with complete frank-
ness: ceiling beams were dressed logs not even adzed to square-
ness, corbels were carved with simple grace and no loss of
function. But in the altarpiece, and here again the craftsman
felt himself in the artificial world of "art," was wood disguised
under plaster and paint—those dishonest imitators of labori-

ous carving and expensive surface. This is not to deny the power and effectiveness of native religious sculpture, but to observe that few native artists, any more than artists or other men anywhere in the world, were sufficiently daring to free themselves from the tyranny of tradition.

Gypsum and other minerals abundant in New Mexico were basic materials for artist and layman. Crystallized gypsum was an opaque substitute for window glass. Powdered gypsum, mixed with water and a cohesive, solidified to a hard white plaster used on interior and exterior house-walls. The artist evolved a similar formula which he used as plaster of paris in sculpture and as an absorbent gesso base for paint. The use of gypsum in any form has virtually disappeared from native life in favor of modern chemical products. Of the selenite windows, quite common until 1880, only a few empty frames remain. Colored clays were ingredients of house paints, artists' pigments, and cosmetics. Pumice stone and sand were the abrasives to polish wood and metal.

Plants provided not only food, but medicines, dyes, brushes, fiber rope, and the materials for basketry. Both Indians and Spaniards were expert tanners and leatherworkers, fabricating an enormous number of objects from skin. Not only clothing and bedding, but bags, ropes, bellows, hinges, harness, and chests, paintings, even sculpture involved the use of leather and rawhide. Tallow and sinew were likewise valuable. The processing of wool was introduced by Spaniards, and both weaving and needlework achieved high levels of craftsmanship and originality in the villages.

Work in metal came late in the common tradition, but not too late to be influenced by regional cleverness. Ornamental tinwork became a popular art. Spanish silver techniques

stirred the creative impulses of Navajo and Pueblo Indians to invent a style of jewelry now widely appreciated. New Mexican goldsmiths, stimulated by an active market during the nineteenth century, perfected filigree ornaments which represent an extreme refinement of the provincial tradition.

The fine arts—painting and sculpture—were associated almost exclusively with religion, and consisted of portraits of the saints and the Christian hierarchy. Emotional intensity characterized the work, lifting it above mere decoration, and into the realm of transcendent expression. Poverty of materials kept the artist from straying into the path of facility for its own sake, and the carved and painted saints speak to us with the directness of Gothic art. Color was secondary to linear design, but had the melodic harmony of low-keyed earth pigments. In the corners, the borders, the garments—areas not dictated by religious protocol—the artist freed his fancy with decorative inventions of great charm.

Our knowledge of religious arts and customs in New Mexico is much indebted to the fact that many nineteenth-century travelers were Protestants, and wrote detailed accounts of matters which might have passed unnoticed by Catholic observers. Victorian Americans had very definite ideas on "art and beauty," and the items which did not conform to Raphael slickness and sweetness were vigorously condemned. "Mexican" art was a term of reproach, even as "Gothic" long ago

was synonymous with *barbarous* to the admirers of Roman architecture. Yankees were, and still are, at loss to understand the terrifying emotionalism of village crucifixes, much less the bloody dramatization of Christ's last hours by members of the flagellant *Penitente* Order. They forget that Spain's bitter front-door crusade against Mohammedanism lasted eight hundred years and filled Spaniards with an indelible passion for Christianity which no people in Europe could match for fervor and fanaticism. New Mexican art remains stark, powerful, and histrionic.

Despite this austere approach to the fine arts, the villager practiced the greatest intimacy with his religion. The saints were his close friends, watching over his daily life, mentioned continually in his proverbs and sayings. If he awoke late, he had "slept until St. John lowered his fingers." St. Rita— the natives say "she burned her dress when she went to get her husband out of hell"—could be counted on to achieve the impossible. Even thieves had an intercessor in El Buen Ladron, who was crucified beside Christ. At Christmas and Easter, the community dramatized stories from the Bible, chanting musical themes almost forgotten by the world outside. Twentieth-century skepticism has not destroyed a comforting belief in the supernatural. Stories of religious miracles are current coinage, and, in rural villages, processions and miracle plays still signalize the Christian holidays.

For more than a hundred years now, people of American parentage have called New Mexico their home. They have fallen in love with the landscape, the climate, and the picturesque heritage—the staunch earthen houses, the simple honesty of native furniture and fabrics, the cheerful fatalism of the inhabitants. Half a century ago artists, writers, and his-

torians recognized the passing of a regional tradition, and begged the public to salvage its virtues. Slowly a revival of native arts was set in motion, first in architecture, and then in its complementary fields of furniture, weaving, and decoration. Today it is possible to escape from the commonplaceness of the machine world by furnishing an adobe house in what is reputed to be the Hispanic manner, conceding, of course, to the non-traditional elements of electricity, plumbing, and innerspring mattresses.

New Mexico village arts demonstrate that if the people of any society are left to their own devices long enough, they will call upon the resources of personality and environment to provide elements which make labor easier and life more interesting. Remembering European antecedents, the New Mexicans carved plows and looms of wood, and portrayed the saints in homemade pigments. In matters of this sort, their chief claim to invention was the application of known principles to new situations. Conversely, if these things came ready-made without undue expense, as when the natives had the opportunity to secure steel plows, factory-made clothing, and mill-ground flour or store-bought bread, they were glad to relinquish whatever esthetic pleasure existed in making these things for themselves.

Vanity is a factor in the perpetuation of art. There is no greater impetus to the spread of an artistic invention than for it to become fashionable, and no greater deterrent to a style of art than for it to pass from popularity or be slow of public acceptance. The provincial was pleased to emulate whatever styles reached him from the urban world, and the commerce in chests and metalwork was a prime example. But where the difficulties were many or the cost insurmountable, as in ob-

taining professional training, superior tools, or special materials, the native showed himself quite capable of original solutions. Measured in terms of obstacles overcome and completeness of self-expression, his success in art was very great.

It is always easier to copy than to create, and there is no debate about the acceptance of practical techniques such as irrigation and adobe. The present fetish of regional art is but a repetition of the nostalgic impulse to imitate the outer symbols of previous civilizations, whether they be Greek, Gothic, or Pennsylvania Dutch. This is not to deny essential values in the creations of people long-since dead, but to remind us that our own society contains the ability to originate and utilize art in ways fully as admirable as those of any historic group.

Beautiful things made by hand provide a relief from the systematic lines and textures of machine manufacture, and keep awake sensitivities that are dulled by standardization. It is now a rare experience to have known the living tree from which our doorstep is cut, or to have fed the sheep from whose wool our suit is woven. Only the absence of these elementary patterns makes us mourn their passing, for our ancestors accepted such events as matters of course.

The long-ago existence of the New Mexico village attracts us for certain elements that we seem to lack in our own lives, yet even if we forego the conveniences which we call modern, and accept the labor from daylight until dark which our ancestors endured, there is no returning. The tide of history engulfs us all.

 GLOSSARY

Adobe. Mud; earth used as a building material.

Bulto. Statue; the carved figure of a saint.

Campo santo. Cemetery.

Canales. Drainspouts.

Chamiso. Rabbit brush; *Chrysothamnus graveolens,* a bushy plant with yellow flowers.

China Poblana. Mexican skirt and blouse.

Clearstory window. Clerestory; concealed window which illuminates the main altar of a church.

Cobija. Small, square shawl worn by women.

Colcha. New Mexican wool embroidery.

Coping. Course of brick or stones covering the top of an adobe wall to prevent erosion.

Corbel. Short, carved timber supporting the weight of a roof beam.

Curandera. Healer; a woman skilled in the use of herbs.

Farolito. Lantern made by setting a candle in sand inside a paper bag, displayed during fiestas.

Gesso. Gypsum plaster. See *Yeso.*

Hacendado. Owner of an hacienda, or large estate; citizen of the wealthy class.

Horno. Outdoor oven made of mud.

Jerga. Serge; woolen cloth.

Katcina dolls. Painted wooden religious figures made by Pueblo Indians.

Kiva. Religious chamber of Pueblo Indians, often circular and below ground-level.

Luminarias. Small bonfires lighted during religious celebrations. See *Farolito.*

Manta. Mantle; square of cotton cloth formerly worn by Indians as a blanket.

Mission. The complete religious establishment, including church, residences and offices, devoted to the conversion of Indians to Christianity. A "mission church" is the church building of a mission. See *Parish church.*

Nicho. Niche; a shelf or cabinet for religious statues.

Parish church. A church maintained by local funds, as opposed to a "mission church," which is supported largely by funds from outside its congregation. See *Mission.*

Penitente. One of the Penitent Brothers, a religious order of laymen, noted for flagellation ceremonies.

Politico. Politician; a member of the official class.

Pueblo. Pertaining to certain town-dwelling Indians of the Southwest who live in permanent settlements; also, their town or village.

Ranchero. Rancher; a landowner.

Rebozo. Oblong shawl worn by women.

Reredos. Altarback; a framework containing paintings or niches for sculpture, rising behind an altar.

Retablo. Picture; a native religious painting.

Rico. Rich man; a member of the ruling class.

Santo. Holy; the carved or painted representation of a holy person or religious event. See *Bulto, Retablo.*

Santero. Artist; a maker of religious statues and paintings.

Sarape. Blanket worn by men as an outer garment.

Tápalo. Black shawl worn by widows.

Tempera. Paint; a dry pigment mixed with water, egg, or other vehicle.

Trastero. A cabinet of native design.

Viga. Log used as a roofing beam.

Yeso. Gesso; native gypsum plaster similar to plaster of Paris.

BIBLIOGRAPHY

Adair, John. *The Navajo and Pueblo Silversmiths.* Norman: University of Oklahoma Press, 1946.

Adams, Eleanor B., and Chavez, Fray Angelico. *The Missions of New Mexico, 1776: A Description by Fray Francisco Atanasio Dominguez, with Other Contemporary Documents.* Albuquerque: The University of New Mexico Press, 1956.

Austin, Mary. "Art Treasure." *Contemporary Arts of the South and Southwest,* Vol. 1, No. 1, Nov.-Dec. 1932.

Benrimo, Dorothy, with Rebecca Salsbury James and E. Boyd. *Camposantos.* Fort Worth: Amon Carter Museum of Western Art, 1968.

Betts, M. C., and Miller, T. A. H. *Rammed Earth Walls for Building.* Farmers' Bulletin No. 1500. Washington: United States Dept. of Agriculture, 1926, Revised 1937.

Bloom, Lansing B., ed. "Bourke on the Southwest," *New Mexico Historical Review,* Vol. 8-13, 1933-38.

Bloom, Lansing B., and Donnelly, Thomas C. *New Mexico History and Civics.* Albuquerque: The University Press, 1933.

BIBLIOGRAPHY 255

Borhegyi, Stephen F. de. "The Miraculous Shrines of Our Lord of Esquipulas in Guatemala and Chimayo, New Mexico," *El Palacio*, Vol. 60, No. 3, March 1953.

Boyd, E. *The New Mexico Santero.* Santa Fe: Museum of New Mexico Press, 1969.

———. *Popular Arts of Colonial New Mexico.* Santa Fe: Museum of New Mexico Press, 1959.

———. *Saints and Saint Makers of New Mexico.* Santa Fe: Laboratory of Anthropology, 1946.

Brewster, Mela Sedillo. "A Practical Study of the Use of the Natural Vegetable Dyes in New Mexico," *University of New Mexico Bulletin*, No. 306, May 15, 1937.

Bunting, Bainbridge. *Taos Adobes: Spanish Colonial and Territorial Architecture of the Taos Valley.* Santa Fe: Fort Burgwin Research Center, Museum of New Mexico Press, 1964.

Byne, Arthur, and Stapley, Mildred. *Decorated Wooden Ceilings in Spain.* New York: G. P. Putnam's Sons, 1920.

Byne, Mildred S. *Forgotten Shrines in Spain.* Philadelphia: J. B. Lippincott Co., 1929.

Calvin, Ross. *Sky Determines: An Interpretation of the Southwest.* Revised edition. Albuquerque: The University of New Mexico Press, 1965.

Chavez, Fray Angelico. *Archives of the Archdiocese of Santa Fe, 1678-1900.* Washington: Academy of Franciscan History, 1957.

———. *Our Lady of the Conquest.* Santa Fe: The Historical Society of New Mexico, 1948.

———. *The Cathedral of the Royal City of the Holy Faith of Saint Francis.* Santa Fe: Santa Fe Press, 1947.

Coan, Charles F. *A Shorter History of New Mexico.* Ann Arbor: American Historical Society, Inc., 1928.

Curtin, L. S. M. *Healing Herbs of the Upper Rio Grande.* Santa Fe: Laboratory of Anthropology, 1947.

Davis, W. W. H. *El Gringo; or, New Mexico and Her People.* New York: Harper and Bros., 1857.

Dunn, Dorothy. *American Indian Painting of the Southwest and Plains Areas.* Albuquerque: The University of New Mexico Press, 1968.

Drumm, Stella M., ed. *Down the Santa Fe Trail and into Mexico: The Diary of Susan Shelby Magoffin, 1846-1847.* New Haven: Yale University Press, 1962.

Emory, W. H., with J. W. Abert, P. St. George Cooke, and A. R. Johnston. *Notes of a Military Reconnoissance, from Fort Leavenworth, in Missouri, to San Diego, in California.* Thirtieth Congress—First Session, Ex. Doc. No. 41. Washington: Wendell and Van Benthuysen, Printers, 1848.

Espinosa, Gilberto. "New Mexico Santos," *New Mexico Magazine*, Vol. 13, March, April, May 1935.

Espinosa, José E. *Saints in the Valleys: Christian Sacred Images in the History, Life, and Folk Art of Spanish New Mexico*. Revised Edition. Albuquerque: The University of New Mexico Press, 1967.

Ewers, John Canfield. *Plains Indian Painting*. Stanford: Stanford University Press, 1939.

Federal Art Project of New Mexico. *Portfolio of Spanish Colonial Design in New Mexico*. Santa Fe: Works Progress Administration, 1938.

Fergusson, Erna. *Albuquerque*. Albuquerque: Merle Armitage Editions, 1947.

———. *Dancing Gods: Indian Ceremonials of New Mexico and Arizona*. New York: Alfred A. Knopf, 1942. Reprinted by The University of New Mexico Press, Albuquerque, 1957.

Gregg, Andrew K. *New Mexico in the Nineteenth Century: A Pictorial History*. Albuquerque: University of New Mexico Press, 1968.

Gilbert, Fabiola C. de Baca. *Historic Cookery*. New Mexico Extension Circular No. 161. State College: New Mexico College of Agriculture and Mechanic Arts, 1946.

Hewett, Edgar L., and Fisher, Reginald G. *Mission Monuments of New Mexico*. Albuquerque: The University of New Mexico Press, 1943.

Hodge, Frederick Webb, Hammond, George P., and Rey, Aga-pito. *Fray Alonso de Benavides' Revised Memorial of 1634*. Albuquerque: The University of New Mexico Press, 1945.

Hubbell, Elbert. *Earth Brick Construction*. Education Division, U.S. Office of Indian Affairs. Chilocco, Okla.: Chilocco Agricultural School, 1943.

Hunter, Russell Vernon. "Santa Inez of the Penitentes," *Southwest Review*, Vol. 32, No. 3, Summer 1947.

Hurt, Wesley R., Jr. "Shadows of the Past," *New Mexico Magazine*, Vol. 18, May 1940.

Jackson, Clarence S. *Picture Maker of the Old West, William H. Jackson*. New York: Charles Scribner's Sons, 1947.

James, George Wharton. *New Mexico, the Land of the Delight Makers*. Boston: The Page Co., 1920.

James, Rebecca. *The Colcha Stitch: Embroideries by Rebecca James*. Santa Fe: Museum of New Mexico Press, 1963.

Jensen, Merrill, ed. *Regionalism in America*. Madison: The University of Wisconsin Press, 1965.

Jones, Hester. "New Mexico Embroidered Bedspreads," *El Palacio*, Vol. 37, Sept., Oct. 1934.

———. "Uses of Wood by the Spanish Colonists in New Mexico," reprinted from *New Mexico Historical Review*, June 1932.

Keleman, Pàl. "The Significance of

the Stone Retable of Cristo Rey," *El Palacio*, Vol. 61, No. 8, Aug. 1954.

Kendall, Geo. Wilkins. *Narrative of the Texan Santa Fe Expedition*. 2 Vols. London: Wiley and Putnam, 1844. Facsimile reproduction by The Steck Co., Austin, 1935.

Knee, Ernest. *Santa Fe, New Mexico*. New York: Chanticleer Press, 1942.

Kubler, George. *The Religious Architecture of New Mexico in the Colonial Period and Since the American Occupation*. Colorado Springs: The Taylor Museum, 1940. Reprinted by The Rio Grande Press, Chicago, 1962.

Lammert, Fr. Angellus. *San Jose Mission—Old Laguna, New Mexico*. Privately printed, 1942.

Laughlin, Ruth. *Caballeros*. Caldwell, Idaho: The Caxton Printers, Ltd., 1945.

Lichten, Frances M. *The Folk Art of Rural Pennsylvania*. New York: Charles Scribner's Sons, 1946.

Long, Haniel. *Piñon Country*. New York: Duell, Sloan & Pearce, 1941.

Lowe, Cosette Chavez. "Hallowed Ground," *New Mexico Magazine*, Vol. 19, Aug. 1941.

Lucero-White, Aurora. *Los Hispanos*. Denver: Sage Books, 1947.

Lumpkins, William. *Modern Spanish-Pueblo Homes*. Santa Fe: Privately printed, 1946.

Marriott, Alice. *María: the Potter of San Ildefonso*. Norman: University of Oklahoma Press, 1948.

New Mexico Department of Vocational Education, compiler. *New Mexico Colonial Embroidery*. Santa Fe, 1943.

——. *New Mexico Tin Craft*. Santa Fe, 1937.

——. *Spanish Colonial Furniture Bulletin*. Santa Fe, 1933.

——. *Spanish Colonial Painted Chests*. Santa Fe, 1937.

——. *Vegetable Dyes Bulletin*. Santa Fe, 1935.

New Mexico Writers', Music, and Art Projects, WPA. *The Spanish-American Song and Game Book*. New York: A. S. Barnes, 1942.

Otero-Warren, Nina. *Old Spain in Our Southwest*. New York: Harcourt, Brace and Co., 1936.

Quaife, Milo Milton, ed. *The Commerce of the Prairies by Josiah Gregg*. Chicago: The Lakeside Press, 1926.

——. *The Southwestern Expedition of Zebulon M. Pike*. Chicago: The Lakeside Press, 1925.

Quimby, George Irving. *Indian Culture and European Trade Goods: The Archaeology of the Historic Period in the Western Great Lakes Region*. Madison: The University of Wisconsin Press, 1966.

Ritch, W. G. *The New Mexico Blue Book, 1882*. Facsimile edition. Albuquerque: University of New Mexico Press, 1968.

Robacker, Earl F. *Pennsylvania Dutch Stuff*. Philadelphia: University of Pennsylvania Press, 1944.

Ruxton, George F. *Adventures in Mexico and the Rocky Mountains*. New York: Harper, 1848.

Saunders, Lyle, compiler. *A Guide to Materials Bearing on Cultural Relations in New Mexico*. Albuquerque: The University of New Mexico Press, 1944.

Scholes, France V. "The Supply Service of the New Mexico Missions in the Seventeenth Century," *New Mexico Historical Review*, Vol. 5, 1930.

Sedillo, Mela. *Mexican and New Mexican Folk Dances*. Albuquerque: The University of New Mexico Press, 1945.

Segale, Sister Blandina. *At the End of the Santa Fe Trail*. Milwaukee: The Bruce Publishing Co., 1948.

Shalkop, Robert L. *Wooden Saints: The Santos of New Mexico*. Colorado Springs: The Taylor Museum, 1967.

Three Centuries of European and American Domestic Silver. San Francisco: M. H. de Young Memorial Museum, 1938.

Tormo y Monzó, Elías. *Monasterio de Guadalupe*. Barcelona: H. de J. Thomas.

Underhill, Ruth. *Pueblo Crafts*. U.S. Indian Service. Phoenix: Phoenix Indian School, 1944.

———. *Workaday Life of the Pueblos*. U.S. Indian Service. Phoenix: Phoenix Indian School, 1944.

Villagrá, Gaspar Pérez de. *History of New Mexico, 1610*. Gilberto Espinosa, translator. Los Angeles: The Quivira Society, 1933.

Webb, James Josiah. *Adventures in the Santa Fe Trade, 1844-1847*. Ralph P. Bieber, ed. *The Southwest Historical Series*, Vol. 1. Glendale, Calif.: The Arthur H. Clark Co., 1931.

Wenham, Edward. "The Colonial Silver of Early Spanish America," *The Fine Arts*, Vol. 18, No. 4, March 1932.

———. "Spanish American Silver in New Mexico," *International Studio*, Vol. 99, No. 410, July 1931.

Wilder, Mitchell A., with Edgar Breitenbach. *Santos, the Religious Folk Art of New Mexico*. Colorado Springs: The Taylor Museum, 1943.

INDEX